PRIVATE VIEWS

spaces and gender in contemporary art from britain & estonia

edited by angela dimitrakaki, pam skelton, mare tralla

published by **Women's Art** *Library*

Published in 2000 by **Women's Art** *Library*
107-109 Charing Cross Road, London WC2H 0DU

Distributed by I.B. Tauris & Co Ltd
Victoria House, Bloomsbury Square, London WC1B 4DZ
175 Fifth Avenue, New York NY 10010
http://www.ibtauris.com

The exhibition *Private Views* was originally produced for the Estonian Art Museum, Tallinn in June 1998. It has since toured to Hungary and been presented in Yugoslavia, the Netherlands and the United Kingdom.

ISBN 1 86064 655 7

A CIP catalogue record for this book is available from the British Library.

Designed by Robin Forster at wiz, robin@wiz.ltd.uk

Private Views on-line at http://www.research.linst.ac.uk/pviews

Publication funded by

Funded by
THE
**ARTS
COUNCIL**
OF ENGLAND

Central Saint Martins
College of Art & Design

THE LONDON INSTITUTE

LIVERPOOL
ART SCHOOL

cair
centre for art international research

PRIVATE VIEWS

spaces and gender in contemporary art from britain & estonia

http://www.research.linst.ac.uk/pviews

acknowledgements

The editors would like to thank especially the Arts Council of England for funding this volume and the Women's Art Library for undertaking this publishing project. The editors gratefully acknowledge additional financial assistance from Central Saint Martins College of Art & Design and the Centre for Art International Research at Liverpool Art School, John Moores University. Special thanks go to Ceri Hand and Althea Greenan for their assistance and support, and Robin Forster for his enduring patience; to Jacquie Swift, Tom McCarthy and Mary Sands, and to all the artists and writers who have contributed to this volume. This book emerged out of an exhibition project made possible through the financial support of the Soros Center for Contemporary Art, Estonia, the British Council, Central Saint Martins College of Art & Design, Eha Komissarov and staff at the Art Museum of Estonia, Tallinn, to whom the editors and participating artists are greatly indebted.

The editors would also like to thank Sue Malvern and Judith Mastai, the organisers of *Virtue and Vulgarity: A Feminist Conference on Art, Science and the Body*, the third Biennial Conference of FAHN (initiated by Griselda Pollock in Leeds). Held at the University of Reading in 1997, the conference provided a space for networking, and some of the writers and artists involved in this project first met there. And finally, a very special thanks for the endless support and encouragement of Stephen Emmott, Tony Fletcher and Miltos Tsiantis.

Contents

preface

Private Views is a timely book on more than one front. Feminism as practice and theory has now been around for over twenty years and has gained a certain, not entirely flawless, authority. This collection of essays from Britain and Estonia serves to review some entrenched ideas surrounding the feminist project. They demonstrate how 'Feminism' has matured into the more substantial 'feminisms' which recognise feminist practice and theory in a myriad of contexts.

In this way *Private Views* reflects the emergent focus of the Women's Art Library as a continuum from the early eighties that is a manifest incarnation of activism, theory and art combined. As the late nineties saw American women's studies programmes incorporating the firsthand experience of volunteer work in women's organisations as part of degree coursework, the two spheres of feminism - of activists and academics - are coaxed into a third space, and the necessity for this is also recognised. Art as a well-trodden stage for the meeting of theory, practice and activism gains much from being re-framed into an extant social context, especially that which reaches beyond the West. A truly interdisciplinary approach as offered in *Private Views* is rare in the discussion of art, though, as the archive of the Women's Art Library proves, the scope of women's art has long indicated this possibility.

Questions raised by the persistence of feminism are aired and have thus secured a place in a debate which, thanks to this publication, is so brilliantly enriched by the contributions of writers and artists from Estonia. Their critique of the implications of feminism for women living in a post-communist state provides an invaluable context for the set of artworks making up the exhibition *Private Views,* while casting light on some of the forgotten ramifications of feminism in the West. If the ideal of the universality of women's experience is the original cloth from which this feminism was cut, the stuff proved too weak to sustain those excluded from the privilege of educated white middle-classdom. The actual geographical location of contributors appears at first glance to connect only Estonia and Britain, but as a group represents a shifting trans-national perspective. Such a broadly international, interdisciplinary collaboration succeeds in distinguishing rather than submerging the acutely different challenges facing women inhabiting different social realities, without negating a possibility of a collective feminist project.

Artworks re/present further spaces through which the reader is guided by considering framing, social contexts, the body, the spectator, the private and the public. This intricate investigation (or 'itinerary') reflects the challenge facing contemporary art in the West. It suggests a buzzing intersection of art that exists, art that has yet to be made and the lives of those who make it. And if any single idea is emphasised at all in this book, it is the idea of the 'lived reality'.

Althea Greenan
Women's *Library* Art

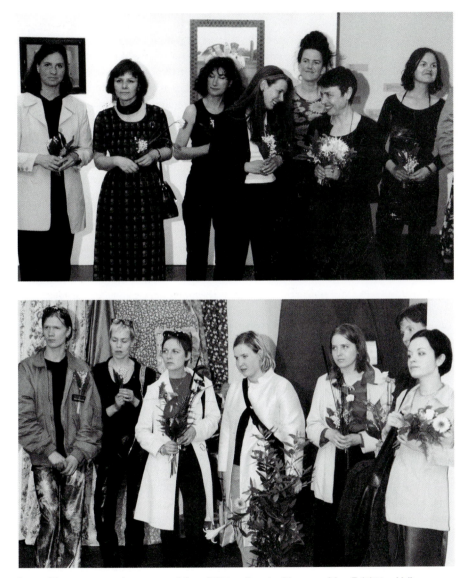

Private Views; artists at the opening of the exhibition, Estonian Museum of Art, Exhibition Hall Rottermann's Salt Storage, Tallinn 1998

introduction

shifting subjects - beyond the east/west divide

Pam Skelton

chance meetings

Liverpool, April 1997: *Video Positive*, the festival of new media in the arts, hosted a conference, *LEAF*, which brought together participants involved in media art and information culture from all over Eastern Europe. The conference was an East-West European initiative that provided the context for a forum which emphasised communication and the dissemination of information through an artist-led organisation known as the *Syndicate* (an international mailing list which aims at addressing new media in Eastern European countries)[1] The presentation of work and ideas from Eastern Europe provided the opportunity in Liverpool for Western artists, theorists and historians to consider the new incentives, the views and the positions which are currently being undertaken in the former territories of the Eastern bloc. The importance of networking and fluid systems of communication were the key to many of the topics and themes taken up at *LEAF*. At the same time, it provided a unique opportunity to meet people, which, combined with the accessibility of the Internet, could help create new alliances and would perhaps facilitate future partnerships and friendships.

As a Western artist and teacher, I was drawn to the conference by an interest in the changes that were taking place in the rapidly changing landscapes of Eastern Europe: by necessity a process of constantly redefining, relocating and, ultimately, redressing the parameters in which power operates. I was also eager to gain some kind of insight into the position of women artists in Eastern Europe at this particular and very crucial time in their history. Were there, perhaps, comparisons to be made in relationship to interventions which had taken place in British art education and gender politics in the early eighties? The struggle for equal opportunities in British art education and the lack of women's visibility as artists had, for many women in this period, been a defining experience. The collective actions and initiatives which challenged the marginalisation and exclusion of women artists from professional roles in art education and the gallery were successful, at least up to a point.[2] There was a gradual shift of perspectives which took place in the academy and in the gallery in eighties Britain, in which the status of women artists could at last be seen to be slowly improving. These gains, made possible by the radical interventions of the Women's Liberation Movement in the late sixties and seventies, were also the swan song of radical politics.[3] In comparison, the nineties have been fallow years, a decade of retrenchment where once radical strategies and interventions became absorbed into either the academy or the mainstream or both.

However, the underlying reason for my interest in Eastern Europe emerged in the late eighties as a desire to probe into, and come to terms with my family's Jewish roots in Eastern Europe.[4] This investigation significantly influenced the direction that my art practice would take over the next decade. Unfortunately, enquiries such as this in early nineties Britain gained scant visibility in the art world and as a result there

[1] *Liverpool East European Electronic Arts Forum (LEAF)* organised by Iliyana Nedkova took place in April 1997 as one of three major conferences covering diverse aspects of art, culture and technology included in the *Video Positive 97*. LEAF aimed at reflecting critically on a number of new and developing media arts projects and issues. *Syndicate* mailing list: http://colossus.v2.nl/syndicate/index_fr ames.html

[2] For an account of collective actions undertaken by feminist artists, students and art historians in the seventies and eighties see Roszika Parker and Griselda Pollock (eds), *Framing Feminism, Art and the Women's Movement 1970 - 1985*, Pandora Press, London 1987, pp3-77.

[3] For an informative description and chronology of the history of the political struggles charting women's emancipation in politics and art from the late sixties through to the end of the seventies in Britain, see Sue Malvern, 'Women: Work, Politics and Art, A Chronology of the 1970s' in Judith Mastai (ed), *Social Process/Collaborative Action: Mary Kelly 1970 - 75*, Charles H. Scott Gallery, Emily Carr Institute of Art and Design, Canada 1997.

was little evidence of artistic practice or critical debate. At the same time in the former Eastern bloc countries the absence of Jewish communities together with the suppression of their history made any intervention by artists unlikely. It is perhaps worth remarking that particular discourses seem to be out of bounds for visual artists, attesting to Julian Stallabrass's observations that "to survey the scene of contemporary art is to look upon a vista at once chaotic and strangely uniform. Amidst the variety, so many things now seem forbidden".[5]

Overall, the presentations by artists at the *LEAF* conference tended to avoid the major historical questions that had marked the lives of the older generation. It was, therefore, not the catastrophic events of history nor the legacy of the Soviet system which were the main concerns of the participants in the *LEAF* conference. Rather, the overthrow of the derelict state apparatus provided the starting point from which to navigate new incentives while negotiating how these might be achieved. The issues that seemed pressing were the establishment of independent artist-led initiatives and fluid communication systems through the Internet. Many of the presentations were, understandably, locatable within agendas that focused on opening up routes of communication and networking outside their specific geographical region. Communication and networking were of particular importance in this context, bearing in mind that overseas travel was still beyond reach for many Eastern European artists. It is clear from this outline that issues concerned with hierarchies and gender positions were not the topical themes of the conference. However, there were some presentations which dealt specifically with histories and identities as experienced by women in Eastern Europe.

Feminism: A Media Toy, delivered by a young Estonian artist, particularly attracted my attention. In her presentation (and in the conversations which followed) Mare Tralla described the influences which had shaped her practice. The feminist project in Estonia marked its beginnings in 1994 with an exhibition called *Kood-eks*, a Swedish-Estonian collaboration, and was followed by a series of feminist exhibitions and projects, the most recent being the exhibition *Private Views: Space Re/cognised in Contemporary Art from Estonia and Britain*. Informed by Western feminist theory and practice which began trickling into Estonia from the mid-nineties, Tralla's work developed partly as a critique of the traditional canons of Western feminism, which she considered both out of date and inappropriate for the needs of contemporary Estonia. Critical of the limited status of women artists in Estonian art and the media's construction of women as objects rather than subjects, this artist has developed a practice which in the Western world would be perceived as being postfeminist in approach. Using irony, and with the intention to provoke, Tralla has in the past employed visual language, such as hard-core pornography captured from cable television. In her practice I perceived an interesting contradiction: although the formal aspects of the work could be seen as postfeminist, the effort to articulate a feminist critique was evident.

It is not possible to discuss gender in Eastern Europe through the same discursive framework as in Western Europe. The historical precedents and lived experiences of women in Britain, are, for example, very different from those of women living in Poland. The ideological and economic models of capitalism and communism have

[4] My work as a painter, video and installation artist has evolved as a practice which is principally situated in the mapping of the fragmented archaeologies of culture, memory and history.

[5] See Julian Stallabrass, 'Money, Disembodied Art, and the Turing Test for Aesthetics' in Lolita Jablonskiene, Duncan McCorquodale and Julian Stallabrass (eds), *Ground Control: Technology and Utopia*, Black Dog Publishing, London 1997, p69. The impetus of this book was an exchange programme between artists from Lithuania and Britain and, despite its different focus, appears to provide the only comparable British publication so far to *Private Views*.

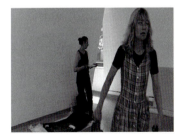

Anu Juurak and Susan Brind at the Institute of Contemporary Art, Dunaújváros, Hungary, July 1999, video still

introduction

effected real differences between how women were, and continue to be, constructed as subjects in their respective societies. To give one example: British women's struggle for equal opportunity in the workplace bears little relationship to the perceived access to skills, education and work which was the norm in Soviet society for all women. However, to complicate matters, the entrance of Eastern Europe into the market-driven economies of Western capitalism has created new divisions, new problems and new identities.

The methods that Estonian artists have adopted in their efforts to give a voice to their concerns in the nineties clearly have some similarities with the emerging feminist agenda in Britain of the seventies and early eighties. I am specifically referring here to the phenomenon of feminist art conferences, events and exhibitions which overall embraced a broad constituency of the work of women artists.[6] While there have been comparable projects in Estonia, these have not been as frequent as in Britain; nor have they generated, so far, the sort of theoretical debate which was integral to the critical underpinning of the British women's art movement. How feminist Estonian art practices relate to the British feminist model cannot be adequately understood at this point in time, as the issues have not yet been contextualised. This no doubt reflects certain elements of postmodernism which emphasise the fluidity of meaning, the blurring of boundaries and the dissolving of histories. The hybrid practices which have characterised women's art in the nineties in Estonia 'reflect' global culture in all its ramifications as well as national issues and local concerns. The visual languages principally adopted by these artists at this time are photography and video, which in formal terms are often indistinguishable from the dominant approaches favoured by the international art world. If we choose to consider 'difference', it can perhaps be found within the specific historical formations from which the work itself has emerged.

[6] R. Parker and G. Pollock *op. cit.*

It is only recently that the former states of the so-called Eastern bloc have acquired access to a body of knowledge which makes up the canon of British feminist theory and practice. At the same time, an intense destabilisation of traditional values and practices has taken place. While feminist art theory and practice have evolved in Britain over a period of years, they have appeared in Eastern Europe as a *fait accompli* packaged, promoted and ready to be consumed. It is significant that this resource can now be accessed, as it provides an index in which the agenda of British feminism can be thoroughly mapped, its history charted, its causes, effects and outcomes appraised. Feminism has entered Eastern Europe at the same time as a lot of other more influential 'isms' such as capitalism, globalism and postmodernism. From an eruption of competing ideologies it is not surprising that many of the visions and positions which are taken up in the visual arts are articulated as an experiential response to the material and psychological conditions of capitalism, rather than as imported ideological or theoretical positions adopted from Western post-structuralism and feminism. What, then, is the relevance of Western feminism to women in the Eastern European countries? And what is the relevance of Eastern European women's struggles to Western feminists? Questions such as these are central to any discussions revolving around practices of representation today.

Pam Skelton, Katrin Kivimaa, Lívia Páldi and Naomi Dines at the café of the Institute of Contemporary Art, Dunaújváros, Hungary, July 1999, video still

12

from *virtual vulgarity* to *private views*

Virtual Vulgarity and *Private Views* were two exhibitions that followed on from my meetings with Mare Tralla after the *LEAF* conference. Both exhibitions came about as a response to feminist practices in the visual arts in the nineties. Both projects can be identified as artist-led initiatives which were organised in the first instance with no financial support and in the second instance with very little. Mare Tralla and I relied fundamentally on the goodwill of each of the artists and their common interest in participating in the projects.

Virtue and Vulgarity: A Feminist Conference on Art, Science and the Body, organised by Sue Malvern and Judith Mastai at Reading University in September 1997, provided the invitation and the context for the first exhibition.[7] *Virtual Vulgarity* featured new work by artists Susan Brind, Naomi Dines, Mare Tralla, Sonja Zelic and myself and explored diverse positions of female subjectivity in the languages of electronic media, film and photography. The works shown in the exhibition could all be seen as having been influenced by a variety of feminist positions. However, despite the context of the exhibition, most of the artists professed a reluctance to define their works as feminist in intent. The reasons for this are perhaps to be found in the possible rigidity with which feminist art, as a signifying practice, is understood today, together with its unfashionable image in both the art world and popular culture. The term 'postfeminist' has provided a label which appears to allow more leeway for women artists, but unfortunately does so at the expense of evacuating the most important and relevant aspects of feminist enquiry. A more useful strategy in general terms could be to build on feminism's success while at the same time addressing its failures.

Eha Komissarov, a curator from the Estonian Art Museum in Tallinn, had, in 1996, invited Mare Tralla to curate an international feminist exhibition. This invitation provided the opportunity for a collaborative project to take shape. *Private Views: Space Re/cognised in Contemporary Art from Estonia and Britain* was shown in June 1998 at the Estonian Art Museum in Tallinn and brought together a selection of work drawing on two markedly different traditions. This event provided an opportunity to take a glimpse at the variety of ways in which this group of artists expressed concerns which have emerged out of different geographical positions and socio-cultural models. As the title of the exhibition suggests, *Private Views* presented works made by women (and one man) in photography and electronic media which explored the intimate and private and, in some instances, the public spaces in which Estonian and British artists are physically and/or psychologically positioned. This work was often intensely personal, while the languages in which it had been constructed were, in fact, those used by the media to convey information, entertainment and advertising. The concepts of feminism and postfeminism again proved to be problematic in terms of definition, as the work could be seen to be occupying a multiplicity of positions. The artworks appeared to provide a consensus of readily consumable images which often interceded and crossed boundaries with one another as they interacted in the gallery. At another level, though, the narratives which were concealed in these works could not simply be approached through the transparency of the media which fashioned them. The attempt to contextualise the

[7] Feminist Arts & Histories Network, Third Biennial Conference, University of Reading, September 1997.

The opening of *Private Views* at the Institute of Contemporary Art, Dunaújváros, Hungary, July 9th 1999, video still

introduction

show, together with the information that was displayed as exhibition panels addressed to the public, was intended to provide a comprehensive framework for approaching the work. This, it must be said, did not prevent numerous misunderstandings and misreadings from occurring.

cultural territories

The twentieth century has been a time of turbulence, ruptures, wars, genocides and repressive ideologies: an age the historian Eric Hobsbawn calls 'the age of extremes'[8] and an age which the social and political historian Hannah Arendt documents in her chilling trilogy *The Origins of Totalitarianism*,[9] in which she analyses the sources and influences which gave birth to anti-Semitism, imperialism and totalitarianism. In the last decade we have witnessed a further sea change in world politics with the collapse of the Soviet Union and processes presumably leading towards the reunification of Europe. The struggle of the ideologies of Western capitalism and Soviet-type communism have apparently come to an end in (mainly) bloodless coups, with capitalism emerging as a problematic but uncontested victor.[10]

The question of difference in relationship to gender, geography, history and culture is bound to be underscored in an exhibition which brings together Eastern and Western European artists. To speak of culture denotes the formation of social and intellectual patterns. For each of us, the culture which we are part of is pervasive and all-embracing. We cannot escape, or easily see through, the dominant ideologies and myths which shape our lives. It can, therefore, be difficult to approach another culture and understand the codes by which it operates. The exhibition *Private Views* underlined the need for studies which address the social and political projects of feminist histories and art practices as they evolve and interact in the spaces of Eastern and Western Europe. The intention of the editors has been inevitably to provide an interdisciplinary approach to the subject, which we hope will allow for cross-fertilisation to occur between the distinct specialisms and provide a more comprehensive understanding of the topics discussed. The contributing authors to this volume are, therefore, drawn from a range of disciplines which connect and intercede with the social, geographic, historical and cultural fields of knowledge. And it should be stated at this point that we are not attempting to map the cultural position of these two nations, for such an ambition would be misplaced. Rather, our aim is more modest: to examine aspects of art, its production and consumption, cultural hegemony and gender.

Pauline van Mourik Broekman's insightful interview with Mare Tralla confounds and undoes stereotypical assumptions that a westerner might have in imagining that they understand the dynamics of the present day situation in Estonia. The different national histories which underlie and reveal the underbelly of present day Estonia and Britain are hinted at and at times exposed in this conversation. Comparisons are made between the status of young British and Estonian artists and the differences and similarities of the art scenes in post-communist Europe. What is brought into play is ironically enough the realisation that art, feminism, social upheaval and rebellion are important interludes which can still punctuate resistance at the end of the 20th century.

[8] Eric Hobsbawn, *Age of Extremes, The Short Twentieth Century 1914 - 1991*, Michael Joseph/Penguin Group, London 1994.

[9] Hannah Arendt, *The Origins of Totalitarianism (Part I: Anti-Semitism, Part II: Imperialism, Part III: Totalitarianism)*, Harcourt Brace & Company, San Diego and New York 1985.

[10] The crisis and breakdown of the economy in Russia could have proved to be the first exception. See Boris Kagarlitsky, 'System Error', *Red Pepper*, October 1998, pp16-20.

Exhibition view at the Institute of Contemporary Art, Dunaújváros, Hungary, July 1999, video still

Joanna Sharp reminds the reader that we are now living at a point in history where the transitional spaces of Eastern and Western Europe collide to form a new Europe. In her essay, she investigates the geographies which make up the complex spatial differences of gendered identities and argues that gender is articulated differently in different spaces, but ultimately "resists 'capture' by static concepts like scale". In mapping the private and public spaces of women's experience, Sharp argues that nationalism, as related to processes of identity formation, is inherently gendered, and goes on to explore what she defines as "the other spaces of gendering that co-exist with and contradict nationalism".

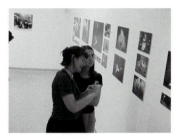

The opening of *Private Views* at the Institute of Contemporary Art, Dunaújváros, Hungary, July 9th 1999, video still

Angela Dimitrakaki introduces, in a wider context, some of the issues underlying the staging of *Private Views*. Her essay revolves around contemporary understandings of space: space which is defined as both public and private; space in which radical identities emerge and yet power seems always to be at play. Dimitrakaki is particularly concerned with how feminism, as a critical project developed in specific geographies, can attend to the materiality of gender difference (as for example it is evidenced in *Private Views*) where, significantly, cultural difference is always implicated. Her readings of the artworks consider, amongst other things, aspects of spectatorship, the meanings of 'attitude' and the investment in technology, as well as the production of the gendered body in spaces of representation.

The three Baltic states of Estonia, Latvia and Lithuania were the first republics to leave the Soviet Union and are rapidly becoming active participants in the ever-expanding culture industry. Katrin Kivimaa examines the status and tendencies in feminist and women's art practices as they have developed in the post-communist period in Estonia. In so doing, Kivimaa attempts the difficult task of unraveling the issues emerging from debates around gender in relationship to the perceived reluctance of the art world, and society on the whole, to engage with them. In a country lacking any precedent for feminist interventions, either in the arts or in society as a whole, feminism is understood largely as an unwanted Western export, newsworthy as a subject open to attack and notable principally for its 'scandalous image'.

In Britain, feminist history and visual culture have been principally disseminated through texts and pedagogical practices. From her position as an academic, artist and teacher, Aoife Mac Namara investigates how her understanding of feminist practices has been constituted in British university departments in the late eighties and early nineties. Mac Namara reviews the systems of meanings and values which have been so influential in the shaping of feminist practices, and argues for the importance of approaching these practices as historically specific discourses which should be positioned within the wider field of current social and cultural experience if feminism is not to be understood as merely another discourse producing new forms of cultural hegemony.

The legacy of Soviet society is one of equal opportunity, which Barbi Pilvre describes as sharing some perspectives with certain Western feminist tendencies whilst also acknowledging the limitations of this position. Pilvre describes and examines the social processes which have impacted on a culture seeking to redefine itself in

introduction

Exhibition view at the Institute of
Contemporary Art, Dunaújváros,
Hungary, July 1999, video still

[11] Manuel Castells quoted in Paul Du
Gay (ed), *Production of Culture/Cultures
of Production*, Sage in association with
the Open University, London 1997,
p24.

[12] For a comprehensive examination
of the ways in which contemporary
cultural products are bound up with
the economic processes of production,
circulation and exchange see P. Du Gay,
op.cit., pp19-66.

[13] For more information on the
effects and influences which are
exerted on the arts by corporations,
see Theodor W. Adorno and Max
Horkheimer, *Dialectic of Enlighten-
ment*, Verso, London 1947. Also see
Theodor W. Adorno, *The Culture
Industry, Selected Essays on Mass
Culture*, edited by J.M. Bernstein,
Routledge, London 1991.

relation to Western capitalism while in retreat from Soviet values. The reinvigorated discourse on femininity located within an essentialist model of feminisation to which Estonian women now aspire, Pilvre argues, is largely the result of the influence of consumerism through gender-specific marketing strategies which sell youth, fashion and beauty as the defining tools for individual transformation.

If the culture and fashion industries position difference as an exotic and consumable 'other' in the context of their market strategies, then the Internet is its biggest and most radical tool for disseminating difference, described by Tiziana Terranova as "the organic machine for the production and circulation of difference". However, this is only part of the story. In her essay on approaches to media culture, Terranova introduces the reader to the arguments circumventing digital technologies and their interaction with and connection to cultural, political and economic structures. Fundamental to these enquiries are the challenges, opportunities and contradictions which interactivity and the World Wide Web hold for women and feminist artists today.

the crisis in meaning

We are living in a culture which has been described as a new world order in which the industrial foundation of mass production, catering to the national and international market, has been replaced by so-called globalisation which uses information technologies. These constitute a means of organising economic production with the aim of surpassing national boundaries to achieve an exploitation of markets on a world scale. Time, space and place are refigured, or even transcended, by the new sciences of information technology and telecommunications which enable global corporations to coordinate and integrate their economic interests through "the space of flows rather than the space of place".[11] Global enterprises function across international territories transcending geographical constraints and providing an interface between the physical and the virtual world of corporate networks and commercial centres. Although this is still debated, the Information Age could be understood as the process by which nation states are mutating into corporate states which then define and drive local as well as global markets.[12]

The relationship of the local to the global in economic and cultural terms has, as we might imagine, interesting parallels in the production and consumption of meaning in art practices. The foundations and arguments laid down by Theodor Adorno and Max Horkheimer in their analysis of the culture industry in *Dialectic of Enlightenment* still hold more than a modicum of truth.[13] Writing in the mid-forties, Adorno and Horkheimer argued that culture had already been industrialised and standardised to conform to the demands of the mass market and profit. Today, their analysis of the culture industry seems to be almost prophetic in its relevance to the post-industrial virtual landscapes of charts, flows, trends and profits, which in the hands and pockets of corporate businesses at best support and at worst define and control the arts as well as the entertainment industries. In the West, the escalating interest in contemporary art and the rapidly expanding audiences in art galleries are largely due

to the success of marketing and promotion. Having created an audience as well as a circuit of production and consumption, the connoisseur, the influential curator, art dealer or corporate sponsor is well placed to speculate in 'futures'. Art as a potentially valuable and marketable commodity is then circulated via the gallery system and consumed by other artists, students and, most importantly, the general art audience. Contemporary art as a multiplicity of practices is continually at the mercy of the spokesperson, mediator and definer of taste, and today we may justifiably ask: what place is there for practices in art which do not acquire their meaning through the markets?

new challenges

The essays in this volume consider aspects of the social, historical and educational structures that underpin the production of women's art practice in Estonia and Britain. Estonia is currently reclaiming a national identity within which gender issues find their distinct meanings, while at the same time the country is attempting to claim its presence in a global culture. Meanwhile, in Britain, the promotion of privatisation and corporate sponsorship supports the decline of public subsidy in key areas such as education, health and the arts, while dissent against these procedures remains muted.

Against the backdrop of social and economic changes which are taking place, the individual and, specifically here the female subject, may constantly be in the process of renegotiating the means by which it is possible to function in the changing society within which she finds herself. This is to ask: what does it mean to be a woman and an artist working in new media today in two European countries where different feminisms and diverse traditions intersect? These points of diversity and convergence are potentially useful and empowering structures, not only because they disrupt simplified interpretations of common knowledge, but because in so doing they help to dispel the myths that shape our views about ourselves and others. We cannot take it for granted that the values which we are taught as Western or Eastern Europeans can provide us with a reliable framework for deciphering the world around us. There is an urgent need now to work through existing models of value and strive towards new forms of dialogue. It is also necessary to recognise the influences that the diverse uses and investments in technology have in relation to sexual difference and gendered practices of art across spaces of cultural hierarchies, and how these impact upon our understanding of the historically produced subject. But subjects are not only constructed from past history; rather they are constituted from a multiplicity of influences which make up *lived experience*. Estonia and Britain appear here as two countries with distinct histories which have evolved from different cultural models. The paradigms which make up our understanding of these two cultures have provided us in this instance with the opportunity to approach, locate and investigate the private, and not so private, views of social formations situated in a world mediated by powerful and defining structures. Difference is not only located within the obvious or easily accessed places which make definition possible. It must be looked for in other spaces too, the gaps between hidden agendas, unspoken stories and conflicting desires.

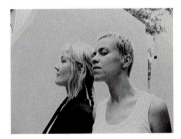

Anu Juurak and Ene-Liis Semper at the Institute of Contemporary Art, Dunaújváros, Hungary, July 1999, video still

chapter 1

state of play
an interview with mare tralla

Pauline van Mourik Broekman

[PvMB] One leitmotif common to many of the texts in the retrospective *Private Views* anthology is the dual, perhaps triple, problematic introduced by 'feminist' art in Estonia and other post-Communist countries. Namely, the necessity to tackle feminism proper as well as historical complexifications of that social and intellectual tradition in one go. Allied to this, there is the tension to consider in relation to all feminisms, and especially their more academic variants, of being a Western export product.

I'd like to begin by asking you about your experience of these tensions and also their effect on your art. For example, you had been reading all these books in Estonia, but some of them came from your own library and some from friends' libraries. How does that perhaps speak of the situation in a more general sense? These books were your introduction to a big intellectual tradition, but you had to deal with the whole tranche, from Simone de Beauvoir to re-readings of Lacanian feminist theory, in one go.

[MT] Personally, it all started with cyberfeminism. I saw VNS Matrix's work in Helsinki in February 1995; I don't think I had really read many books before then which dealt with feminist theory. I had probably read articles about women's art, but not about the theory. I was sent to Helsinki by Eha[1] – with whom I had agreed to do this *Est.Fem* show – to listen to the Finns talk about subjects such as pornography. I think that was really the first point at which I got some sort of an idea of which books to read. Another interesting thing that hasn't been discussed in anybody's text on *Est.Fem* is our sense of 'strategy'. When Eha invited me, she said, "We have to deal with that. It will go very well in the West. We could use it (feminist concerns) to break into the Western art world".

So it's kind of two-sided because on the one hand Eha, who is a very clever and intuitive person, just had a feeling that East European feminist art would make an impact. But, since she had struggled all this time to make, or put on, work in Soviet society (she worked for the art museum for a long time) that will have had an effect too. From Eha and Reet's [2] position, there was this existing personal struggle, which probably made them interested in feminist theory. Having to face problems every day makes you want to rebel against them; it's not like you have to have read the theory to act.

It also depended on your age. For Reet and Eha the interest was more for the first and second wave feminism. For myself and the younger generation, it was more about discovering inspiring art and the relevance of it to your personal life.

[PvMB] So, their roles in a sense mirrored their relevance for different generations in Estonia? Which is perhaps quite logical.

[1] Eha Komissarov, a curator of contemporary art at the Art Museum of Estonia and 'Vaal' Gallery, Tallinn.

[2] Reet Varblane, art critic and art editor of the cultural weekly *Sirp*; co-curator of *Est.Fem*.

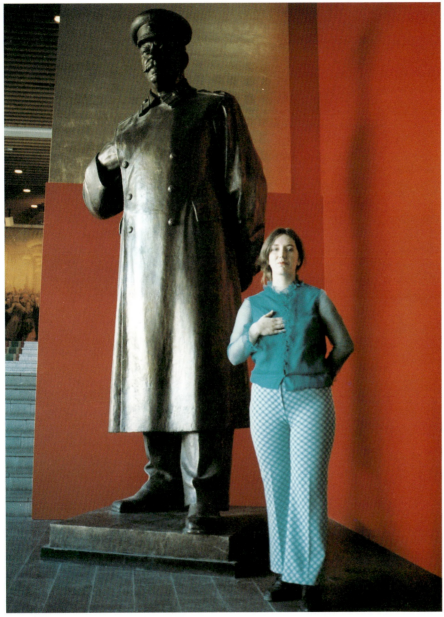

Mare Tralla *Yesno*, ETV TV series, still, 1995

[MT] Yes, it is. I also think there is a difference between the practising artist and the theoretician. I found that artists were much more free doing their work and that they didn't necessarily feel deprived without knowledge of those discourses. For writers it seems different, because everything came at the same time and they really needed to grasp it. They had this kind of desperate need to read everything and thought that only once they had done that could they make up their own mind.

[3] See 'Cybertides of Feminsm', a conversation between Iliyana Nedkova and Mare Tralla in next Cyberfeminist International, obn, Hamburg 1999, pp86-90.

[PvMB] I think that is a problem you can have in the West as well.

[MT] Exactly. But here at least you have easy access to books.

[PvMB] You have mentioned in another interview[3] that, before *Est.Fem*, you did not want to be seen as a feminist? Was that something you had in common with other women in Estonia?

[MT] It was a very natural response at that time. The word carried over certain associations from Soviet times and some leading male critics used the word feminism as a negative term. Secondly, we can't say that during the Soviet time none of the Western women's liberation movements were known in Estonia. If you take the women's magazines of the seventies and eighties, you can see lots of articles reporting on women protesting in nuclear plants, talking about equality in the workplace, and so on. All those things were there, but not the cultural theory. Very often these phenomena were explained from the point of view of Soviet reality – showing how 'equal' women were in the Soviet Union. Like, for example, "in the West they still have to fight for the right to abortion," or other things which were somehow very 'natural' for women in the Soviet Union. But only those aspects of women's equality were shown – nothing else than the workplace and peacekeeping. If you look at it like that, the idea of a feminist movement as explained by Soviet propaganda, for post-Soviet women it belonged to an earlier time people wanted to move away from.

[PvMB] At that point it was a term tolerated by men, referring to a female or feminine experience. So perhaps there were two different kinds of moments, two different problems with feminism, or gender equality.

[MT] We have this saying that during Soviet times women were more equal than equal. My thinking on feminism's difficult position is that it is largely indebted to this Soviet experience. Then again, I haven't seen any analysis of how the Western feminist or women's movement was explained in the Soviet press.

In the late eighties, there were women artists who had dealt with female sexuality and other more internalised questions, but those dealing with social issues were still quite rare: people would try not to deal with politics in their work. For the younger generation which took part in *Est.Fem* it became like a testing ground; it really opened a door for them because it was a completely unused area. It wasn't like we all really believed in feminism, but it was a combative way of expressing different ideas, as well as finding an unoccupied niche.

[PvMB] How about female experience as an artist?

[MT] There were seventeen girls and three boys at the diploma course in Tartu Art School, so it was heavily 'female' oriented. But we didn't have any discussions about being a woman artist or being a male artist. The only thing we knew was that all the boys got in, no matter how bad they were.

Painting was high art, probably in the same way as it used to be at the Royal Academy. If you are a painter then you are a 'real' artist. Girls sort of accepted that they would never be as famous as, let's say, the eight boys from their year. It was unspoken knowledge. In the painting department of the art academy there were only two female teachers and they were teaching mural painting, a secondary area.

So, you could say it was male dominated, but the question of why there weren't more female lecturers was never posed. I represented students on the board of governors and came across these issues at a more official level. There was an open debate once, in which a male professor questioned whether an unmarried female teacher could lead the faculty. His statements were outrageous and students recommended to the board of governors that he should leave. It got really dirty; everybody thought he would. But instead, he managed to damage his female colleague's reputation, so she had to quit instead. In my opinion the situation regarding inequality has not been addressed. As far as I know there are no equal opportunity policies in practice in the academy. There are *some* lectures about feminist theory, but that's only because women have really fought to get them started.

[PvMB] Is the make-up of classes still similarly divided between women and men?

[MT] In the Estonian art world lots of administrative positions are occupied by women: the director of the art museum, the director of the art hall, the director of the Soros Centre for Contemporary Art– they're all women. However, it is still the men (art critics or dominant male artists) who seem to have the power and influence. Women artists, of whom there are many, sort of 'co-exist'; they have to keep their place. And although there are several really powerful young female artists, they still don't send them to the Venice Biennale. The Estonian participants (three) in the 1999 Venice Biennale were all white, middle class, middle aged, married and male. The curator, Johannes Saar, issued a statement[4] prior to the show, which categorically outlined the criteria for selection. It doesn't surprise me that criticism regarding his statement did not make it into the mainstream press.

[4] Johannes Saar, 'Curator's note on the Estonian exhibition at the Venice Biennial' in *Estonian Art 1*, 1999, pp4-5.

[PvMB] I am interested in your relationship to Estonian nationalist sentiment and the mistrust there is of something like that here in England in a 'liberal' art environment. National dress and songs were important to you: do you see nationalism in general as having a specific, different function in Estonia than it might have here?

[MT] Yes, it is different. All those people who participated in the independence movement in the late eighties and early nineties were part of a historic change. In that situation, you had to act; you had to fight what was happening.

Starting from when I was about fifteen, I had the need to criticise, to look at things in a critical way. The first possible instance for that was the Soviet occupation. One looked back to independent times, to the national awakening: when you grow up in this kind of oppressive environment you turn to your national identity and nationalism – singing those Estonian songs and doing those Estonian things we all did

when we were growing up, gave one pride. Baltic peoples were proud that during the Soviet time they were Estonians, Latvians and Lithuanians; pointing out your nationality was a rebellion against Soviet power.

I've experienced that people from smaller countries tend to be more nationalistic. However, I think capitalism is already killing most of this kind of national culture. Not the nationalism, but the national culture in Estonia. Instead, the nationalism I see at the moment is hindering the development of the country.

[PvMB] There could be an argument that you're making one nationalism more innocent because it's in the past; the other has to be faced in the present. However, this is too complex an issue to be dealt with in the context of this interview. What aspect of it was empowering for you as a woman and how does that relate, now, to what you see as other typically Estonian characteristics?

[MT] In history or literature courses, we learnt all about the last century's national awakening movement, and the role of the Estonian poet Lydia Koidula. She managed to inspire the first independence movement and, symbolically, the second as well. She was so idolised, made holy – a suffering woman, but educated, which was very unusual at the time. Firstly, she had a kind of power as a person, an individual; secondly, she embodied this myth we all grew up with of a strong Estonian woman, the kind of powerful woman my grandmother would have embodied for me. If you start to analyse the actual position of women, they weren't so powerful, but there is this kind of 'first sight' impression and that was empowering, because you would have this image of those women in front of you.

I too declared that I was this Estonian woman; that I would wear a stripy skirt and go to the forest, collect herbs and do all those important domestic things. That was really important at the time and I think not everything was bad for women.

[PvMB] Perhaps more atomised?

[MT] Yes. They liked to live with their natural environment. The big industrial cities created by the Soviet occupation were completely alien. Lots of people started to find those old 'natural' ways empowering, especially women. But that's not necessarily nationalism. It was driven by nationalist ideology when it started, but now I think, for women, the nationalist ideal means being proud in the sense of your *husband* being proud of you. I think it has become a very restrictive position for women. Especially if you realise they can only get certain occupations on a professional level. I have many well-educated friends and they work as secretaries, but often they can't even get secretarial jobs, because they aren't 'presentable'.

[PvMB] It's interesting to think though that from that position, the one feminist tendency that really spoke to you was cyberfeminism. Because it also has this funny mixture of utopianism, irony, myth and 'reality'.

[MT] Cyberfeminism really worked on that level of irony. I was surrounded by these deadly serious male artists. My ex-boyfriend, for example, ate fish conserve and

cheese every day and then exhibited his shit and put the menu up on the wall. I was just surrounded by people doing work like that – 'philosophy', existential crises, you know... I personally found it very difficult to follow that male trend, even though I was aware that this practice would have been interpreted as a critique of art as commodity in the West. Finding cyberfeminism was like finding the complete opposite. At the *Ars95* in Helsinki, aside from VNS Matrix, there was also Christine Tamblyn with *She Loves it or She Loves it Not: Women and Technology*. I hadn't seen anything like that before – it was a completely different language, one which made me think about how one can use irony and have this kind of twisted reality and probably achieve more than anything this very 'serious' boys' stuff could.

When I read all the 'essential' texts later, it didn't really move me in the same way. 'Playing' these powerful women did much more so: it was a turning upside down of reality, a playing with it. At that time, all these problems were already there in the art academy and in my everyday life. They were there in everybody's life, but we were afraid to talk about them. Maybe finding that mode of irony gave us a way of talking.

[PvMB] Did you also incorporate the digital medium immediately, or was it first a more performative approach?

[MT] It was more performative. I had an email account already at that time, which was very advanced, but I had little access to computers. My first real struggle with computers was putting together a catalogue for *Est.Fem*.

[PvMB] In terms of historical consciousness, how do you feel about, let's say, a comparable artist to yourself in England? What do you feel, on the whole, about their sense of historical placement? Do you think people are preoccupied with these kinds of issues directly, or do you think they get filtered through other questions?

[MT] I don't really know many of these female artists personally but what I've discovered in discussions with the artists I know is that history in general is not important. In my opinion British artists today don't seem to want to deal with it in wide respects; they would rather concentrate on one small issue which is personally interesting for them. We generated history during our lifetime: most of the artists I know in Estonia changed something in society via their own, personal activities. Here the artist very often hasn't had the experience of changing things in society. So, we probably don't deal with history as commentators, but more as something you've lived through and changed. You look at it a little bit differently, maybe more subjectively.

[PvMB] But in both environments, measuring the degree to which you've been effective occurs through media filters which are controlled by comparable bodies.

[MT] That's true, but I think for us at the time, when one had the possibility to change something, you lived through this incredible experience of having power, not just desiring it. Other artists may not have had this feeling but, when being involved in these student activities, for example, and successfully lobbying the government, I

did. This happens very rarely to artists – having this sense of close political influence.

Estonian society is small and we don't yet have a class system as understood in the West. This gives you a different vantage point on history. Likewise we don't have an experience of imperial history because we were ruled for 700 years by the Swedish, Danish, Germans and Russians. So you don't have this kind of historic guilt. In Britain, lots of things are driven by historic guilt: Germans have the guilt of the Second World War, the English have the guilt of being an empire and occupying half the world. We miss that in our consciousness.

[PvMB] How do you think the position of so-called cyber-artists, or even women cyber-artists, differs between Estonia and Britain?

[MT] In the first instance, it's important to note that in Estonia there are only a handful of artists who are working with digital media. I am, therefore, reluctant to segregate them further by gender. Critics in Estonia wouldn't take me on as a female cyber-artist, because of this 'disgusting girl' prototype I developed. There is also an unwillingness to consider digital art as art 'proper'.

Here, I haven't really had any intention to get into the 'real' art world and mostly socialise with people who work with digital media, so I can't really say. The women who work within digital media make quite powerful work but, at the same time, they still have the problem of being seen as technically less capable than men. As for Estonia, I can't really comment. The Internet as a commercial domain is so far developed now that it leaves very little space for other practices.

When I left there in '96, art students didn't even have an email account. Then a year later the same students were doing their transactions on line: they'd use the Net as a completely utilitarian facility, not as a space available for art. There wasn't the time for artists to occupy that domain, whereas here it started in the academic institutions – people who were in the cultural field used it as an alternative possibility to publish their ideas.

[PvMB] There's also the big debate about whether software structures themselves are conceptually, even ideologically, predetermined. Gender comes on top of that and, moreover, is connected to education, class, etc.

[MT] Yes, software applications obviously have their predeterminations, but you don't necessarily have to take that as bad. A video camera, a piece of canvas or paint, are also predetermined. The problem that I see with software is that it is still in its infancy. I think that if you want to work with it, you probably have to forget about that.

[PvMB] And stop thinking of software as a meta-tool?

[MT] To a certain extent, yes. Whilst I am aware of the debate, when it comes to the production of the work, for me the software is a tool.

[PvMB] Still, you're both female and working with digital media. Even if you don't

see it yourself, why do you think other people draw parallels between your post-feminist, or 'ladette' tactics and the ones that are endemic to digital art? Do they feel so different to you?

[MT] They don't feel different, that's the bloody problem! It's the same old boys' game. I was really tired when I left Estonia, really fed up with all these games and intrigues and power strategies.

[PvMB] But, beyond the art game, how does that reticence work politically? In Estonia, the workings of your gestures were clear. Here, the same tactic means something so different. That must be something to do with it...

[MT] What I discovered to be difficult was finding any inspiration because, to me, the issues I saw artists dealing with in Britain weren't 'life-affecting' issues. They seemed somehow artificial. I found it very difficult to make any social comment, even when I saw problems which touched me personally. I felt like a Martian. It seems more like people are trying to find 'issues' than actually concentrating on problems that are really there. It's kind of like that big bird, the ostrich, with its head in the sand. I have questioned so many things here: why I did something before or why I might do something again. I managed to be very shocking in Estonia – my whole personality, my whole art was this 'disgusting girl', so I was perceived in that way. I don't want to shock anybody any more, because shocking here is a mere aspect of formality. There is no other language to make things visible.

[PvMB] In Estonia digital culture didn't go through this kind of introductory phase where it was framed by the academy and the cultural world. How do you think that is reflected in a bigger sense in the way that culture relates to the media in both contexts?

[MT] In Estonia, art and the wider culture were an extremely important part of everybody's life right up until 1996. Newspapers had more pages about culture than sport and artists were the elite, the nobility, of the country. Artists, in general, were also the force behind the Singing Revolution: in 1988 the Creative Union plenary meeting openly demanded the return of power to Estonians in their own country. The artists were really leading the people and therefore everything that happened in the arts, besides the big politics, was the thing of interest. Only in 1997, the newspapers started having less pages for art than for sports. In the new capitalist society the money and the commerce occupies the space which before was there for culture. Culture becomes more marginalised or rather, it's moving into the same position as in the West. In London my neighbour wouldn't know any artists, whereas in Estonia, if I went to a council block and talked to people, they would be familiar with at least ten Estonian artists – even recognise them by sight. People don't know who visual artists are here, or how they look. They might know Anthony Gormley because he's been on the news a few times, or Tracey Emin, but even so it is not really important in their daily reality.

You must also consider that, during the Soviet time, people used to go to exhibitions

to see something beautiful – something which was different from their everyday experience. Now the art scene has completely changed and they don't have the same reference points. I don't exactly know how it works here, but it seems to me that the art world is one thing while the rest of England just lives for football.

[5] yBa – young British artist

[PvMB] Pam (Skelton) refers to the situation which has been acknowledged by most feminist scholars over the last ten to fifteen years with the whole yBa[5] phenomenon: art has become depoliticised, while at the same time feminist concerns have moved into the academy. What do you think of such assumptions? It's funny because our conversation is also slowly veering towards this rather pessimistic sense of cultural stasis.

[MT] Well, I think you see the world from the position you occupy. If you work in the academy, then you see what is happening there. This may or may not have political impact. It's very difficult to see activities of a smaller scale, because they're more marginalised. Although I'm not entirely sure, I believe there are groups of people who don't belong to the art community or the academy and who might not really talk about 'feminism', but who might be doing something that has political/social impact. These things may be analysed and spoken about in different ways in ten years' time.

[6] Hal Foster, *The Return of the Real*, The MIT Press, Cambridge, Mass. 1996.

[PvMB] This is an issue that's touched on in Hal Foster's *The Return of the Real*. In one of his first chapters he talks about this kind of inbuilt mistrust that exists of repetition. This central chapter argues that this is based on a completely false model not only of time, but also of cultural value – he attempts to revise the idea that these movements were meaningful only in their first instance.[6]

[MT] I think it is difficult to find new ways to play here because most of the strategies have already been practised. This cyber thing has created a slightly different space for parallel strategies and that's probably something that will be written about with regard to the nineties. In that sense I've found it difficult to relate to Western feminism whilst living in London. In Estonia you could take relevant bits of Western feminism and incorporate them into your work; somehow it helped us to review our own social and political situation. Obviously, as I am now living in London, I need to review my position.

I value just sitting here having our talk more than trying to conquer some sort of market; I don't know if that will really change anything. Living here, I've started looking more inside myself than looking outside – analysing my earlier life more. I tend to go back to those old memories. It may be a bit sentimental, but somehow very small things have become really important and started to symbolise the whole feminist phenomenon. Which doesn't necessarily have to be good, but it is illuminating.

F.F.F.F. *F-files*, photo-installation, detail, 1998

Mari Koort *Everyday Adjustments*, photo-installation, detail, 1998

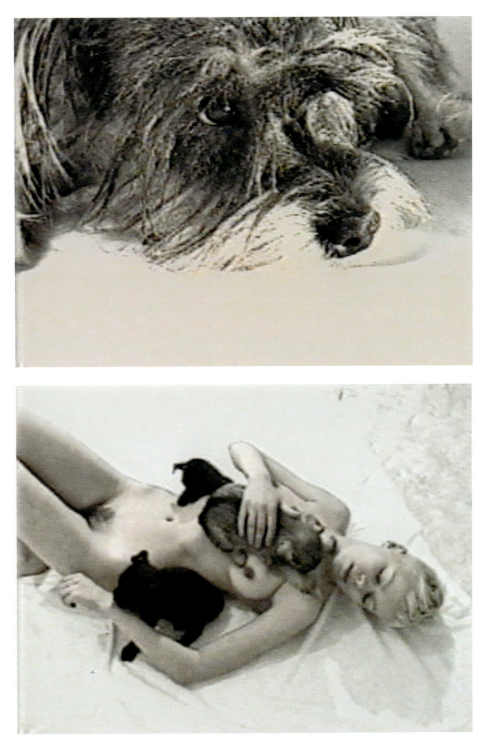

Ene-Liis Semper *Natural Law*, video-installation, stills, 1998

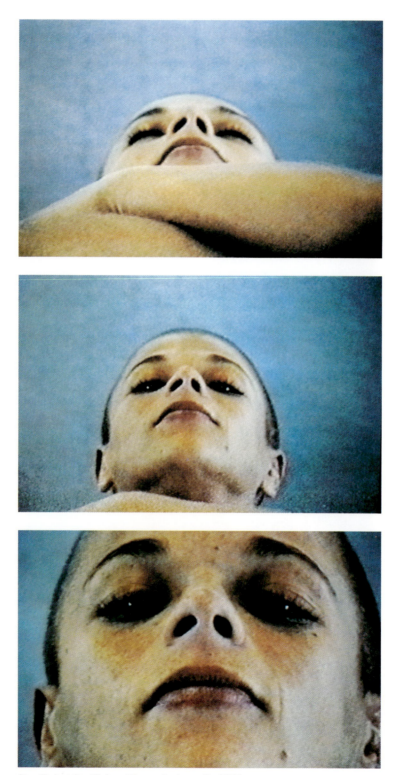

Pam Skelton *ExerMedea*, video-projection, stills, 1997

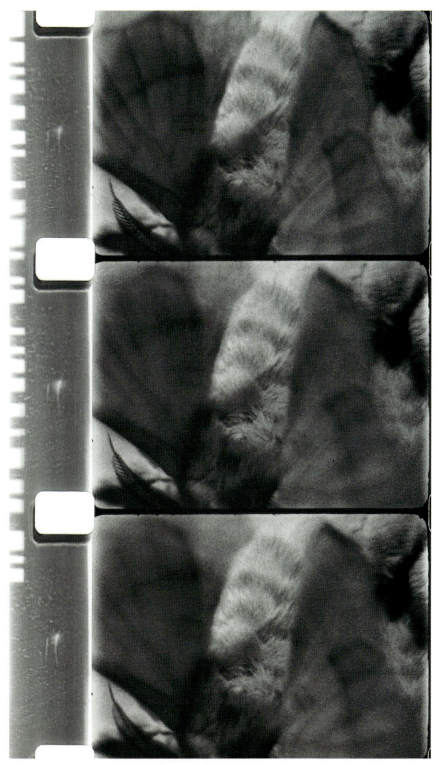

Sonja Zelic *Blue movie*, 16mm film-installation, filmstrip, 1997

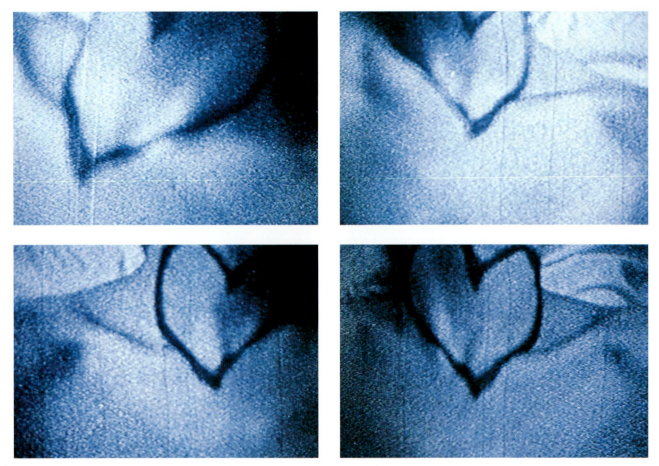

Marit Følstad *Something between My Heart and Your Mouth,* video-projection, stills, 1997

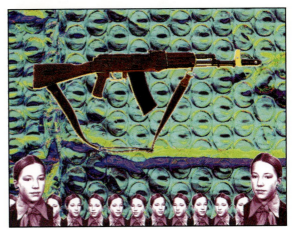

Mare Tralla *her.space*, CD-Rom installation, screenshots, 1996-97

Susan Brind *Out of Your Body - Out of Your Mind,* photo-installation, detail, 1997

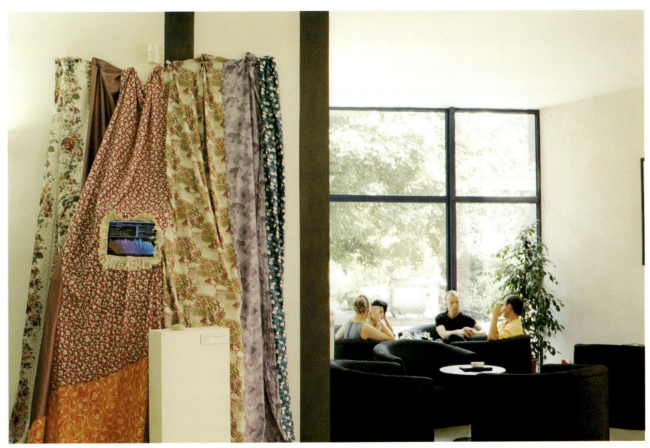

Private Views at the Institute of Contemporary Art, Dunaújváros, Hungary, exhibition view, 1999

chapter 2

space, gender, art
redressing *private views*

Angela Dimitrakaki

framing

If today it is commonplace to talk about unfixity, fluidity and ambiguity in relation to contemporary art, then perhaps it is time to rethink the meaning/s of this presumed impossibility of conclusions under the current historical circumstances. Undeniably, the tradition of deconstruction has demonstrated the flexibility of signs. Yet like any intellectual tradition, deconstruction itself did not emerge in a vacuum. Its insights developed within specific socio-cultural contexts, where they acquired their status as 'knowledge' – crucially, a knowledge which disclaimed a monological 'truth'. This means that the lexicon featuring unfixity, fluidity and ambiguity has some kind of historical resonance - as the convergence of deconstruction with the political project of feminism attests. Yet this convergence entails a contradiction because feminism as an oppositional praxis implies, or even requires, a provisional stabilisation of meaning as 'subversive'.

Questions remain. Does this conscientiously pursued openness relate postmodernity to a kind of transition above everything else? If so, what is then implied is a departure from something both concrete and intelligible (i.e. modernity) as opposed to a present where everything seems somehow suspended in the hope that when the (equally transparent) future arrives, it will solve the riddle of the transition as well. This outlook can contribute to a certain mystification of social experience, and not solely on account of the temporal continuity thereby suggested. The concept of transition also obscures the multiple possibilities constantly emerging and dispersing across the interaction of social spaces. Social space itself is reduced to an abstract synchronicity in which the unfixity of meaning becomes inevitably 'meaning'. On the other hand, addressing social space in terms of 'multiple possibilities' can be an operative misrepresentation of complex but structured social relations. 'Multiple possibilities' can also turn into a form of overarching 'meaning'. Predictably, the only possibility missing in this context is that of learning how to produce politically significant knowledge. An approach seeking to counteract such effects should then be attentive to the materiality and interconnectedness of social experience rather than state its presumably endless variety.

This is by no means an easy task. Two main problems can be identified. The first has to do with the complexity of contemporary social spaces and the ways they are interconnected. This complexity is being inscribed in representation, since representation itself does not exist outside social spaces. Henri Lefebvre already argued in the early seventies that "*social spaces interpenetrate one another and/or superimpose themselves upon one another. They are not things, which have mutually limiting boundaries and which collide because of their contours or as result of inertia*"[1] (author's emphasis). Lefebvre also located the distinction between private

[1] Henri Lefebvre, *The Production of Space*, trans. Donald Nicholson-Smith, Blackwell, Oxford 1991 (1974), pp86-87.

and public within a wider social space: "the space of a room, bedroom, house or garden may be cut off in a sense from social space by barriers and walls, by all the signs of private property, yet still remain fundamentally part of that space. Nor can spaces be considered empty 'mediums', in the sense of containers distinct from their contents".[2]

Feminism in art theory and practice, at least in those regions of the world where its influence was most felt, developed parallel ideas in arguments of unprecedented intensity. After all, difference, including sexual difference, is produced and reproduced in social spaces. To offer one well-known example, the policed division between the public and the private was seriously challenged once feminist discourse turned to the way gendered identities were defined. The debates generated were illuminating, but along with the answers new questions emerged. Acknowledging the complex interpenetration of social spaces meant two things. First, that although gender and sexual politics had to be the focus of analysis, they could never be ultimately separated from other parameters of identity such as class, ethnicity, sexuality and age. This may seem self-evident but the articulation of these parameters within critical discourse is always underwritten by acknowledged or unacknowledged priorities. Second, that feminism - or, rather, the distinct and even antagonistic positions developed within feminism in the last quarter of the century - could not miraculously step outside existent power relations which defined 'culture' on a global scale. In short, cultural hierarchies (never strictly 'cultural') proved hard to defy.

Although diversity came to be a major issue within post-colonial and feminist discourse on the production of meaning in art, it mostly rendered visible the structures of exclusion from the perspectives available within the dominant spaces of Western culture. [3] Quite simply, historical conditions have, up to now, caused and allowed feminist art history's emergence in fairly specific geographies. Yet even if feminist art history had been a global project, this would not necessarily mean that cultural hierarchies would have been transgressed as a matter of course. Moreover, feminist art history cannot be identified with a methodology nor with a specific interpretative/theoretical framework directing a systematic understanding of the relationships between gender and the shifting parameters that characterise the production and regulation of art as such. At the same time, and perhaps inevitably, there has been an emphasis on 'strategies'. The alternative traditions, even canons, often forming in this context do not necessarily define their geographical/ historical frame of reference. And again, even if they do, *how* such traditions come to be recoded across different communities constitutes a process paradigmatically subject to the workings of cultural power relations.

The concept of Eurocentrism, elaborated in post-colonial theory (often circumscribed within the intellectual adventure of the Western academy), has had a considerable impact on feminist discourse. It proved enabling in certain contexts and disabling in others. Its analytic and descriptive potential seemed to recede when confronted, for example, with the currently transforming landscape of Europe, which was often treated as the homogeneous background of a dominant cultural model. There was a risk of theorising an abstract projection of a meta-European

[2] *Ibid.*

[3] My concern here is with feminist art history's occasional lack of self-reflexivity when coming to the cultural/geographical specificity of strategies and objectives. Although the creation of a feminist canon in art history is by definition a subversive act, the fact that most of the names included in it belong to fairly specific geographies is profoundly problematic. Post-colonial criticism challenged the Anglo-Saxon tradition of feminism in art and brought to the forefront the complex structuring of certain exclusion mechanisms in the West. (On this see Gilane Tawadros, 'Beyond the Boundary: The Work of Three Black Women Artists in Britain', *Third Text* 8/9, Autumn/Winter 1989, pp121-150.) But it did not really challenge the dominant position of certain spaces at a global level which tends to peripheralise developments elsewhere. So that at the moment, in terms of visibility (not just of artists but of arguments and positions) the colour of one's skin seems as important as where one is based. For an interesting perspective on feminism and canons in art history, see Griselda Pollock, *Differencing the Canon: Feminist Desire and the Writing of Art's Histories*, Routledge, London and New York 1999. The problem of who sets the terms in which feminism is discussed and 'signifies' in intercultural spaces extends far beyond the realm of art and far beyond the issue of canons. Renata Salecl has argued: "If [...] Western feminists speak about feminism, they can discuss such abstract issues as 'women in film noir', 'the notion of the phallus in feminist theory' [...], someone coming from Eastern Europe must speak about the situation of women in her own country". Renata Salecl, *The Spoils of Freedom: Psychoanalysis and Feminism after the Fall of Socialism*, Routledge, London and New York 1994, p2.

chapter 2

[4] The 1990s yBa phenomenon in Britain is exemplary in this respect. For a critical discussion of some of the issues see Duncan McCorquodale, Naomi Siderfin, Julian Stallabrass (eds), *Occupational Hazard: Critical Writing on Recent British Art*, Black Dog Publishing, London 1998.

[5] David Harvey, *The Condition of Postmodernity*, Blackwell, Oxford 1990, pp56-57.

[6] Perry Anderson traces the history of the term 'postmodernism' back in the thirties in his recent *The Origins of Postmodernity*, Verso, London 1998. He notes that "contrary to conventional expectation, both [terms, 'modernism' and 'postmodernism'] were born in a distant periphery rather than at the centre of the cultural system of the time: they come not from Europe or the United States, but from Hispanic America", *ibid*., p3. This, however, does not negate the specific uses of the contemporary paradigm in a context of global relevance where cultural hierarchies are shaped and where feminist art history and theory developed. Notably, women, as a social group, and feminism, as a political project, are conspicuously and alarmingly absent from Anderson's account which extends to the nineties - when referents such as gender are not dismissively linked, along the lines of a familiar but deeply problematic argument, to "a weaker set of antagonisms", *ibid*., p104.

citizenship to which anything 'European' could somehow be affixed. Yet Europe is populated by concrete subjects who are producers as well as products of a living history. Speaking about the 'white' subject of a 'white' feminism can hardly cast light on what it means to occupy the position 'woman' in and in relation to systems of representation when attention shifts, for example, to UK miners' wives and female tractor drivers in the former Soviet Union. The recent collapse of the Eastern bloc states brought this fact into sharp focus by giving rise to new (and not only ideological) battles over identity.

In the West, what has been described as the academicisation of both radical theories and oppositional art practices during the past ten years or so was combined with a widespread disillusion over what radical movements could actually achieve in the face of increasingly reactionary state policies (the post-Thatcher syndrome in Britain). This led to an unprecedented degree of media-based visibility of artistic 'careers', a peculiar form of exportable national-identity-art where the parochial generational model (*young* British artists) was revived to bind together and confer meaning on artworks that would not necessarily sit together comfortably in the culture wars of the eighties. Understandably, this meaning involved a carefully marketed, justified and celebrated distanciation from the political.[4] These seemed to be the rules of the game in the nineties, rules which for many marked a crucial failure on the part of both radical theory and practice to transform the art establishment and society at large in a spectacular way. In the Age of the Spectacle, which does not seem to be drawing to an end, history has to be spectacular as well. Otherwise, its very status as *history* is in doubt. History has to make sense *as spectacle* precisely in order to be judged "in terms of how spectacular it is".[5] The very notion of historical process is frequently confused with a certain serialisation of events, as if the two were interchangeable. In this context, the blurred outcome of social praxis can be conveniently discarded as ineffectual. The impact of this way of thinking on contemporary politics of representation should not go unnoticed.

Whether something called postfeminism was simply a side-effect of all the above or was generated for other reasons, at the same time helping to shape what has come to be seen as a renunciation of the political, remains an open question. Significantly, the term postfeminism, like postmodernism, has acquired its particular currency in the metropolitan spaces of the West.[6] Indeed, both terms redirected attention to the West because what they made evident was that in the dominant spaces of the latter, readings of a cultural sensibility had already evolved into a different phase, somewhere far ahead in the exciting land or dreaded dead-end of 'post'. The rest of the world had to learn to use the new alphabet - an essential in the etiquette of intercultural 'translation'.[7] It is important to remember at this moment that although art is produced and consumed in fairly specific sites (the World Wide Web being a relatively recent addition), the spaces it encodes, and in which art itself is encoded, are spaces of multiple interactions. This, however, does not mean that they are chaotic, nor that they necessarily defy materially-grounded, operative canons. The ways social relations are linked to practices of representation are complex and shifting, yet far from arbitrary. The over-pronounced reassertion of locality in postmodernism has not managed to eschew the term's authoritative global pretensions.

And yet things have changed. At a certain moment, the specificity of objectives in feminist and post-colonial discourse made imperative a radical break with accepted approaches to the so-called object of research in the history of art (that is whatever was qualified as 'art').[8] The debates to which this challenge led, although geographically and historically specific, continue to mark the late twentieth century cultural landscapes in ways that have yet to be identified. What has then been perceived as the gradual de-politicisation of the visual arts in the nineties points more to a specific understanding of the political in artistic discourse, rather than to the general state of contemporary art. As I have argued elsewhere, "the depoliticisation of art, if one wished to speak in these terms, is not primarily a statement [secured in the space of the artwork]: it is a *condition* produced across the material limits of those discourses which fix art's operation within social formations".[9] These social formations exist in specific spatio-temporal matrices. The types of social agency developed within them are also concretely rooted in space and time, as argued by contemporary cultural geographers.[10] Such observations are important if one wishes to consider the modes of social experience effected within the global dominance of multinational capital, and to understand concurrent models of asymmetrical gender relations in their specific sociocultural manifestations.[11]

Understanding the heterogeneity of intersecting contemporary social spaces is by all accounts an ongoing, if discontinuous, project. The critical face of postmodernism has been identified as "bound up, too, with its own complicity with power and domination, one that acknowledges that it cannot escape implication in that which nevertheless still wants to analyse and maybe even undermine".[12] When postfeminism arose in the dominant cultural geographies of postmodernism, however, the implications were somehow different since it did not develop as a critique but rather as a negation of the critique instigated by second wave feminism.[13] Those who embraced it chose to reduce the complex arguments and debates comprising feminism as a political and theoretical project into the spectre of a limited and limiting didacticism. More alarming, however, has been the politically naive assumption that the social issues to which the diversity of feminisms responded had been resolved. In a recent interview the artist Martha Rosler, whose work has been of outstanding significance in seventies and eighties feminist politics, was asked what she thought about the "the amnesia of an a-historical present" in that "so much of what passes for feminist work today looks like its precursors but stripped of the politics". Rosler replied that "every generation of artists have to understand themselves [...] We are often the mothers of a tradition [...] The politics may be there, but we cannot recognise them".[14] Rosler's argument has to be considered but still the negation inscribed in the feminism/postfeminism dichotomy is not reducible to the problematics of generational difference. The latter has to be taken into account but does not overdetermine the recognition of meaning. First, as there is more than geography tied to location, not every young woman artist has a feminist art tradition available to either embrace or reject. Some (young Estonian artists being a case in point) have found themselves in the absurd situation of having to disclaim what has not been claimed, if they want to be seen as 'contemporary'. Which spaces have the power to define the meaning of 'contemporary' is then crucial. Second, the problem with so-called postfeminist art is not primarily its dismissal of, or, at best, ambivalence towards, an earlier generation of feminist artists but its forms of

[7] Recently Nikos Papastergiadis suggested that "contemporary culture cannot be mapped against the co-ordinates of the centre-periphery grid of political economy. This model presupposes that power is concentrated in the centre and dispersed concentrically. [...] The periphery is condemned to experience a belated modernity". See Nikos Papastergiadis, *The Turbulence of Migration*, Polity Press, Cambridge 2000, p107. The problem is that the centre-periphery division is not just an explanatory model. It has also been, and continues to be, a powerful ideological construct. It is therefore one thing to dispute its explanatory potential in social theory but quite another to consider how it has affected the perception of one culture's relationship to another. Papastergiadis discusses brilliantly and extensively the politics, and indeed "the limits of cultural translation", as the title of his chapter goes. But he concludes, rather optimistically, that "a translation constantly undoes and disperses the authority of the original". *Ibid*, p144. It is difficult to see however how cultural translation stands outside the hierarchies which prioritise the representation of certain meanings across geographies. The power Papastergiadis assigns to translation is not intrinsic to it; it has to be negotiated as a precarious effect of cultural encounters through which social groups claim agency.

[8] See Griselda Pollock, 'Women, Art and Ideology: Questions for Feminist Art Historians' in Hilary Robinson (ed), *Visibly Female: Feminism and Art Today, An Anthology*, Camden Press, London 1987.

[9] Angela Dimitrakaki, 'About Di/vision/s: New British Painting in the 1990s, *Third Text* 38, Spring 1997, p103.

chapter 2

[10] On the concept of spatio-temporal matrix see Nikos Poulantzas, *State, Power, Socialism*, Verso, London 1978. Space and time have frequently been presented in a polarised model where time was implicitly or explicitly identified with change and progress as opposed to space which connoted immobility and fixity. See Edward Soja, *Postmodern Geographies: The Re-assertion of Space in Critical Social Theory*, Verso, London 1989, p11. The research of feminist geographers has contributed to the existence of a currently extensive bibliography on space and gender. For a general discussion of some of the issues see Beatriz Colomina (ed), *Sexuality and Space*, Princeton Architectural Press, Princeton 1992; Sue Best, 'Sexualizing Space' in Elizabeth Grosz and Elspeth Probyn (eds), *Sexy Bodies: The Strange Carnalities of Feminism*, Routledge, London and New York 1995; Linda McDowell and Joanne P. Sharp (eds), *Space, Gender, Knowledge: Feminist Readings*, Arnold, London 1997. For a critical view of the empowering use of spatial terms in social theory see Patricia Price-Chalita, 'Spatial Metaphor and the Politics of Empowerment: Mapping a Place for Feminism and Postmodern Geography', *Antipode* 26, 3, 1994, pp236-254.

[11] There has been the argument that "'patriarchy' as *explanation* of gender relations perpetuates the theoretical tradition of abstract 'semi-autonomous structures'" (emphasis mine) and that "this loses the tension between agency and structure necessary to understand social process". See Anna Pollert, 'Gender and Class Revisited; Or, the Poverty of 'Patriarchy'', *Sociology* 30, 4, November 1996, p640.

[12] Linda Hutcheon, *The Politics of Postmodernism*, Routledge, London 1989, p4.

response to gender relations or situations of outright oppression *today*. How postfeminism could respond to women's condition in the series of traumatic presents spreading from European inner cities to Afghanistan is an interesting but depressing thought. Postfeminism, then, as a mode of address, has effectively misapprehended the continuous production of a social abject - both within and beyond Western geographies. Nonetheless, the postfeminist ethos has had probably one positive result: it made evident that the political intention motivating the feminist enquiry was not just a cause of historical change but also a fragile effect of historical processes. Feminism's continuing relevance to contemporary culture/s lies precisely in the fact that the outcome of feminist praxis brings to the surface something almost inexplicable each time, something which already demands a different approach from the one which just rendered it *partly* visible.

space re/cognised: social views of private contexts

The above was aimed as a brief introduction to the main issues pertaining to the staging of *Private Views: Space Re/cognised in Contemporary Art from Estonia and Britain*. With one exception, all participating artists were women. Yet this did not make *Private Views* automatically a 'feminist' show. Feminism *per se* did not provide the exhibition's exclusive axis, but at the same time it has been highly relevant to it. In fact, the way the term 'private' had to be rearticulated in relation to space and across two distinct cultural/geographical realities in Europe could hardly have become visible outside the frame of feminism - or, more precisely, the frame provisionally maintained by the different meanings feminism proved to hold in the context of one specific show.

Yet the approaches effected cannot be described as postfeminist either, since the term fails to account for the particular social experiences emerging in the works. The exhibition, then, makes the case that feminism, as a space of political and ideological struggle, necessarily informs current modes of representation as well as spectatorship. Moving away from issue-based art (whatever the issues in Estonia and Britain might be) should not be conflated with a self-conscious distance from the political. However, if the political needs to be redefined once more, as happened during the seventies in the West, this is a different issue. The redefinition of the political in art may be one of feminist art theory's most pressing tasks today, a task which inevitably calls attention to the demands of specific subjects. Feminist praxis and the changes it effected in both women's and men's lives, in all their concrete materiality, have triggered a variety of conscious and unconscious responses in the field of cultural signification and production. In other words, feminism has intervened at the level of ideology when the latter is grasped as "the more or less unconscious medium of habitual behaviour".[15]

In order to understand what the 'private' designated in the show, it is important to briefly refer to the different investment of the term in the cultural environments that came together in the show's context. The politicisation of the private sphere, as understood by Western feminists, was self-consciously negated in Estonia.[16] With the advent of so-called economic 'development', the 'private' underwent significant

changes; its very definition was close to becoming frighteningly restricted. On the other hand, the overt politicisation of the private in British feminism grew to be problematic for those who felt that it implied even a certain policing of desire under emerging configurations of visuality and the feminine. There has been, then, a mutual interest in expanding on the possible meanings of the term.

The private views that the exhibition promised to deliver were concerned with space. It could not have been otherwise. The notion of space has acquired a new urgency in contemporary Europe: itself a space, or rather an intersection of spaces, in which the power plays implicated in the construction of dominant and less-than-dominant 'private' views have been traditionally concealed. This is even more apparent when the interstices of feminism, art and gendered subjects are the issues.

But why talk about space in terms of re/cognition? What this suggests is that every cognition of space is simultaneously a form of *recognition* by specific subjects and communities of subjects. Recognition cannot exist without agency. Space is recognised both individually and collectively. Re/cognition also implies that space cannot be apprehended once and for all. If today space has to be re/cognised, this is because it can no longer be perceived as static. The process of re/cognition signals a temporary convergence of subjectivities, one that is concrete and yet ready to dissolve under the pressure of transformation. These multiple, simultaneously registered acts of recognition connote the plurality of subjects which perform this act, the subjects which determine space as much as they are determined by it. And so perhaps in this way, the abstract space threatening to swallow the encounters of contemporary life is counter-appropriated.[17]

The artists in *Private Views* chose to approach space through new and less new technologies, ranging from photography to video and digital art. Occasionally, these technologies interact, as for example in the case of digitally manipulated photographs. The twentieth century itself is marked by the new visualities engendered in the context of consecutive technological innovations (especially since every technological innovation is currently destined to be soon outdated). One has to ask, for example: in what way is the Estonian project *Women's Letters on the Internet* (initiated by the S.Girls Group and displayed in a veiled computer screen in the gallery) different from Western women's mail-art projects of thirty years ago? Has sophisticated technology altered the terms in which identities are claimed? After all, *Women's Letters on the Internet* offers an assortment of diary excerpts - except that now these can be traced and expanded by today's digital flâneuse. The desire on the part of the artists to explore the diverse investments of art in technology, and even the situated meanings of this investment, are grounded in the particular uses of technology in contemporary life, and the way space is perceived and represented in images which always promise to be 'new'. Art, then, attempts a critical reversal by focusing on how contemporary life is used, managed and encoded in the visual scapes crafted by technologies. The work brought together in the show indicates that the medium is not necessarily commensurate with the message - the contextual emergence of the latter cannot be suppressed, but neither can it be taken for granted. What is important is how this contextual emergence of meaning is linked to cultural difference, when cultural difference is defined as precisely "*the movement of*

[13] See Amelia Jones, 'Postfeminism, Feminist Pleasures and Embodied Theories of Art' in Joanna Frueh, Cassandra L. Langer, Arlene Raven (eds), *New Feminist Criticism: Art, Identity, Action*, HarperCollins, New York 1994.

[14] See 'Pop Goes Politics: Martha Rosler Interviewed by John Slyce', *Dazed & Confused* 54, May 1999, pp75-76.

[15] See Gregory Elliott, 'Ideology' in Michael Payne (ed), *A Dictionary of Cultural and Critical Theory*, Blackwell, Oxford 1996, p252.

[16] I say 'as understood' because whether, for example, performance art (especially when focusing on the body) staged at private apartments can be seen as not politicising this 'private' space is disputable. Zdenka Badovinac has argued that such "actions in public, particularly in the streets, were most frequently banned - and artists even arrested by the police". See Zdenka Badovinac, 'Body and the East' in *Body and the East: From the 1960s to the Present*, Ljubljana Museum of Modern Art 1998, exhibition catalogue, p15. She also argues, and this is highly relevant to the arguments of this essay, that "if we know the context in which these works were made, we also know that the very fact of the appearance of a naked artist in public had a political dimension", *ibid*, p16.

[17] According to Lefebvre's theorisation, "this abstract space took over from historical space, which nevertheless lived on, though gradually losing its force, as substratum or underpinning of representational spaces. [...] Formal and quantitative, it [abstract space] erases distinctions, as much as those which derive from nature and (historical) time as those which originate in the body (age, sex, ethnicity)". See H. Lefebvre, *op. cit.*, p49.

[18] Avtar Brah, *Cartographies of Diaspora: Contesting Identities*, Routledge, London and New York 1998, p234. As far as the present volume focuses on media art, it is important to note that, as Maria Fernandez has argued, "postcolonial studies and electronic media theory have developed parallel to one another but with very few points of intersection". She also argued that although "encouraging everyone in the world to enjoy the freedom of cyberspace became a crusade", "what allows us to discuss issues of colonialism in relation to electronic media today is the fact that the incorporation into the global market of parts of the world that can afford connectivity has already occured". See Maria Fernandez, 'Postcolonial Media Theory', *Art Journal* 85, 3, 1999, pp59-73. Here pp59-60.

[19] Hal Foster, *The Return of the Real*, The MIT Press, Cambridge, Mass. 1996, p166.

reiterative performance that marks historically variable, fluid, internally differentiated, contested and contingent specificities"[18] (emphasis mine). *Private Views* is, then, just another space where cultural difference is performed; but it is also a space which holds ways of seeing through difference.

bodies/surfaces/identities

Culturally specific ways of seeing are especially evident in these works which take the thematics of the body as their point of departure. It is impossible to approach Estonian works focusing on aspects of femininity without considering the particular configuration of essentialism and the market in post-Soviet Estonia (on this see Barbi Pilvre's essay in this volume), where femininity has been recently marketed as a 'natural' state that had been denied to women but that can now be 'achieved'. The market, in other words, assumes the position of an agency that restores the body to its natural *visibly* gendered condition. Mari Koort's photo-series *Everyday Adjustments* engages with the habitus of the body during cosmetic surgery. It is divided into three parts entitled *The Ventriloquist*, *(Birthday) Present for Our Daughter* and *The Investment*. Koort 'framed' her enhanced but blurred close-ups of the open body during the operation with smaller, clear-focus images of certain expressive details of the process. The latter are either objects or parts of the body itself - constructed as the object *par excellence* of medical discourse. The blurred close-ups are deliberately presented as a swift imitation of an abstract pictorial plane where details are foreclosed. And yet these images *are* the frozen, magnified details of a process occurring *in* (and not just on) the space of the body. Koort's images are not intended as a documentation of the process of cosmetic surgery. Neither do they exemplify what Hal Foster has aptly called "the envy of abjection", an envy endemic in contemporary Western culture.[19] In the highly symbolic structure of the work, the abject has left centre-stage and has been assigned a complementary role as the 'frame' of the main image. Barthes' punctum has not been expelled but has been regulated. Its operation is dependent on the viewer's willingness to move close to the work and this will happen only if s/he is allured by the luminous opaqueness of the large format prints, reminiscent of the presumed innocence of a flat canvas simply 'filled' with colour. At a first level, Koort's formal technique plays out the age-old debate around photography's broken promise to sustain a traditional form of realism. At a second level, however, these images offer a glimpse of the continuous production of the (female/feminine) body across cultural/discursive circuits where the very visuality of the body is constructed as precisely that. Anything can be turned into surface. What photography documents in this case is its own complicity in the processes of objectification, its effective production and manipulation of the body's stillness, its capability to *sensualise* the abject in the spaces of visual signification.

F.F.F.F. are a group of five female artists engaged in collaborative work. Their two pieces in the show, the *F-files* photo-series and the *Guide of Identification* video, construct a dialogical space for the diverse routes towards identity politics. The axis of this juxtaposition is the impossibility of ultimately locating the body in the mirror-surface of the monitor and the smooth surface of the photograph. *Guide of Identification* is a serial parade of faces on the screen. The mask-quality is intensified

by the treatment of images as photographic negatives. The viewer is required to perform an act of recognition; to discern the human faces as they are succeeded by representations of human faces taken from the realist traditions of European painting. Except that in this work 'realism' and 'reality' are introduced into a process of mutual erasure, effectively cancelling each other out. The pace of the images' succession has nothing to do with popular culture's frantic rhythms. Moreover, it is punctuated by an austere voice-over giving the faces a name and an age. Both the bluntness of the nearly-inhuman voice and the mutual de-naturalisation of the body and its representation make this act of recognition a challenge. The imperceptible movement of the human face becomes eerie instead of offering a clue to the materiality of life (as perhaps distinct from the materiality of the sign). Viewing is strenuous. Strangely enough, this active denial of pleasure in the image recalls the formal distanciation principle of feminist video practice in the West during the seventies.[20] But instead of giving in to the monitor as a surface of categorical surveillance, *Guide of Identification* enacts an assimilation of difference; identity is forestalled and identification becomes impossible.

The *F-files* photo-series takes quite a different stance - or, rather, it explicitly inverts the *Guide of Identification* approach. In each of the photographs the viewer sees five women and recognition is, at first level, immediate. Five Estonian women in traditional costume signal the female body's appropriation by the national imaginary - as something that can be framed and displayed in the Tallinn tourist information office; five self-confident businesswomen waiting for their flight in the airport; five mothers proudly photographed with their children; five young girls confronting the camera in an apt incorporation of their own images into the memorabilia of their urban, nocturnal, rock-revival life; five older women of the emerging underclass searching through piles of garbage; five smiling women in army gear - and the list goes on.

The F.F.F.F. artists stage a life-based spectacle around and about the colluding faces of the feminine in their immediate environment - which as expected transcends the 'limits' of the local. But reading this work as a parodic rehearsal of the 'femininity-as-masquerade' doxa induces a feeling of guilt in the female viewing subject.[21] It is virtually impossible for one not to become self-conscious of the fact that the recognition of femininity in this circuit of encodings ultimately depends on *whether* and *how* one relates to the images. As a feminist art historian, I could not help imagining an additional photograph of five feminist art historians debating the meaning of these images before them - and at the same time I came to recognise the overlapping of certain aspects of my life with some of these rather transparent encodings of the feminine. These photographs, then, seem to extend infinitely in the consciousness of the viewers in all the latter's predictable or unexpected nuances. Instead of operating as a veil covering the in/famous Woman-that-is-not, the photographs offer a glimpse of the *materiality* of appearances which can never be fully separated from the social experiences of femininity to which they correspond. The pleasure of recognition, for the female viewer at least, occurs simultaneously with the pleasure of dis-identification. It is this friction which opens up the possibility of a different problematic around the ever-elusive 'female' gaze.

[20] See Laura Kipnis, 'Female Transgression' in Michael Renov and Erika Suderburg (eds), *Resolutions: Contemporary Video Practices*, University of Minnesota Press, Minneapolis 1996.

[21] See Joan Riviere's classic essay 'Womanliness as a Masquerade' in Joan Raphael-Leff and Rosine Perelberg (eds), *Female Experience: Three Generations of British Women Psychoanalysts on Work with Women*, Routledge, London and New York 1997.

chapter 2

[22] L. Kipnis, *op. cit.*, p336.

[23] I am indebted to Susan Brind for alerting me to my own cultural baggage (the ways of seeing available in the context of British feminism) forming my initial response to this work.

[24] Elizabeth Grosz, 'Inscriptions and Body Maps: Representation and the Corporeal' in Linda McDowell and Joanne P. Sharp (eds), *Space, Gender, Knowledge: Feminist Readings*, Arnold, London 1997, p237.

Ene-Liis Semper's audio-visual installation, purposefully entitled *Natural Law*, is a profoundly disturbing work. Two video sequences are projected onto the opposite walls of an enclosed space, which means that the viewer cannot follow both narratives at once. On one wall are images of a dog clearly in distress, its howling reverberating round the gallery walls, its eyes fixed at a certain point - this point being realistically and metaphorically the image on the opposite wall, where several puppies happily play on and around the naked body of a woman (the artist herself) who has usurped the dog's role as mother. Unlike other works in the show, the body is not presented as fragmented, and, as Laura Kipnis has commented, "a naked body is always enough of a frisson to arouse at least some minor interest on its own: that's precisely why performance and video artists take off their clothes".[22] Yet it is impossible for the viewer to hold his/her gaze fixed on this naked body simply because it is impossible to ignore the dog's (the real mother's) suffering. In this case sound, enhanced through speakers, operates as a kind of inescapable distraction. For the viewing subject, bodily pleasure is punctuated by pain.

There is still nothing more difficult to grapple with, nothing more discomforting than such close proximity of maternal desire and nature. Yet reading the work in these terms means introducing it in the context of debates which have marked Western feminism's discourse on the body. A different approach is in order, especially if the social frame in which Semper's piece was produced is to be considered. At the moment, the emphasis on the essential attributes of the feminine has come to signify, for Estonian women, both their distancing from the Soviet woman but also, as discussed, a position available within the new market economy which has actualised new forms of power relations. This specific juxtaposition of imagery effects a treatment of maternal instinct and its manipulation by the artist/(naked) woman, who only mimics maternal affection, as a metaphoric transcription of an incessant power play.[23] The power the work refers to is closer to what Elizabeth Grosz, influenced by Foucault, has described as "a *material* series of processes" (emphasis mine).[24] The nakedness of the woman perversely signals a trick played upon the naturalness of nature itself, an act of deception enunciated by the specific female subject in its claiming of pleasure. Seen this way, *Natural Law* engages with the persistent reinscription of pleasure within new spaces where consent and coercion are not clearly distinguishable.

Susan Brind's photographic installation *Out of Your Body - Out of Your Mind* is a meticulously structured investigation of a crisis located in, and locating the subject at, the borderline of consciousness and rapture. This crisis has been of central concern to Western feminism and is linked to the problematics of the body as social text, for, in these terms, the body's particular mode of textuality seems to *incorporate* a self-deconstructive impulse. The viewer is surrounded by three panels where light provides an experiential grid, subtly texturing minimal figurative references to nature (sky) and culture (architecture). The reference in two other smaller prints which temporarily conclude the installation is, at the elementary level, to the process of reading. Yet the fingers, as a metonymic edge of corporeal energy, dive into the space of the page - a page not only displaying language but also, crucially, displaying the end-product of Saint Teresa's transcendental experience as captured in her own words. In Western feminist discourse, where the dichotomy of emotion and intellect

has been challenged, the female mystic has emerged as a fascinating subject since she embodies the "explicit sexualisation of knowledges".[25] The work acknowledges the viewing process to be a material one, but this materiality does not refer to the presumed empathy of the viewer's body and a supposed loss of the self. Rather, the materiality of the process betrays a necessary distance between subjects, a distance which provides the matrix in which witnessing occurs. In the visual discourse proposed by Brind, meaning is linked to the limits of this witnessing. The viewer is not invited to partake of rapture but rather to imagine. Imagination, and in particular imagination imagining *jouissance*, relies on distance in order to exist. But this is not the distance symbolised by the straight line; it is a distance rushing elliptically on the borders of subjects and its significance can be political if seen to define a borderline space that one can never truly own.

spaces of spectatorship

In an essay on video practice in the nineties, Ewa Lajer-Burcharth argues that in the predominant form of video installations today, where the act of seeing takes place in "a self-enclosed audio-visual environment geared to captivate the viewer on whose interrupting presence these spatial enclaves conspicuously depend", there emerges "a shared concern with the body as a kind of *invisible (impossible) reality*"[26] (emphasis mine). Lajer-Burcharth effects a reading of contemporary video practice based on the disrupting emergence of the Lacanian Real,[27] as further elaborated by Judith Butler, who sees it, in Lajer-Burcharth's words, "as a critical reminder of the always deficient or failing grip of the Symbolic"[28] in which the gendered subject is constituted. What is particularly interesting in Lajer-Burcharth's arguments is the reconfigured problematisation of the constructionist approach to the body which has had an impact on the debates in feminist art theory and practice. She specifically argues that

> to imagine the 'lived body' as Real is not to suggest some innate or self-reliant pre-symbolic corporeality. Rather it is to explore the idea of the unfinishedness of the self as a specific body and to envision the instability of the internal psychic boundaries as a concrete embodied experience.[29]

Lajer-Burcharth's compelling theorisation of contemporary video installation is particularly apt for approaching certain works in the show which seem to fall both into and out of line with these arguments. The first question that arises is whether the mode of spectatorship invoked by Lajer-Burcharth is structurally connected with the enclosedness of video installations, a spatial arrangement actively and purposefully denied by specific video installations in *Private Views*. Pam Skelton's *ExerMedea*, Marit Følstad's *Something between My Heart and Your Mouth* and Sonja Zelic's *Blue Movie* work with various types of screens simultaneously projecting images in the space of the gallery which is thereby crafted as a space of interaction. This is further intensified by sound: the sound of the film projector in *Blue Movie*, music and the sound of waves in *ExerMedea*, and the agonising breathing, the sound of distant trains and rustling leaves in *Something between My Heart and Your*

[25] Elizabeth Grosz, 'Bodies and Knowledges: Feminism and the Crisis of Reason' in Linda Alcoff and Elizabeth Potter (eds), *Feminist Epistemologies*, Routledge, London and New York 1993, p188.

[26] Ewa Lajer-Burcharth, 'Real Bodies: Video in the 1990s', *Art History* 20, 2, 1997, p187.

[27] The Real theorised by Lacan "is not synonymous with external or empirical reality, but refers to that which lies outside the Symbolic [order, which itself refers to language] and that which returns to haunt the subject in disorders like psychosis", in M. Payne, *op. cit.*, p257. Lajer-Burcharth proposes that the contemporary "aesthetic concern with the Real may be seen as a response to a certain conceptual impasse in thinking about identity as an effect of cultural construction". See E. Lajer-Burcharth, *op. cit.*, p190.

[28] *Ibid.*

[29] *Ibid.*

[30] Charles Esche has suggested, in relation to Douglas Gordon's *24 hour Psycho* (1993), which also featured a "projection screen being visible from both sides", that "this recalls the notion that life is transformed on the other side of the cinema screen". In the case of *ExerMedea*, however, there is a deliberate intention to transpose the omnipresent eye of the camera over the gaze of the represented subject, which seems to trace the movement of the viewer as s/he moves around the image. See Charles Esche, 'Video Installation, Conceptual Practice and New Media in the 1990s' in Julia Knight (ed), *Diverse Practices: A Critical Reader on British Video Art*, The Arts Council of England and University of Luton Press 1996, p200.

Mouth. The large screen suspended from the ceiling in *ExerMedea* allows the viewer to freely move around it, observing and being observed by the image (the face of a woman whose eyes hardly ever permit the camera to escape the grip of her look) from all possible angles.[30] The prominence of the film projector and the conspicuous material presence of the film (the rotating movement of which materialises the otherwise invisible space above and around the projector) are highly functional parts of the installation in *Blue Movie*. The gigantic screen of *Something between My Heart and Your Mouth* traces the metonymic function of the corporeal fragment which lingers in our field of vision until it claims a presence *not as a fragment*.

The complex mode of spectatorship thereby suggested is firmly located in an equally complex spatiality, articulated by image, sound and the random trajectory of the viewing subject. All three installations display a preoccupation with sensuality, agony and pleasure in their relation to the fragment. But such an articulation of viewing practice could not emerge outside this convergence of semiotic processes. What does it mean that, in the dark enclave of the solitary artwork, the viewer is forced into a one-to-one communication process - between the artist and the viewer? I would contend that this is one way in which the claim to the 'unity' of the artwork can be safeguarded. The radically discontinuous viewing process constructed in the disarray of signs among the three works discussed here, then, questions the aptitude of this dialogic model, a model crucially requiring the presence of two already-there (shall I say 'complete'?) subjects. In contrast, the space constructed here is plural. It is a space attentive to the *contemporary experience of the image*, governed perhaps not by a law of instability but by the *event* of simultaneous presence. The fragmentary image is not ultimately recuperated in the uninterrupted wholeness of the artwork (which seems to persist despite the non-traditional modes of narrative in much contemporary video work).

Blue Movie dispenses with the body as form. The viewer is confronted with a natural pace of production: silk-moths producing silk fill the screen in an unremitting activity. The viewer never sees the consequent introduction of this energy into the space and temporality of the commodity, neither does she see a female body enfolded in this foremost symbol of sensuality. Zelic has used the camera to arrest the sequence nature-commodity-femininity. For culturally specific audiences, the constant movement of the silk-moth signifies, therefore, its opposite: a stillness. And by doing that, it successfully exposes not only that it is impossible *not* to think nature outside a culturally specific process of semiosis, but also that the rhythm and space of nature are inevitably 'produced', as opposed to 'framed', within the latter. This is why the materials through which the image comes into existence are far from peripheral to the installation. If there is a kind of implicit totality operative here, it is the one articulated and mediated by the commodity, this crucial link through which nature and femininity are connected.

ExerMedea is the most cinematic of all three works. The 'observing' screen presents a narrative based on the nearly still image of a woman's face, slowly building into a crescendo of slowed-down intensity in her movements, and an ambiguous ending where the phrase 'oxygen=energy' hovers for a few moments over the overwhelming image of a swelling sea transformed by the reflection of the sun into

a pulsating mass of light. The mirror of the camera fails to reflect the body as fully there, and yet this body is unmistakably present - not as partially imagined by the viewing subject but as the space of self-controlled pleasure. What this body does remains unclear (in fact, this is a woman exercising). Above all, the body, whose activity is erupting in slow, discontinuous motion in the facial expression of the woman, defines itself as the space of agency. However, Skelton constructs this narrative of empowerment only to add a final and decisive question mark, for the 'energy=oxygen' phrase and the image of the swelling sea, subtly reminiscent of post-conceptual advertising techniques, actively oppose the effortless 'naturalness' of the previous sequence. It is precisely through the image of nature, parodied in the self-evidence of language, that the body returns to, or rather crashes upon, culture.

In *Something between My Heart and Your Mouth* a convulsing corporeal surface features a magnified heart drawn with a Kohl pencil on the neck. This is a work that curiously, for the time and age in which it exists, reintroduces the issue of a certain distance between content and form. Their relation is one of incommensurability. The minimalism of form is suspended because of the emotional impact of image and sound and vice versa. The agonising twisting of the body, whose gender remains unidentified, in a sense brings the heart 'to life'. The movement of the flesh which seemingly tries to undo this marking on the body is the same movement that naturalises this mark by animating it, making it part of that specific body, absorbing it onto the surface of the flesh. Flesh is therefore not the passive topos of inscription, and its marking is never just skin-deep. The materiality of the body is not the body's terminal condition.[31] Materiality is a process structured by a dialectics of self-re/cognition, a precarious balance between entering and stepping out of an identity. The agony of the body on the screen emerges as a highly symbolic reference to the *production* of this dichotomy. Why the subject takes pleasure in the latter and what this pleasure signifies (abandonment or opposition) in the field of social relations are the questions underpinning these images.

The juxtaposition of the works, as described above, throws into relief the radically different forms of pleasure available to the female body. An important aspect of all three pieces is the function assigned to the artistic subject in relation to the body. In *ExerMedea*, the artist records the movements of another body (the body of a friend exercising); in Følstad's work, the body of the artist is positioned as subject-matter; in Zelic's work, the artist regulates the flow of the image which only alludes to the body through complex associations. But in their shared space, this distinction loses its conventional meaning. The constant disruptions, based on both sight and sound, suggest that the viewer (this now being an inadequate term) has to actively produce his/her own pattern of decodification dependent on intermittent associations. There is no final image of the body, no final absence or presence apart from that effected by the viewing subject's desire. This returns us to Lajer-Burcharth's theorisation of the 'body as a kind of *invisible (impossible) reality*'. But this invisibility, which is related to the body's *partial* visibility in the postmodern modalities of the visual, is not just an insight of contemporary art offered to the unsuspecting viewer. Its emergence corresponds to a culturally based familiarity with the discontinuous intertextualities which confront the contemporary viewing subject in his/her daily experience, as theories of the postmodern have asserted again and again. "The monitor-based

[31] This reading is based on Judith Butler's radical de-essentialising of the 'material' (normally seen as the 'basis' upon which the edifice of identity is constructed). See Judith Butler, *Bodies That Matter: On the Discursive Limits of Sex*, Routledge, London and New York 1993.

[32] E. Lajer-Burcharth, *op. cit.*, p191.

[33] See Heidi Reitmaier, 'What Are You Looking At? Moi?' in D. McCorquodale, N. Siderfin and J. Stallabrass, *op. cit.*

disincarnation" effected in contemporary culture, as argued by Lajer-Burcharth, implies a viewing subject lost in a labyrinth of signs on the screen, one that requires the resurrected mythical identity of an enlightened, active artistic subject once more leading the way towards "resituating the self".[32] The spectatorship demanded by the interpenetration of spaces traversing these three installations, however, possibly suggests not only that it is inaccurate to describe any subject as passive but also that there are different ways in which any subject can be active.

private and public I: the contextual meaning of attitude

Being provocative in your art holds explicitly different meaning in Estonia than in Britain at the moment. This has to be mentioned because of the way sexual politics and gender issues have been reconfigured in the 'attitude' art of the yBas for instance, and more specifically in the practice of a new generation of women artists in Britain, where the latter have been framed as the ultimate embodiment of the new postfeminist ladette.[33] This different meaning of provocation is one of the issues raised by Mare Tralla's personal journey in Soviet mythology and KIWA's language of self-parody.

Tralla's interactive computer installation *her.space* is a work about tradition, despite the latter's radical dispersal in the hide-and-seek patterns filling digital space. The screen's colourful chaos playfully enters the world of kitsch by way of being enshrined in a waterfall of patchworked fabric which enfolds the computer. Old pyjamas, old curtains, old tablecloths and old dresses have all been conscripted to 'domesticate' technology - highly entertaining technology. Technology in the service of education. One wonders how many of the viewers, or rather players, knew how to fill the blank map of Europe with all its new and old spaces, its borders made out of broken lines; and how many of those who did felt cheated when the minute they thought everything was in place, the map disintegrated in front of their eyes and a new spatial confusion suggested that there is a certain amount of futility in this task. This was just one of the many routes to be taken in *her.space*. There is no point in attempting to describe all of them. Sex, work, lipstick, roses, Soviet heroines (women astronauts and women truck drivers), motherhood, alternative ways to cook fish and how to make a Kalashnikov - all are blended in a fascinating muddle of exorcised cultural experiences in the universe of digital simultaneity, projecting an unpredictable dispersion of a geographically located memory: not that of the 'woman artist' but of this specific woman/artist. Tralla's photograph as a young Soviet 'pioneer' was the real start button generating this flood of moving, flickering memories, spaces and female voices exclaiming 'revolution'. But if anything, this condensation of life, perpetually interrupted by life itself, is symptomatic of the persistent engagement with irreducible specificity in contemporary Estonian art, as most of the Estonian work in this show suggested.

Being the only male artist in the show, KIWA chose, quite pertinently, to focus on the space most associated with male creativity. The mythology of the artist's studio as the protected sanctuary of freedom and self-expression *par excellence* has risen across diverse techniques of visual signification ranging from paintings to

documentary photography to film. This is the space (allegedly) most desired by women making art. As Griselda Pollock has claimed, access to the studio means access to a celebrated subjectivity.[34] The symbolic hold of the artist's studio is not of course unrelated to the illusion of non-alienated labour, an illusion purposefully maintained in late capitalism and which has played a certain role in the post-Soviet definition of the artist in Estonia. It is precisely this illusion, actively supported by an art system dependent on it, which disallows a collapse of 'high' art into 'popular' culture, despite the diverse configurations of these two regimes of signification in the course of the twentieth century. In *Paradisco*, KIWA offers a video-clip version of this emblematic space of desire, with a superfluous amount of self-parody. There is an intentional stretching of the myth, since it is introduced into this other most-desired, mythic space of 'in your face', self-proclaimed, pop outrageousness. A number of exaggerated activities performed by the Master of His Universe, the artist himself, denote the foremost pop dream of I'm-here-doing-it ('you sucker' being the soundtrack's sample). But doing what exactly? The haphazard blending of scenes does not even remotely suggest a narrative encapsulating a process of 'making art'. The actions recorded are offered to the eager voyeuristic eye of the spectator who (at last!) has the chance to see the artist performing his re-invented self in his re-invented playground: drinking, going through his records, singing, dancing, thinking art, peeing in the sink, smoking a joint, being in drag, being 'himself'. Again there is at least a double axis of meaning here, for in the male-dominated, post-Soviet Estonian art world, where artistic gesture has acquired a new relevance denoting a politically invested self-realisation, this devious version of the artist's studio has not, for many, the right to exist. Not just yet. It's cheap, it's loud, it looks like an edited home video, it manifests an over-emphasised irreverence to current claims of taking one's culture and, crucially, one's place in culture, seriously.

[34] Griselda Pollock, 'Painting, Feminism, History' in Michèle Barrett, and Anne Phillips (eds), *Destabilizing Theory: Contemporary Feminist Debates*, Polity Press, Cambridge 1992.

private and public II: every day everywhere

Three works in the show deal specifically with the domestic. They are by Estonian artists and exemplify the profound changes effected in this sphere in the nineties. Annika Tonts' *Flower* and *Floor* create a conflictual space of mobility and immobility. The stark simplicity of her digital prints of floors covered with rags incorporating subtle traces of life at home, traces of movements which have already happened, suggest an everydayness which in its inevitable repetition negates the very possibility of memory. Her funny, battery-operated, plastic *Flower* gyrating in its pot is a humorous comment on the possibility of a momentary diversion in a world where the commodity is expected to perform the function of a pleasant surprise.

The issue of popular culture is currently of considerable interest to Estonian artists and it yields a love-hate response. In Anu Juurak's *Kitchen*, whose polished designer surfaces are *not* reminiscent of Soviet kitchens, four saucepans with transparent tops are on the hob. Inside the saucepans, the viewer is confronted with a staggering range of images, a parade of 'reality' shows, Brazilian and American soaps, children's TV, soups bubbling, tubes of washing machines, Martians landing on Earth and so on. For Estonian women, who are now presented with the 'option' of staying at home, the fast sequence and triviality of images are proposed as a narrative rather than the

absence of one. It is doubtful, however, that this work could ever hold the same meaning for the Estonian and the British viewer, although a nostalgic impulse may inform both. But if in Estonia this refers to the rapid transformation of the domestic, in Britain this has more to do with a sense of overt familiarity, a nostalgia over television culture itself.

Eve Kiiler and Mari Koort are also preoccupied with the liminal spaces created by multinational capital, but from a quite different angle. They exhibit snapshots of McDonalds interiors taken by various people in major cities around the world, from Tallinn to Jerusalem to New York to Hong Kong. These photographs have a specific focus, the attempt to give this space character by creating a certain 'style', as indicated by the title of the work, *Art Space McDonalds*. They display a touching variety: dramatic European sculpture in Stockholm, highly decorative stained glass in Lisbon, a chainsaw and a water-pump in Hong Kong, streamlined American automobiles in Jerusalem, a Soviet *Pravda* next to an enhanced image of a hamburger in Helsinki, nothing in particular in Tallinn, a dark, blurred lack of focus in London. As expected, the chosen decoration in each place bears no direct link with the wider urban environment in which it is located. There is nothing tying Jerusalem to big, shiny American cars, or is there? Is it that the way these spaces have been captured by the camera held by several different subjects cannot be ultimately separated by what these subjects saw? And so, some of the pictures have clearly diverted from the initial focus, turning the camera upon the flow of daily exchanges, to smiling or moody customers, to employees in their Mc uniforms; to whatever cannot be pinpointed but is inescapably there, a parade of spaces of consumption, defeating the particular taste of each branch's manager and therefore exposing the function of this taste, its particular currency.

private and public III: spaces between memory and fantasy

For Estonian women, the factory, as the space where the myth of Soviet 'equality' unfolded, is a highly symbolic reference. Liina Siib has produced three digitally manipulated images of a deserted paper factory. Her formal technique has allowed her to create in *Le Canceri* the illusion of a vibrating surface highly reminiscent of Seurat's dissolution of modern space. The views in the abyss of the debris left behind after this space ceased to be a place of 'production' are breathtaking precisely because the images generated seem to fluctuate between an imminent materialisation and an imminent disappearance. Tallinn, in its new post-Soviet era, hosts an indefinite amount of derelict industrial units, places left in such a hurry that decorations of past celebrations are still left on the walls, signalling an act of abandonment in progress. The anxiety this work elicits mainly has to do with how 'full', how inescapably inhabited, such spaces look - inhabited not by the phantasmatic presence of an activity producing culture, but by always already structured matter which draws the viewer's gaze in an act of inevitable recognition. In *Le Canceri*, the poetics of the sublime has been displaced from nature to culture, as befits the localised experience of the postmodern.

Naomi Dines' installation *Drying up, Pulling away* introduces a deceptively accessible narrative, influenced by the tropes of cinematic montage. In the installation space, the viewer peers onto the frozen actions of two women, one observed through an open window and the other observed through an open door. These scenes are literally *directed* as immediately recognisable: a woman drying up the dishes in her house surrounded by all the indications of her exact time-space co-ordinates and a woman ready to drive off in her car. Yet neither of these two acts is suggested in terms of an unbearable daily reality or the fantasy of an escape, although both scenes have carefully been selected among the themes that have haunted the feminist imagination in the West (especially in film). The simplicity of images and acts is striking and momentarily arrests the voyeuristic look of the viewer. I say 'momentarily" because soon a feeling of uneasiness takes hold when the gaze is confronted with two initially minor disturbances. The flesh on the face of the woman drying her dishes and the flesh of the arm of the woman driving away seem to be pulsating, sculpted from within by the touch of fingers - now absent rather than invisible. The illusion of this animating pulse does not last for long, but when it subsides, the stillness that replaces it is not the same as that of the snapshot, since now the abject is aligned with the daily spaces of intersubjective negotiation. As it has been said, "reality never ceases to 'sear the image'", and it is fascinating to witness how the conjunction of contemporary technology and art mobilises aesthetic consciousness specifically in this direction.[35] What is even more interesting is how this detail shifts attention to the relationship between the two images and, as a result, to the bond between the two women. The digital image has here imprinted time on space and has registered both memory and fantasy upon the topos of the body as re/cognised among women.

[35] Georges Didi-Huberman, 'The Supposition of Aura: The Now, The Then, and Modernity', trans. by Jane Marie Todd, in *Negotiating Rupture: The Power of Art to Transform Lives*, Museum of Contemporary Art, Chicago 1996, p49.

re-framing

The schematic structure of the present text, suggested by the limited space of this essay, does not fully disclose the complex relations even among the issues raised within it. Instead, it offers a partial reflection on the prospects and the possible points of a crisis. Not of the perennial crisis in representation, this unique legacy of certain modernisms to certain postmodernisms, but of the crisis pertaining to current practices of re/cognition of space where subjects embodying distinct (and yet crucially interconnected) identities act and are acted upon. One such practice is art - art that now makes no sense unless one acknowledges not only the correlation of power circuits in which it is inscribed, but also the enactments of disruptions which these circuits often manage to both display and contain.

I will not attempt to summarise the instances of social existence circumscribed by the 'private' views unfolding, interacting with and even opposing each other in the context of this show. Suffice to point out that in mapping the spaces where current models of femininity are shaped, lived and questioned, the private can be considered as expanded a term as the social in a way that defies a static grouping of 'national' subjects while not negating the importance of cultural/historical positioning. Is it that history also effects its own deconstructive moves? Or is it that certain so-called marginalised subjects have now made a critical move into history? Perhaps these are

chapter 2

[36] As claimed by Donna Haraway, "witnessing is seeing; attesting; standing publicly accountable for, and psychically vulnerable to, one's visions and representations. Witnessing is a collective, limited practice that depends on the constructed and never finished credibility of those who do it, all of whom are mortal, fallible, and fraught with the consequences of unconscious and disowned desires and fears". See Donna Haraway, *Modest _Witness@Second_Millenium.Female Man_Meets_Oncomouse: Feminism and Technoscience*, Routledge, London and New York 1997, p267.

[37] Victor Burgin, *In/Different Spaces: Place and Memory in Visual Culture*, University of California Press, Berkeley 1996, p211. Although Burgin here refers to the uses of psychoanalysis, his remarks are of a wider relevance.

not the right questions to ask, for perhaps no either/or formulation can attend to the new modes of witnessing the processes of transformation which unravel across different spaces at their interface with spaces of difference. The choice of verb is not accidental. For some feminist theorists today, witnessing refers to agency in terms of both making art and responding to art.[36] Witnessing entails and depends upon processes of re/cognition as these have become operative in the context of this exhibition.

Invoking the private in the title of the show, in order to avert the danger of an imminent generalisation reinforcing rather than dispelling cultural hierarchies, entailed another risk, here eloquently described by Victor Burgin:

> It is only by owning up to the inevitably 'individual' dimension of reading, then, that a hypothesis about general, unconsciously generated meaning may be arrived at - precisely because the subject of individual biography is not socially unique. This is no more than to restate the insight expressed in the feminist slogan, 'The personal is political'. That this maxim was so widely misunderstood - as a call for a turning away from the 'public' to the benefit of the 'private' - is testimony to the narcissistic fervour with which humanist ideology defends the 'individual'.[37]

Hopefully the itinerary offered here problematises this possibility. The responsibility of generalising conclusions of either kind belongs to the communities of viewers. But hopefully (again), the interpenetration of social spaces as a lived reality, rather than as a conceptual trope, will allow for more complex modes of spectatorship. One sound conclusion, however, is that the artists coming together in this show re/cognised more in each other's private view of space (be it the body or any material residue of social relations) than they had perhaps formerly imagined. This is hardly a positive realisation - unless one chooses to overlook, for example, the configuration of femininity, nature, technology and the market. But it demonstrates at least that the celebrated 'unfixity' of meaning, strategically useful as it may be when particular meanings are found to be oppressive, is not the underlying condition of our social experience.

Liina Siib *Le Canceri #1 — #3*, digital print series, #1, 1998

Annika Tonts *Flower*, object, 1997 and *Floor*, photo-installation, installation view, 1998

Eve Kiiler, Mari Koort *Art Space McDonalds*, photo-installation, detail, 1998

Anu Juurak *Kitchen/CMYK*, video-installation, detail 1998

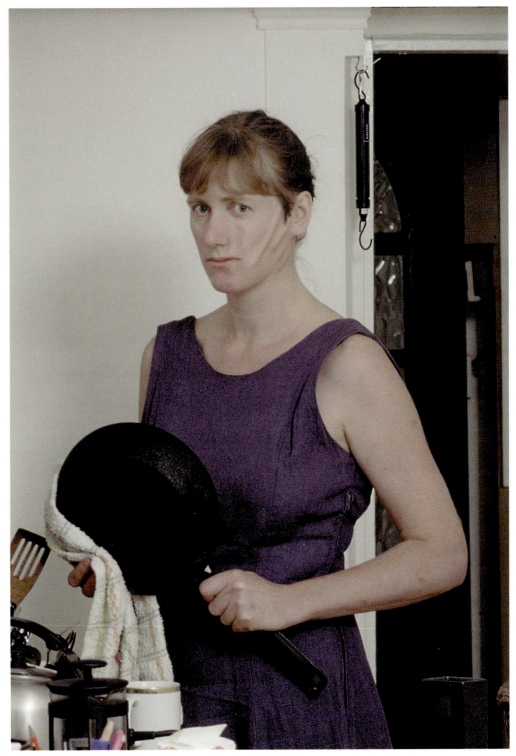

Naomi Dines *Drying up, Pulling away,* photo-installation, detail, 1997

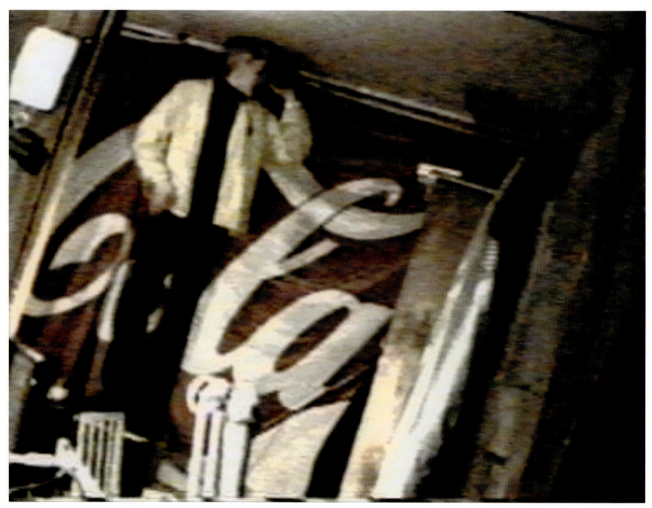

KIWA *Paradisco*, video still, 1998

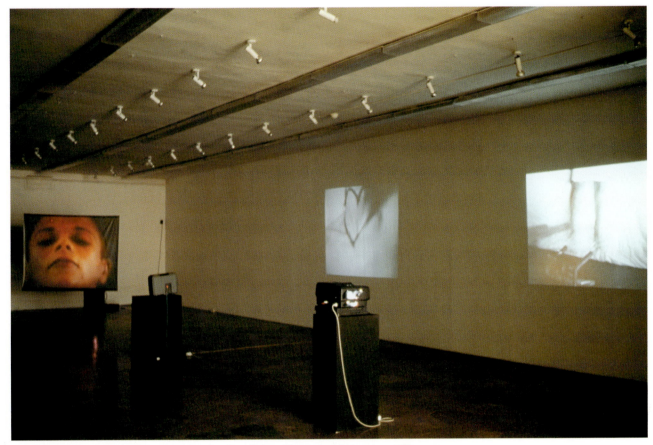

Private Views at the Institute of Contemporary Art, Dunaújváros, Hungary, exhibition view, 1999

chapter 3

taming the phantom of feminism in estonia
equal rights and women's issues

Barbi Pilvre

'the powerful estonian woman' licks the wounds of 'equal rights'

At times when their whole life is upturned, people hang on to the grand narratives of their culture. The myth of the powerful Estonian woman constitutes such a narrative in contemporary Estonia. Admittedly, because of specific historical conditions, Estonian women have enjoyed a greater degree of 'freedom' than women in neighbouring countries to the South or East. This, however, does not mean that gender difference has not been constitutive of social relations in Estonia. According to popular myth, the Estonian woman is Nordic, independent and strong, and even lends man a hand if necessary.[1] In this context, raising questions of 'women's oppression' has seemed absurd, for the oppressed subject is, at least for some, a figment of the (feminist) imagination. Despite the fact that Estonian and Scandinavian cultures differ in many respects, Estonians typically compare themselves to the egalitarian Scandinavians, whose own popular myths suggest that the Nordic countries have been a woman's 'paradise'.

To shake the foundation myths of a culture is an unappreciated and rank exercise. For although immersing oneself in myth is a form of self-deceit, one is at least left with a sense of identity. For the greater part of the twentieth century, and especially today, Estonian nationality has been at stake. Predictably, the home and family have been seen as holding the nation together. This belief has been a stronghold for the Estonian people throughout the entire Soviet period, and questioning it today is, for many, distressing. The Estonian woman's traditionally central role in the household, as witnessed in other Central and East European countries, and her participation in non-domestic labour during the Soviet times, have been repeatedly brought forth in arguments against the necessity for a women's movement in Estonia.[2]

The myth of the powerful Estonian woman currently helps preserve some sort of stability in the flux of the post-Soviet world. It provides the ground upon which the debate about the possibility and historical necessity of feminism in Estonia is unfolding. What sort of affairs should feminism manage in a society which still licks the wounds of Soviet equality - an 'equality' which has added yet another layer to the myth of women's power in post-Soviet regimes?[3] Could it be like breaking through an open door?

the myth of genderless society

During the Soviet period, as is well-known, class provided the exclusive focus of state and academic discourse. Consequently, gender never rose to be a significant

[1] Hasso Krull, Feminism ja eesti kogukond *Est.Fem*, exhibition catalogue, Tallinn 1995, p9 (also at http://www.zzz.ee/foorum/index.html).

[2] Jirina Siklova, 'Why We Resist Western-style Feminism: Defining Equality for the Post-communist Culture', *Transitions: Changes in Post-Communist Societies*, Vol.5 No.1 January 1998, pp30-35; Elena Gapova, 'National Dreams and Domestic Goddesses: When Motherhood Means Nationhood', *op. cit.* pp72-75.

[3] Marju Lauristin, 'Introduction: Women in Today's Estonia' *Idäntutkimus 3-4*, 1996, pp8-11.

category for the analysis of social relations. There were neither women nor men: just comrades, the working class and its historical opponents.[4] Gender was practically eliminated in theory while it also fell outside the parameters of political discourse. For example, on International Women's Day (8 March) it was the worker-who-happened-to-be-woman who was celebrated. Gender was mainly understood as a personal 'trait' akin to other personality attributes, and was not therefore considered constitutive of one's identity. This partly explains why the very notion of identity has not been associated with gender in post-Soviet Estonia. Sexuality as such remains an issue of peripheral concern: heterosexuality and homosexuality are simply not on the agenda of any kind of public discourse. Overall, sex has been taboo and the over-indulgence in sex in contemporary Estonia is understandable after such an enforced secretiveness.

From one angle, the Soviet concept of a woman's social position seemed to be congruent with the ideals of an equal rights feminism: women worked and received equal pay to men, although wages were low for both. There were women in the Supreme Soviet and there were women who studied in agricultural colleges to become tractor drivers. Also, women became cosmonauts and scientists and, to set the record straight, women's participation in the public sphere under the Soviet rule allowed them to claim their right to speak - if not as and for women, then at least as members of groups who would have certain demands. The Estonian woman speaking in public did not just appear during the Singing Revolution;[5] these were the same women who had already pursued prestigious careers during the Soviet era and were highly reputable academics and public figures (Marju Lauristin, Valve Kirsipuu, Ivi Eenmaa, Liina Tõnisson, Siiri Oviir, Krista Kilvet and others).

It cannot be denied that equal rights as implemented in the Soviet Union and equal rights feminism in the West share certain premises.[6] To offer one example, the right to have an abortion (being fought for in the West until the seventies and still an issue in the USA today) was restored in all regions of the Soviet Union, including Estonia, as early as 1955. Women could have an abortion in the Soviet Union before World War II, until Stalin outlawed this during wartime (although this did not apply in Estonia which did not belong to the Soviet Union until 1940).[7] But although abortions were legal, they were carried out in inhumane conditions, and, in addition, a report was sent to the workplace by the authorities informing them that their employee had had an abortion. There was a lot of secrecy surrounding contraceptives and family planning, and there were no special sanitary products for women.

Soviet women did not belong to a surplus labour force. Women who stayed at home were either suffering from poor health or were shirkers/freeloaders. Healthy women's participation in the workforce over the past twenty years, of which Swedish activists, for instance, are so proud, has been a fact in Estonia for decades. Our mothers and grandmothers have always worked but this by no means meant that all their problems were solved. Mother's Day was banned throughout the Soviet Union as a bourgeois legacy. Despite this, motherhood constituted an obligation rather than a right for Soviet women. There was a state policy ensuring the regular renewal of the workforce directed by the Communist Party. Young girls were raised

[4] The situation was more complex since, during Stalin's time, deportations were taking place on the basis of class allegiances - in other words, kulaks were eliminated as bourgeois relics. The nation was also seen as something distinct and of minor interest, a category which needed to be liquidated in the course of time, except, of course, the 'great Russian nation'.

[5] The Singing Revolution involved mass demonstrations and the consolidation of a political movement against the Soviet Union in Estonia (summer 1988 lasting until December 1989). The term describes those forms of demonstration which involved thousands of people singing together.

[6] On developments in Soviet Russia during the seventies, see Elena Zdravomyslova and Anna Tjomkina, 'Vvedenie. Sotsialnaja konstruktsija gendera i gendernaja sistema v Rossii. Gendernoe izmerenie sotsialnoi i polititsheskoi aktivnosti v perehodnoi period. Sb. nautshnyh statei/ Pod reaktsii Elenoi Zdravomyslovoi i Annoi Tjomkinoi' *Trud*. Vol.4. Tsentr nezavisimyh sotsialnyh issledovanii, Sankt-Peterburg 1996 pp5-12.

[7] In the pre-World War II Republic of Estonia abortions were illegal.

[8] Zdravomyslova and Tjomkina, *op. cit.*

[9] Marju Lauristin, Peeter Vihalemm, Karl Erik Rosengran, Lennart Weibull (eds), *Return to the Western World: Cultural and Political Perspectives on the Estonian Post-Communist Transition,* Tartu University Press 1997.

[10] Sirje Kivimäe, 'Esimesed naisseltsid Eestis ja nende tegelased' in Ea Jansen, Jaanus Arukaev (ed), *Seltsid ja ühiskonna muutumine. Talupoja ühiskonnast rahvusriigini. Artiklite kogumik,* Eesti Ajalooarhiiv, TA Ajaloo Instituut, Tartu-Tallinn 1995, ppll8-135.

[11] Madli Puhvel, *Symbol of Dawn: The Life and Times of the 19th-century Estonian Poet Lydia Koidula,* Tartu University Press 1995.

to the ideal of fulfilling the double role of the 'working mother' who was ultimately a heroic figure,[8] and mothers of many children received medals and were rewarded with special benefits such as priority to state-funded flats. However, women in the Soviet Union were workers first and mothers second, despite the fact that men were not encouraged to share the domestic workload. And although reproduction was seen as linked to women's specific biology and was therefore considered to be their exclusive responsibility, sexual difference kept being omitted from the agenda both in the academy and in state politics. In other words, Estonia inherited from the Soviet tradition a problematic distinction between 'reproduction issues' and 'sexual difference'. The two never appeared in the same context and, to make things worse, Estonia's recent quest for independence shifted attention to unity based on ethnic origins. In post-Soviet times, this has suggested a discursive space where questions about sexual difference could only operate in a disruptive way.[9]

the strong farmer's wife: between history and fiction

While Estonia reinvents its own myths, some historians[10] argue that Estonian women and men have been serfs throughout history and that the powerful Estonian woman has been more of an achievement at the level of representation (i.e. in art and particularly in literature) than a historical reality. Legendary women such as Anna Kõrboja in *Kõrboja peremees* (1922), a classic work by the Estonian writer Tammsaare, or Ukuaru Miina in the film *Ukuaru* (Tallinnfilm, 1973) by the prominent female director Leida Laius, faced the problem of disempowered husbands, which rendered their own subordination for the most part invisible. The relation of literary characters to the experiences of 'real' women is complex and an analysis of such relations far exceeds the scope of this essay. What is worth pointing out is that, under specific circumstances, practices of representation somehow seem to offer evidence of how things have been. Texts hold particular kinds of meanings, being not mere reflections of a reality existing elsewhere but a space where 'reality is being made'. In the course of time, the grand narratives of a culture tend to be treated as offering access to 'reality' and it simply seems unreasonable to doubt them. Even more problematic is how these great narratives, in which myths are rooted, intersect with representational practices, for it is possible to suggest several versions of a past 'reality', and both fiction and history have operated in precisely that way. An example of such an intersection would be Madli Puhvel's biography of Estonia's famous nineteenth-century poet Lydia Koidula,[11] when compared with certain 'patriotic' versions of the poet's life (which flourish in Estonia). Who, actually, was Koidula, evidently the most prominent woman in the context of a recently reclaimed Estonian history? An asexual, 'patriotic' subject writing for her country? Her father's daughter? The platonic incarnation of the Estonian spirit? Or, on the other hand, the overburdened mother, wife of the Latvian burgher living in St. Petersburg, exhausted by consecutive childbirths (which ultimately led to her death) and fighting the harsh reality of her days? Questions such as these are perhaps destined to remain unanswered. Consequently, the argument that in an ideal past Estonian women were powerful and emancipated seems all the more wrapped up in the realm of myth - a currently important myth for the fashioning of a precarious national identity, but a myth nevertheless.

On the other hand, Estonian women's history is, indeed, unwritten but not necessarily unknown. After all, it is this history which led to the present moment, whatever this moment seems to hold for contemporary Estonian women. A clue about what kind of power and 'freedom' Estonian women enjoyed in the past was to be found in the answers given to the questions on women's rights by the great Estonian ideologist, prominent twentieth century politician and pre-war Prime Minister Jaan Tõnisson. 'Kinder, Kirche, Küche' [children, church, kitchen], as publicly stated by Bismarck in Germany and was later to echo in the words of Adolf Hitler. The Estonian woman has had her 'place' in the pre-Soviet world: it was in a muddy potato field alongside the hardworking male serfs, in the kitchen, with the children and, best of all, in the church listening to the 'Word of God'.

the german influence or claiming a european identity

For the historian Sirje Kivimäe, the position of the Estonian woman derives from the model set by the German petty bourgeoisie rather than any Scandinavian models.[12] The German influence was strongly felt in the Baltic, and so-called Germanised Estonians are an indisputable phenomenon of twentieth century Estonian culture. Despite the fact that Estonia's historical connection with Germany was based on oppression and servitude, Estonians are proud today when talking about their German-influenced cuisine, their German Christmas traditions or their German order and punctuality.[13] During the German President's visit to Tallinn in May 1998, the statement "our 700 year shared history", erasing the bitter memory of about seven hundred years of serfdom under German landowners, was broadcast on Estonia's central news programme, *Aktuaalne Kaamera*. Again, practices of representation had paved the way for the current reinvention of the past. The gentry and their culture provided the concept of an ideal life, while German ladies represented the aspiring model for Estonian women. These tendencies had already been described in literature, as for example in A.H. Tammsaare's classic romantic novel *Ma armastasin sakslast* [I Loved a German], written in 1938.

Significantly, the 'German' model of femininity, seemingly divested of specific class associations, was perceived as more European than the Scandinavian one. Therefore, by aspiring to be German, the Estonian woman could claim to be more European than Scandinavian, even if being European meant in this instance a departure from the model of the emancipated Nordic woman and an adherence to Western patriarchal values. If anything, this suggests that the issue of national identity did not just emerge in the post-Soviet era. It spans the whole of the twentieth century and, as a permanent point of crisis, it has become the measure of all social relations, including those of gender.

modern times: conflicts

Today's commonplace experience gives even less to the notion of Estonian women's power and equality. There are fewer women employed on the basis of their

[12] Lecture in the series Introduction to Gender Studies, Tallinn University of Pedagogical Sciences, March 1998. See also Kivimäe *op. cit.*

[13] Lauristin *et al, op. cit.*

[14] Anu Narusk, 'Gendered Outcomes of the Transition in Estonia' *Idäntutkimus 3-4* 1996, pp2-39. It should be pointed out that the use of the term 'minority' to refer to the token number of women represented amongst the public domain's elite has led to intense debates in Estonia despite the term's acceptance in Europe. Being described as belonging to a 'minority' (in this case meaning an elite) has been profoundly problematic for the few powerful women in Estonia. For them, such terms are part of a statistical jargon, whereas these women see themselves as representatives of at least half of the Estonian population.

[15] Anu Narusk (ed), *Murrangulised 80-ndad ja 90-ndad aastad Eestis: töö, kodu ja vaba aeg* Eesti Teaduste Akadeemia Filosoofia, Sotsioloogia ja Õiguse Instituut, Tallinn-Helsinki 1994.

[16] There are about 160 women's organisations in Estonia which mainly exercise charity, training and other non-political activities. Political women's organisations such as Naire and Mõõdukate Naiskogu have just recently (and probably because of the elections in 1999) 'discovered' the question of women in society. They do not demand equal pay and focus instead on bringing more women into politics.

qualifications in the public sphere than in neighbouring Nordic countries, starting with eighteen female representatives in the Estonian parliament against eighty three male representatives and ending with any public office where money and power are at play. In other words, there is only a token number of women decision-makers.

However, women are not altogether excluded from the public domain. Instead, they are effectively ghettoised in areas of low prestige. They are employed in education, health services, libraries and museums; they may reach the top of their allocated areas but such heights offer no currently valued rewards - no money, no power. In 1999 only two women were to be found in key government posts (two female ministers), although women are found amongst the lower levels of the state administration. This subtle form of marginalisation is something that has only recently been recognised in Estonia,[14] and gives rise to certain questions. For example, where have all those promising female students disappeared to? If they are employed, why have they not risen to the top of their chosen profession? Why would they not be employed in the first place? Why are Estonian women who do not have a wealthy husband in such financial hardship?

To begin answering such questions, one has to take account of a new factor currently in operation within post-Soviet Estonian society: free choice. In perfect compatibility with the 'new' exciting models of social 'success', many women choose to give up the prospect of a career and reconcile themselves to a smaller salary, but this is always in the interest of something; the well-being of the family, their children's future or their husband's self-esteem. There is no need to mention the sociological explanations employing theories of 'rational choice', but to stay within traditional gender roles brings social approbation, although one wonders just how 'traditional' these gender roles really are in a society that has just left behind the traditions of a Soviet regime which, as already argued, involved a particular form of egalitarian politics. It is perhaps worth mentioning that affiliated to the Ministry of Social Affairs is an Equal Rights Bureau which has so far had something less of an impact on Estonian women's lives, especially when compared to the impact that 'free choice' had.

woman's pay - man's pay

Statistical research has recently demonstrated that women only earn 70% of the average salary of men in Estonia.[15] The ratio of women's pay to men's pay is on a par with the European average, but worse than in Scandinavia. This is in fact one of the few available pieces of information concerning women's social existence in Estonia that is based upon statistical research. Neither women's organisations[16] nor female politicians have seriously raised the issue of low pay in women's employment. The comparison to Europe seems to conclude every discussion of the subject with a positive note: since Estonia aims to be a European state (and not a Scandinavian one), there is nothing to worry about. Predictably, this state of affairs is also justified by a return to pre-Soviet social values, according to which the husband is responsible for providing for his family. Women's low wages have come to be considered as 'pocket-money', even when this is not the case.

In Estonia there are considerable numbers of single mothers who provide for their whole family.[17] Despite this, there is an increasing tendency to de-politicise such problems by interpreting them in terms of personal misfortune. During a recent teachers' strike in Estonia it was said that paying such a petty wage to teachers (below the average Estonian salary which is at the moment 4000 EEK, under 300 US dollars per month) constitutes in fact a form of discrimination against women.[18] On the other hand, many women commenting on the situation pointed out that low wages were not the issue: "We are not on strike to get a raise. We want the teaching profession to be appreciated more".[19] Such comments suggest that there is perhaps a lack of awareness converging at the intersection of low wages and social position. Until this awareness is achieved, women will continue to be discriminated against, although as a result of the teachers' strike there was a symbolic rise in wages. However, as a cynical saying among teachers has it, to work as a teacher requires a rich husband. Moreover, a rich husband is also the precondition required to work as a nurse, artist, etc.[20]

the crisis of citizenship

There is no political women's movement as such in Estonia, although single voices are occasionally raised, saying that 'something' has to be done. Women's reluctance to address problems through any form of political activism is not surprising within the context of a weak political life in general.[21] Nevertheless, one could argue that, whatever the word 'politics' has come to define (from state politics to grass-roots activism), it has been mostly used to describe men's activities. In Estonia, there are currently two working women's political education centres. Only recently have large numbers of Estonian women sought to be involved in direct political action. Estonia's Singing Revolution at the end of the eighties was an exceptional moment of social uprising involving many women, most of whom disappeared from the political arena when the new Republic was assembled.[22] There are no strong grass-roots movements in Estonia similar to those found in the West.[23] The once-active green movement dissolved with the advent of independence; it can be argued that it was swept away by the tide of consumerism. On the whole, however, organising on any issue is unusual. There are no anti-racist demonstrations (nor neo-nazi ones for that matter). In general, there is a passive attitude and a reluctance to engage with political issues which is not exclusive to women in Estonia. The only exceptions, perhaps, are the dissenting voices of the Russian pensioners. People are not ready to identify and confront issues and there is a widespread feeling of uncertainty towards what actually constitutes this new 'reality' following the collapse of the Soviet Union.[24] Frequently, the way in which questions are posed and doubts expressed fails to suggest a wider frame of enquiry on social conditions.

The crisis of citizenship transcends gender. Being a politically active subject is at the moment fraught with difficulties; it requires time and energy which are currently lacking or, possibly, invested elsewhere. The tendency to depoliticise social issues by resorting to a language of personal misfortune has been a trend in the course of Estonia's national awakening, and a language of victimisation, especially when taken up by women, is considered very becoming. To sacrifice one's life for others to live

[17] Every second woman is the sole bread-winner in Estonia according to a survey done by EMOR, a public opinion research company, in 1997. In the case of poverty, the groups mostly at risk are families of unemployed and/or single mothers. See Anu Narusk, 'Men and Women: Opportunities, Rights and Obligations' in *Human Rights in Estonia*, UNDP, Tallinn 1998, pp41-52.

[18] There is no statistical evidence to date; however, it is estimated that approximately 90% of teachers in Estonia are female.

[19] Anneli Ammas, Anu Saare, 'Streik: Eile streikis Eestis ligi 16 000 haritlast', *Eesti Päevaheht*, 28 November 1997.

[20] Lately, bus drivers and policemen demanded (and rightly so) pay rises in Estonia. Their demands were immediately met. The overwhelming majority of bus drivers and policemen are, of course, men.

[21] Lauristin *et al*, *op. cit.*

[22] A. Aarelaid, (ed), *Kodanikualgatus ja seltsid Eesti muutuval kultuurimaastikul*, Jaan Tõnissoni Instituudi Kirjastus, Tallinn 1996.

[23] On this see *Estonian Women in a Changing Society*, National Report of Estonia to the Beijing Conference: The Fourth World Conference on Women, Action for Equality, Development and Peace 1995.

[24] *Estonian Human Development Report 1997*, UNDP, Tallinn 1997 (also at http://www.ciesin.ee/undp/nhdr.html).

is the ultimate feminine act. The crisis of citizenship is intensified by the transition to a market economy. The advent of the market has glossed everyday life with a veneer of simplicity based on the widespread illusion that things finally are how they should have been. Why complicate one's existence by asking questions for which there are no immediately available answers? The lack of a women's political movement is symptomatic of this crisis which was perhaps inevitable as the only possible outcome of the Soviet experience in which the notion of political responsibility was significantly distorted.

importing structures and ideas

Within the current quest for a national identity and the consequent tendency to draw a line between 'here' and 'the rest of the world', it has frequently been claimed that feminism, even to the extent it has appeared in Estonia, has been a foreign influence. The argument, although simplistic, is worth considering because of its frequent reiteration. And I say 'simplistic' because it disregards the fact that most cultural phenomena, ideas and theories evolve through some kind of interaction among social agents. Outside the frame of reactionary fantasies around purified national cultures, it seems impossible to distinguish between what is indigenous and what is 'alien'. Even the heartfelt Estonian 'national idea' is nothing more than the remains of eighteenth century German Romanticism. At present, a purposeful eclecticism is manifest in Estonia - a tendency to experiment with everything that appears interesting. Given the resources the market has at its disposal, what appears most interesting, even exciting, is the market itself. The market has proved immensely adaptable, sufficiently local and global at the same time. It constitutes the single successful import in Estonia at the moment, both as a structure and as a concept. It is even difficult to imagine how it was possible to be without it for so long.

In a crude schema the case for feminism in Estonia is somehow parallel to the case for a market economy in Estonia. Are there any grounds for feminism in Estonia? We may as well ask: are there any grounds for a market economy in Estonia? Why is it that only feminism is considered 'imported'? Throughout their history, Estonians have been serfs or servants rather than owners of land or property. To the Estonian people, ownership remains an essentially 'alien' concept if one is to think along the lines of locally bred and 'imported' values. The Estonians are currently discovering a particular form of individualism fashioned to sell a market economy in its own right, regardless of the fact that in the social and intellectual history of Estonia the tradition of individualism has been peripheral. To centuries of serfdom were added the fifty years of the Soviet experience in which all individual initiatives were suppressed by means of sanctions (ultimately the system came to operate in such a way that no new initiatives arose).

Ideas are not assimilated if prevailing conditions are extremely adverse. For the time being, our cultural values derive from the traditions of Eastern Europe - although a profound change, commonly known and welcomed as 'westernisation', is taking place.[25] Admittedly, it is in this context that feminism as a theory and a politics has arrived in Estonia. The links between feminism and the processes of westernisation

[25] Lauristin *et al*, *op. cit.*

are partly responsible for obstructing an understanding of feminism as a complex and evolving set of ideas addressing gender issues in specific patriarchal societies. As in other Central and Eastern European countries, the spreading of feminist theory is inhibited by a lack of consideration for the need for social and cultural analysis. At the moment, the intellectual climate in many parts of Eastern Europe is characterised by the absence of certain analytical tools (such as psychoanalytic criticism) and a tension over certain contested terms (i.e. postmodernism), and these tendencies become all the more problematic when combined with the distortion of Marxism in the former Eastern bloc.[26]

Arguably, an international women's movement has to be based on a much-desired cultural interaction. However, this cannot currently exist in Estonia without financial support from state institutions or the private sector, and women's organisations are criticised for squandering resources on social gatherings. In contrast, cultural interaction among men, in the context of the academy, state politics or corporate structures, is seen as ensuring Estonia's place in the West. Issues discussed by men are regarded as 'neutral' and hence as relevant to society as a whole. In contrast, women's collective action, when and if it is witnessed, attracts scolding from the media, soon to be followed by public condemnation.[27] For men, learning and assimilating new experiences is viewed as self-improvement, whereas women are stigmatised as being brain-washed. What this attitude suggests is that, despite claims to the contrary, women are asked to stay away from public life. Cultural interaction is yet another privilege offered on the basis of gender.

[26] Jirina Smejkalova-Strickland, 'Do Czech Women Need Feminism? Perspectives of Feminist Theories and Practices in Czechoslovakia', *Women's Studies International Forum*, nos.2-3, 1994 pp277-282; Jirina Smejkalova-Strickland, 'Revival? Gender Studies in the "Other" Europa', *Signs: Journal of Women in Culture and Society*, vol.20, no.4, 1995, pp1000-06.

[27] For instance, the Estonian women's delegation at the Beijing conference in 1995 was criticised in public discussions and not really covered in the media. I was among the journalists who travelled to Beijing and published reports in *Eesti Ekspress*.

the path to essentialism is through the market

Not surprisingly, arguments incorporating a form of biologism are currently set against historical explanations in Estonia. In the emergent market-oriented economy and its accompanying ideology of 'healthy competition', an explanatory language that features, for instance, the 'survival of the fittest' has gained ground. This helps explain why feminism, and particularly that tradition of feminism which stresses the social production of the subject, has been so difficult to accept. It can be argued that the existence of social difference and even certain forms of elitism are favoured in contemporary Estonia and, understandably, this may not be the best framework for dealing with equal rights issues, since even equal rights remain unresolved here.

In a sense there is a cult of difference as such: difference in economic terms (the 'return' to class society), difference in terms of ethnicity (we Estonians and they Russians) and, of course, gender difference (women and men). As we shall see, this partly explains why cultural feminism has been far more popular in Estonia than either equal rights arguments or the critique of social relations in which gender difference is crystallised. Essentialism in general seems to operate as an excuse to eschew responsibility for profound social problems. To take one example, prostitution is often referred to as 'the oldest profession' and the 'natural path' of things; with man's 'innate expressive sexuality' and woman's innate ability to seduce men. Arguments are sometimes shocking in their deployment and manipulation of stereotypes. The prostitute is good-looking and has used her 'feminine weapons',

which nature has provided, to compete in the market and become financially independent. The feminist is repeatedly caricatured as the opposite of all the above. She is the unhappy loser, hence she complains. She can afford to complain because she has nothing to lose.

Placing emphasis on 'femininity' has allowed Estonian women to disavow the issue of a feminist politics. Women's organisations in Estonia have so far rarely chosen to consider discrimination based on gender, such as women's salaries, family violence and prostitution (to name but a few of the major problems facing the majority of Estonian women today); they are even less interested in understanding femininity as socially and historically produced. On the contrary, what seems to offer a sense of identity (and therefore to provide the motive to join a women's organisation) is precisely the idea of 'being' a woman, the desire to explore the eternal feminine attributes and to reinstate the previously suppressed female 'nature'. Not only is it 'natural' to be a woman; following the Soviet days when women had to join men in the factories, being a woman is also novel, fashionably 'Western' and even patriotic.[28] In contemporary Estonia, biological determinism, nationalism and the discourse of the market have provided a powerful framework for a convenient return to essentialist models of femininity.

Symptomatic of these tendencies was the reception of Simone de Beauvoir's *The Second Sex* and Clarissa Pinkola Estes' *Women Who Run with the Wolves*, two books which were translated simultaneously in 1997. The latter one, emphasising an archetypal form of femininity, became very popular, at least in the media. Simone de Beauvoir's work was seen, on the other hand, as intelligent but 'cruel' and for the most part irrelevant.[29] Consumerism brought gender difference into sharp focus, and for Estonian women today, 'being a woman' occurs and is only possible within its spaces. Lingerie, cosmetics, fashion, beauty salons, exercising and, of course, plastic surgery, which have existed in the West for decades, have just arrived in Estonia. What the market advocates is that the 'natural' state of femininity can actually be achieved. This has been a recent and overwhelming realisation for Estonian women. Westernisation introduced its own principles for a successful social existence, principles which are far from old clichés in Estonia. Beauty (women) coupled with money (men) is the formula for success.[30] Westernisation as a process seems wholeheartedly based on gender difference and as such the latter is welcome. The pleasure of being a woman is identified with the pleasure of consuming women's goods, and 'commodification' does not necessarily have a negative ring about it.[31] Beauty contests, model-culture, women's magazines, soap-operas - the industry is burgeoning in Estonia. Women's lives as well as women's desire for a collective identity are straitjacketed in its context.

the politics of reflection: women's organisations in estonia

Apparently, there seems to be a specific pattern regarding how women's organisations are formed in Estonia. Let me give an example which could illustrate the general situation. A Swedish women's delegation came for its tenth visit to Estonia and still wondered about the lack of a business women's organisation, only

[28] *Estonian Women in a Changing Society, op. cit.*

[29] Toomas Liiv, 'Beauvoir ja eesti naine'. *Eesti Ekspress*, 6 November 1998.

[30] The situation is similar to that in other Eastern bloc countries. See Slavenka Drakulic, 'What We Learned from Western Feminists: Democracy and the Treason of Lipstick', *Transitions: Changes in Post-Communist Societies,* vol.5 no.l, January 1998, pp42-47.

[31] Terms such as 'babe-culture' have a particular currency in contemporary Estonia. 'Babe' defines a young woman aspiring to marry a wealthy husband and who mostly invests in her looks. In the media, the debate about babe-culture was introduced by the Estonian weekly *Eesti Ekspress* in 1996.

to find upon the eleventh visit that such an organisation had indeed been established. New collaborations with women's organisations from the West rapidly generate discussion, despite the first puzzled reactions ('what on earth do they want from us?'). The First Baltic Equal Rights Conference in Spring 1997, with its opening event held in Tallinn, was a Nordic initiative made possible through Nordic funding. Although events like this are welcome, a lack of self-reflexivity can be detected. The specific needs of Estonian women are neglected because of the desire to appear on a par with current Western models. Women's organisations in Estonia are patterned upon women's organisations in the West; Estonian women are taught by their Western sisters a ready-made language in which to converse. Undeniably, there are also positive effects, for, at least in this context, 'natural' patterns have become, to some extent, questionable. Cases of sexual harassment, unfair economic policies or even gender discrimination in the work environment are now reported. These reveal the myriad cultural threads that inhibit change - change that would benefit the majority of Estonian women.

Two gender studies centres in Estonia have been established as a local initiative with the support of funding from the West - one in the University of Tartu (unofficially in 1990, officially in 1996) and another one in Tallinn University of Educational Sciences (unofficially in 1994, officially in 1995). Also, in 1997, as an initiative of Estonian expatriates and foreign embassies, NGO Estonian Women's Studies Resource Centre (ENUT) was established in Tallinn. Whilst this is the case, the fact remains that there only exists at present an Introductory Module in Gender Studies. This unfortunately reflects the academy's inability to support and develop gender studies and it also explains why there is only a small number of postgraduate students working in this area. Nevertheless, with the support of foreign funds (UNDP, PHARE, Open Estonian Foundation, Naumann Foundation and others), the development of women's organisations is under way. Whether these initiatives will have a greater impact in the future will depend on successfully establishing connections between the local context and Western models of feminist practice.

the trap of essentialism

The quiet but tenacious development of women's organisations and gender studies in Estonia has not, so far, resulted in an immediate improvement of women's social conditions of existence, at least not in the sense that Scandinavian or Western activists would like to see it. Neither has it resulted in a radical re-framing of theoretical debates and practices addressing gender and sexual difference. If a politics can be identified in Estonia today that positions women as a social group, this is conservative and bound, as mentioned earlier, to the essentialist side of Western feminism. Future research will hopefully shed some light on why this happened. A tentative approach would suggest that this fact is not unrelated to the demands made by Western feminism on Estonian women's organisations; demands not always expressed as such but still providing the only available frame of discourse for Estonian feminists.

At the moment, questioning the models of Western feminism would lead to an

chapter 3

[32] UNDP - United Nations Development Programme, PHARE - European Union aid programme for East and Central Europe.

economic crisis for women's organisations in Estonia, since their very existence depends on the support of foreign money and Western feminists. The amounts invested by international bodies in Estonian women's organisations' activities are substantial. UNDP and PHARE have both offered approximately one million Krones (about 70,000 US dollars) in grants for the promotion of equal rights.[32] What takes place instead is a process of selection among the varieties of Western feminisms on offer. Crude as it sounds, the essentialist side of feminism has been a viable option, highly compatible with the demands made on Estonian women in the context of the transition to a market economy and the discursive spaces of nationalism. Implementing Western models of action hinders development when, at the same time, it is hard to see where interaction begins and where hegemony ends. Although women's issues are far from resolved in the West, it can be argued that the agendas of women's organisations are part of the wider picture and have infiltrated social consciousness to an extent. In Estonia, the absence of gender as a category of difference informing academic discourse and state politics, coupled with the problematic egalitarianism of the Soviet times, has shaped social consciousness in a particular way. As stated at the beginning of this essay, the belief that Estonian women are already 'emancipated' is still widespread. It is imperative that the critical questions about gender roles consider the premises and conditions of this presumed emancipation.

To reformulate the agendas of women's organisations in the post-Soviet world, problems have to be approached from a different angle. Within the Estonian context, feminism as a theory and a politics is very vulnerable. A confusion at the level of ideas and practices, along with a discrepancy between set objectives drawing on women's experiences in the West and the social consciousness Estonian feminism aims to address, make the situation all the more problematic. To leave such dilemmas behind possibly requires a continuation from where the Soviet legacy left off. The conditions of a formally accepted equality offers Estonian women certain advantages. Action should be directed towards securing women's rights through legislation, instead of relying upon a model of a seventies collectivity or a DIY activism of which there is no tradition in Estonia.[33] Yet again, confusion at the level of action and ideas is a general trend and as such a major problem in contemporary Estonia. Despite the fascination with an allegedly shared 'female' identity, women's organisations have not formulated a plan of collective action. However, in the 1999 parliamentary elections female politicians advocated coherence on the basis of a shared female identity. Essentialism is central to their discourse: women's 'caring nature' can have positive effects on the country's political life.[34] Lack of clear focus and the underdevelopment of theoretical models addressing gender issues in a local context may lead to a dead end; therefore, the emphasis upon 'femininity' requires rigorous reconsideration. When Estonian women, in the process of disidentifying with the Soviet woman, choose to stress their 'inherent' qualities - for example, their aptitude for caring-based professions - they run the risk of marginalising themselves. Women's schools, women's magazines and women's salaries may potentially result in a women's ghetto – and, worse still, it may not be easy even to acknowledge it as such.[35]

[33] On this see George McKay (ed), *DiY Culture: Party & Protest in the Nineties*, Verso, London1997.

[34] Celia Kuningas, 'Miks meil poliitikas naisi napib?' *Eesti Päevaleht*, 7 October 1998; Barbi Pilvre, 'Naiseks olemine laheb jälle moodi' *Eesti Päevaleht*, 9 October 1998.

[35] Barbi Pilvre, 'Feminismi mitu nägu' *Luup* vol. 6, 17 March 1988.

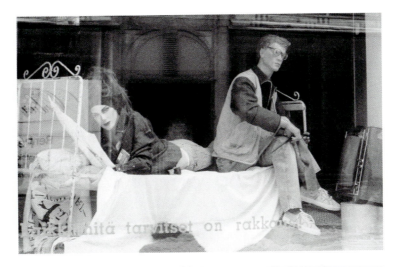

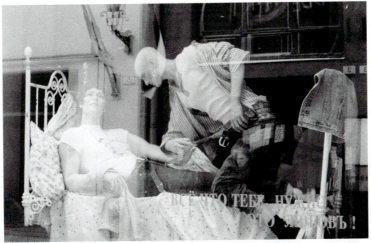

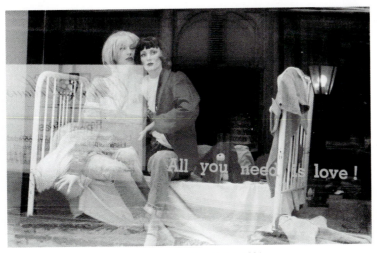

Inessa Josing *Kangur 303*, shop window displays, Tallinn 1996

chapter 4

reading british feminism, art and education

Aoife Mac Namara

[1] Toril Moi, *Sexual/Textual Politics: Feminist Literary Theory*, Methuen, London and New York 1985, p44.

[2] Griselda Pollock, 'Feminism and Modernism' in Roszika Parker and Griselda Pollock (eds), *Framing Feminism: Art and the Women's Movement 1970-1985*, Pandora, London 1986, p93.

[3] Judith Williamson, 'How Does Girl Number Twenty Understand Ideology?', *Screen Education* 40, Autumn/Winter 1981/2, p86.

[4] Aoife Mac Namara, *Producing Subjects: Art, Theory and the Pedagogies of Desire*, Ph.D. Dissertation, Concordia University, Montreal 2000.

Psychoanalysis furthermore informs us that the most powerful motivations of our psyche often turn out to be those we have most deeply repressed. It is therefore difficult to believe that we can ever be fully aware of our own perspective.[1]

Toril Moi

Knowledges of some sort are always mobilised in looking at and understanding what is looked at. This necessary excess baggage shapes the viewing/reading processes. They and the institutional space in which viewing/reading takes place constitute the ground against which a particular configuration of meaning is possible.[2]

Griselda Pollock

I would like to start by saying how and why this essay was written.[3] I first wrote this material as part of a Ph.D. in Art Education.[4] The Ph.D. was concerned with understanding the textual nature of university seminars as events in art education. More specifically, it was concerned with seeing what happened when certain feminist and post-structuralist theories deployed in the analysis of culture through seminar teaching got mobilised - or turned back - on the analysis of the seminar itself. My interest in this project was a long time developing. As a graduate student on the MA in the Social History of Art at the University of Leeds, I spent a great deal of time in seminars where we read and thought about theories of culture, language, ideology, the subject, history, textuality and discourse and where we worked at using these theoretical apparatuses in the analysis and production of culture, particularly visual culture. I spent even more time trying to understand the significance of what I had learned in relation to my practices as a producer and consumer of culture. Being productive and theoretical at the same time is difficult for most of us. Being productive of images and texts in a context where images and texts were constantly subject to critiques launched from an array of equally complex theoretical and political fronts was even more difficult. As Judith Williamson said:

> It is actually quite hard to wrap oneself around both productive and theoretical, deconstructive work at the same time ... one usually takes slight precedence. After a period of learning you need fallow time, as it were, for changes, new approaches, to sink in - and then your transformed understanding informs your productive work, not some external theory you feel you must stick to.[5]

[5] J. Williamson, *op. cit.* p80.

This essay marks the end of a fallow period in my life. The end of the long and difficult process that took me from belligerent, hostile and defensive student, to self-righteous practitioner and on to where I am now; somewhere the approaches to cultural analysis and production, introduced to me via feminism at this time, can inform rather than dictate my productive work, be it as teacher, writer or image maker.

A former art student, I found the experience of being in a situation like this, where I was intellectually challenged on so many fronts, exhilarating. I had joined the course

after finishing an MA in Fine Art because I, like many of my peers at Leeds, had become aware of a serious lack in my art school education, aware of just how limited it had actually been. As is often the way, I had become aware of this lack by chance. Two students on my Fine Art course had come to the programme from non-traditional art school backgrounds: the Conceptual Art pathway at Byam Shaw School of Art in London, and the Joint Honours Fine Art and History of Art at the University of Leeds.[6] These students brought to their studio practice, and our tutorials and seminars, bodies of knowledge and approaches to culture that were at once strange and familiar. Familiar, in that they re-articulated ideas about culture, ideology, society and history that I had come across through my involvement with feminist and left wing politics; strange in that I had never been able to work out how to think about the practice of art in relation to such ideas.

Educated in Ireland and Britain in the late eighties, I was taught by a generation of artists whose sense of what art was made art seem very removed from the culture and society through which I was being produced as a subject in history. My art school teachers had, almost without exception, passed though the British art education system in the late sixties and early seventies - a time when their practices were formed in relation to one form of modernism or another, and where the authority of the individual male producing subject was institutionally unchallenged by feminist or Marxist interventions in the history or practice of art.[7] The circumstances of my colleagues from Leeds and Byam Shaw were, on the other hand, radically different. While our (almost exclusively male) lecturers were attempting to form us as artists in relation to ideas about art, culture and history that understood artists to be self-motivating individuals, self-made and autonomous, my new classmates had been asked (occasionally by women) to think about themselves not as artists but as cultural producers. They were also asked to think about how the work that they were producing in art school was inextricably caught up in a wider social formation of which artistic production was just one part. While I did not fully understand the significance of such a paradigmatic shift in the education of artists, I did realise that if art could be thought of like this, then making art could be about intervention as well as expression. If art could be about intervention in the outside world as well as – or even instead of – the expression of the artist's inner world, then artists should know a considerable amount about the organisation and structure of society.

This was an enormously liberating revelation for me, for, acquiring such knowledge was a tangible project, something I could do without recourse to talent or inspiration. It was a significant departure. My first five years in art school had been coloured by the idea that people were born with – or without – the talent to be artists. You either had it or you didn't. Art school was there not to teach you how to be an artist, but to facilitate one's independent development as one. In this scheme, all failures and difficulties experienced by student artists must be the students' responsibility. Good art students were like good artists: full of lots of interesting ideas, self-motivated in the pursuit of them and creative in their articulation through material processes. Good art students did not need teaching. All natural artists needed was the occasional technical or critical intervention and the artists employed as lecturers and tutors were there to provide it. Looking back at my time at art school, I can now see that what was proposed to us was essentially an

[6] Here I am referring to Jimmy Tse (Byam Shaw) and Chris Riding (University of Leeds).

[7] For a more detailed discussion of art school culture in Britain see Griselda Pollock, 'Art, Art School, Culture' in Jon Bird et al, The Block Reader in Visual Culture, Routledge, London and New York 1996, p51.

[8] Raymond Williams, 'The Romantic Artist' in *Culture and Society*, Chatto & Windus, London 1958.

[9] G. Pollock, 'Art, Art School, Culture' in J. Bird *et al, op. cit.*, p51.

[10] Both Mary Cullen (ed), *Girls Don't Do Honours: Irish Women in Education in the 19th and 20th Centuries*, Women's Education Bureau, Dublin 1987 and Valerie Walkerdine's study on the production of classed and gendered identity in and through early British education ('Sex, Power and Pedagogy', *Screen Education* 38, 1981, pp14-25) provide important insights into the relationship between female art students (and art lecturers) and art school education identified by Griselda Pollock in 'Art, Art School, Culture' in J. Bird *et al, op. cit.* Chandra Mohanty's essay 'On Race and Voice: Challenges for Liberal Education in the 1990s' in Henry Giroux and Peter McLaren (eds), *Between Borders: Pedagogy and the Politics of Cultural Studies*, Routledge, London and New York 1994 further advances this discussion by including in the debate considerations of race, sexuality and nationality.

[11] For an account of the changing position of women in England from the seventeenth century to the 1930s see Sheila Rowbotham, *Hidden From History: 300 Years of Women's Oppression and the Fight Against It*, Pluto Press, London 1973. For an analysis of the gendered production of subjectivity in education see Valerie Walkerdine, 'Sex, Power and Pedagogy', *op. cit.*

[12] G. Pollock, 'Art, Art School, Culture' in Jon Bird *et al, op. cit.*, p51.

idea of the artist developed in Britain in the nineteenth century: what Raymond Williams calls the Romantic Artist.[8] In trying to account for the currency of this nineteenth century idea of the artist in the context of the late twentieth century (and my art education), similarities between this nineteenth century persona and the entrepreneur (the protagonist of Thatcher's Britain and Haughey's Ireland) become manifest. Self-made, self-motivated, independent, autonomous and without need of (or use for) institutional intervention and support, the artist and entrepreneur were equally powerful (and mutually supportive) myths: representations that structured the production of art in this context.

Thinking about the founding myths of art school education in this way helps explain why the art school system in Britain was so notoriously inadequate in accommodating different artistic practices. Despite talk of individuality, what was organised in art schools was an orthodoxy: a conventional idea of "artist as self-motivated competitive individual,"[9] an idea that found support in the free market economy which ordered the consumption and exchange of art outside of college. This system had a very oppressive effect on the education of people who had, by and large, not been socialised as competitive individuals. Women, even the middle class women of my art school generation, were among those not set up to compete in such worlds.[10] Women have largely been educated and socialised to work with other people in the achievement of goals: to support their partners, to work for their children, and, to seek employment in areas where individual success is second to vocational or institutional satisfaction.[11] Few of us had the confidence in our own autonomous projects necessary for the successful negotiation of art school culture. It was into this situation that feminism first intervened in art education. Writing of these early interventions, Griselda Pollock describes her own experience of British art education in the eighties:

> I regularly visit art schools either to give a lecture or as an external examiner and in recent years there has been a recurrent crisis over the assessment of a certain type of art practice. It is usually photo-text, scripto-visual or some such form; it is often sustained in reference to a body of cultural theories; it generally handles questions of gender, representation, sexuality ... Most of the resident staff do not like this work and cannot assess it. (They still try to do so nonetheless.) To an art historian involved in a decade and a half of conceptual art as well as the diverse and substantial feminist practices of that period, such work, if often not brilliant, is recognisable in terms of what it is addressing, what frames of reference are suggested, what work it is trying to do. It is by any criteria assessable.[12]

Here Pollock does two important things. First, she demonstrates the political necessity of the feminist intervention in art education in which her own teaching practice was located. Second, she allows the contemporary reader a way of understanding the historical circumstances for the production of 'feminist' work in and through art education in this country. By subjecting education to analysis as a site of cultural and ideological production, a place where motivated individuals work to produce and reproduce structures of power and knowledge in particular and specific

Pam Skelton *Oneiric traces,* acrylic on canvas, 1988

ways, she emphasises the discursive nature of feminist interventions in visual culture. She also gives a context to it. In this excerpt from her important analysis of art school culture, she does more than acknowledge the conflicts that existed between female students and male lecturers in art schools at this time. She points out that the conflicts were usually staged at the lines between two competing cultural orders: between modernist ideas about the self, individuality and creative self-expression, and structuralist and post-structuralist ideas about the social, textual and discursive nature of production in visual culture. Pollock makes clear that it was not so much the feminist politics of the students that caused conflict *per se*. Rather, what Pollock demonstrates as intolerable to art school culture was the articulation of this politics through practices that theorised the operations of the gendered subject in ideology.

chapter 4

[13] Lisa Tickner, 'Sexuality and/in Representation: Five British Artists' in Donald Preziosi (ed), *The Art of Art History*, Oxford University Press, Oxford 1998, p356.

[14] G. Pollock, 'Art, Art School, Culture' in J. Bird *et al*, *op. cit.*, p51.

[15] Catherine Lupton, 'Circuit-Breaking Desire: Critiquing the Work of Mary Kelly' in John Roberts (ed), *Art Has No History!*, Verso, London 1994, p230.

[16] For an important and critical discussion of the theory/practice problematic in British art school education see Judith Williamson, *op. cit.*; Louise Morley and Val Walsh (eds), *Feminist Academics: Creative Agents for Change*, Taylor and Francis, London 1995; bell hooks, *Teaching to Transgress: Education as the Practice of Freedom*, Routledge, London and New York 1994; Gayatri Spivak, *Outside in the Teaching Machine*, Routledge, London and New York 1993 and Henry Giroux (ed), *Postmodernism, Feminism and Cultural Politics*, SUNY Press, Albany 1991. These are among a growing number of books concerned with exploring questions of feminist (or feminist-influenced) interventions in higher education.

[17] 'Introduction' in Jody Berland, Will Straw, David Thomas (eds), *Theory Rules*, YYZ Books & University of Toronto Press, Toronto 1997.

[18] An example of one such project was the MA Social History of Art programme at the University of Leeds.

[19] 'Introduction' in J. Berland *et al* (eds), *op. cit.*

[20] Terry Atkinson, 'Whence the Interregnum?' in Geoff Teasdale (ed), *Morbid Symptoms*, Leeds Metropolitan University, Sheffield Hallam University and the University of Humberside, Leeds 1993, p9.

Practices that saw art – as a form of representation – first and foremost as ideological; a strategic development which Lisa Tickner suggests was first made possible by "Althusser's reworking of base/superstructure definitions of ideology in favour of the ideological as a complex of practices and representations and, second, by the decisive influence of psychoanalysis (chiefly Lacan's rereading of Freud)".[13] In this way the feminist intervention in art school culture can be seen as a two-pronged attack: challenging the "nature of the discursive exclusion of women from the records we call art history, the effect of which is to celebrate the great and creative as exclusively masculine attributes"[14] on the one hand, while, on the other, constructing for itself a "remarkably self-sufficient and smooth-running mechanism which is very difficult to question or disrupt, without adopting critical positions which this apparatus has already managed to deflect or contain".[15] I am interested in thinking about how these strategies were produced out of the circumstances described above, and, in thinking about the consequences of them for feminist practices in Britain.

The left, feminism and art education have a shared interest – even preoccupation – with the relationship between theory and practice in education.[16] For those of us currently involved in feminist practices in art and art education there are a number of reasons for thinking about the relationship of theoretical enquiry to studio practice at this time. As Canadian theorists Jody Berland, Will Straw and David Thomas suggest in the introduction to their book *Theory Rules*,[17] we are at a point in art education where there are recognisable shifts "in the traditional patterns by which artists are trained and careers unfold", where courses in the feminist and post-structuralist theories of society and subjectivity, which once informed only radical pedagogical projects,[18] have become standard components of art and design curricula, causing the "field of cultural theory and analysis within the academy [to] more and more resemble the market for art, with similar cycles of fashionability and a comparable emphasis on currency and innovation".[19]

Writing of the recent proliferation of such courses in British higher education, the artist and writer Terry Atkinson has suggested that while efforts to "re-establish the supply lines of theory to practice" in the field of visual culture are indeed valuable strategies for those of us interested in doing more with our teaching than using it as an apparatus around which existing orthodoxies get held in place, the current fashionable preoccupation with theory (be it feminist, post-structuralist or whatever) in the academy runs the risk of "being so under-theorised that it ceases to operate as a tool for critical enquiry and moves to being little other than yet another exercise in the affirmation of particular cultural, political and discursive values".[20] It is here, at the intersection of theory with art education in Britain, that the concerns of this essay and Atkinson meet. Following on from his warning, I am interested in thinking carefully about the way feminism is discursively produced in art and art education in this country; in particular I am interested in thinking about Lupton's "remarkably smooth-running mechanism" and how coming face to face with it impacts on practices of actual women.

A project like *Private Views* – where feminism can be seen as one of the determining forces at work in the exhibition – is, in many ways, a good place to begin, not least because the exhibition offers an encounter between artists, audiences and those

feminist theories which have developed in and around the art departments in Britain where artists like Pam Skelton and others have been active in their own work and in the education of students since the eighties. The focus on those feminisms produced in and through the British art school milieu is here an important and purposeful one. It is a decision reached for a number of reasons. Firstly, because historically the vast majority of practising artists (men and women) in Britain have passed – in one way or another – through the formal art education system.[21] Secondly, because these art institutions have produced a particular type of feminist theory and practice; a feminism which has – quite understandably – been forged by women in the countries where feminism had its genesis – the United States, Britain and the colonising countries of Western Europe. A feminism which has built on the experience of women at the end of the last century[22] and which has, according to Irish writer Carol Coulter, emerged from the experience of life in the fifties and sixties[23] in these countries, where "post-war entrenchment forced women back into the home and increased their isolation while at the same time a general rise in the level of prosperity in these countries obliterated the need for collective activities which had in the past offered many women the scope for worthwhile and satisfying pursuits outside the home".[24] As "making culture, like making history, does not take place in circumstances of our own choosing" but rather in "circumstances directly encountered, given and transmitted from the past",[25] understanding how feminism in art education has been produced out of existing historical conditions is central to understanding the nature of feminism as a political and discursive practice in visual culture.

According to Carol Coulter, it was "the stultifying effect of such imprisonment in the nuclear family that provided the impetus for the development of the modern women's movement",[26] a movement with which feminist art and art historical practices in British art departments are inextricably linked.[27] In this way, the focus on a particular feminism, cast in a specific context, has been organised here not to suggest that the experience of all women has been that of imprisonment in the nuclear family where they are cut off from productive work and from "communal interaction with other people, especially other women".[28] Rather, that decision has been reached as a way of acknowledging how - until very recently - the experience of such women has not been part of the discussion of feminism in the British art school milieu.[29]

It is out of these concerns that I became interested in thinking about what happens when 'real' women, located in historically, culturally and geographically specific spaces, find themselves represented in, and through, specific feminist discourses: feminisms within which the material, historical and social circumstances of their lives have not been adequately considered. This idea of production through (and in) representation is what links this trajectory with the opening problematic, namely, the relationship between theory and practice in visual culture and, even more particularly, the relationship between theory and practice in art education.[30] It seems important to consider this, for if the production of meaning in visual culture intersects with theory - and in this instance I am looking at feminist theory - then it is important to account for feminism's relation to the structures of economic, social and political power in the education of artists. Not doing this, I suggest, can lead to an under-theorisation of feminism itself. And, in turn, this under-theorisation runs the risk of voiding feminism of its critical and radical potential as a framework around

[21] For an influential analysis of the relationship between schooling and subjectivity see Louis Althusser, 'Ideology and the Ideological State Apparatuses (Notes Toward an Investigation)' in Lenin, Philosophy and Other Essays, trans. Ben Brewster, Basil Blackwell, Oxford 1971, pp121-173. See also Pierre Bourdieu and Jean-Claude Passeron, Reproduction in Education, Society and Culture, Sage, London 1990.

[22] For a discussion of feminism and modernity in the nineteenth century see Griselda Pollock, 'Modernity and the Spaces of Femininity' in Vision and Difference, Routledge, London and New York 1988, pp50-90. For a discussion of feminism in early twentieth century Britain see Sandra Stanley Houlton, 'In Sorrowful Wrath: Suffrage, Militancy and the Romantic Feminism of Emmeline Pankhurst' in Harold T. Smith (ed), British Feminism in the Twentieth Century, Edward Elgar Publishing, Hants 1990, pp7-25.

[23] For an interesting enquiry into post-war experiences of feminism and the women's movement see Mary Kelly, Interim Part III: Historia (1989) Oxidised steel, silk-screen, stainless steel on wood base, 24 units, 152.5 x 90 x 72.5cm each. Collection McKenzie Art Gallery, Regina, Sask., Canada. See also Caroline Steedman, Landscape for a Good Woman, Virago, London 1989.

[24] Carol Coulter, 'Tradition in the Service of Resistance' in The Hidden Tradition: Feminism, Women and Nationalism in Ireland, Cork University Press, Cork 1993, p40.

[25] Karl Marx, 'Introduction' in Grundrisse, trans. M. Nicolaus, Allen Lane, London 1973.

[26] C. Coulter, op. cit., p41.

[27] For a discussion of the relationship between the women's movement, art and art education in Britain and the USA see Coulter, op. cit.

[28] Ibid., p42.

chapter 4

[29] Lubaina Himid cited in Griselda Pollock, 'Painting, Feminism, History' in Michèle Barrett and Anne Phillips (eds), *Destabilizing Theory: Contemporary Feminist Debates*, Polity Press, Cambridge 1992, p166.

[30] See J. Berland *et al*, *op. cit*. and J. Williamson, *op. cit*.

[31] T. Atkinson, *op. cit.*, p8.

[32] J. Williamson, *op. cit*., p87.

[33] For an extensive and detailed discussion of the idea of ideological state apparatuses see L. Althusser, *op. cit*.

[34] G. Pollock in Jon Bird *et al*, *op. cit*, p54.

[35] *Ibid*.

[36] *Ibid*.

which interventions in cultural production and analysis can be staged. Worse still, under-theorised feminism in art education might, according to Atkinson's logic, find itself operating as "little other than yet another exercise in the affirmation of particular cultural, political and discursive values"[31] – those very values against which it was originally mobilised.

In her 1981 essay 'How Does Girl Number Twenty Understand Ideology?', Judith Williamson anticipates some of Atkinson's concerns with theory and practice as they play out in actual educational contexts. "Do we or do we not believe all our theories about the positioning of the subject through ideological and social formations?" she asked the readers of *Screen Education*. "Because if we do we have to recognise that what we teach is precisely relevant not only to the students' experience of life in general, but to their experience of our teaching, and that our own way of teaching is an ideology equally affected by our experience of teaching them."[32]

Teaching is one of many practices operating in the institution of education, and education (like the family, law, religion, culture and communications)[33] has, as Griselda Pollock reminds us, "been named as one of the major ideological state apparatuses - this is, not just a place of learning but a place where, as in the family, we are taught our places within a hierarchical system of class, gender and race relations... a vital site of social management."[34]

Taking this seriously means we must also take seriously the idea that we are, through our teaching, working to position ourselves and our students in existing systems of social, political and economic order and that this experience will be – for at least some of our students – as oppressive as it is liberating, even if this teaching is done in the name of feminism.

Writing in the book *Feminisms and Critical Pedagogy*, Carmen Luke builds on this early work and suggests that if "repositioning women from the periphery to the centre of social analysis is a central task for feminist theorists, regardless of disciplinary perspectives and theoretical standpoints",[35] then those of us interested in working towards the accomplishment of that task, must think about extending our research so that it goes beyond what she broadly describes as "the deconstruction of 'master narratives'" and extends to the analysis and deconstruction of our own historically located teaching practices. Doing this, it is suggested, would go some way towards ensuring that feminism does not fall prey to the fate suggested by Atkinson, for if "pedagogical encounters and pedagogical texts" can be read "both as a politics of signification and as historically contingent cultural practices"[36] we need to guard against unwittingly reproducing relations of domination through the *practice of theory* in culture and education.

If the encounters staged by artists and academics in education, between feminist theoretical propositions and visual culture, can be read as the practice of a historically located cultural politics, then it becomes important to think historically about the internal problems that accompany the practice of feminism in these specific contexts.

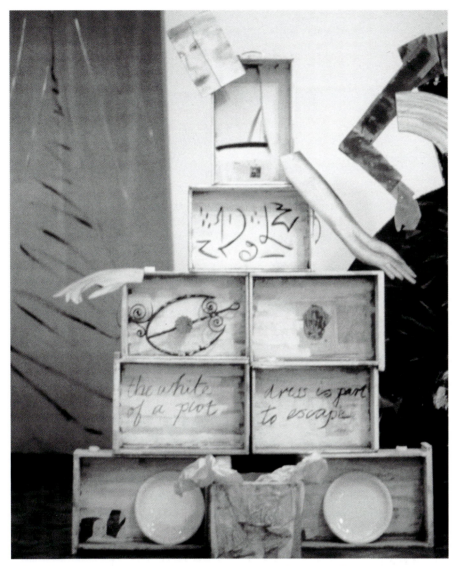

Lubaina Himid *Eager Listener,* from the installation *A Fashionable Marriage,* installation view, 1986

Here Catherine Lupton's discussion of the work of Mary Kelly, cited earlier on in this section, is worth reconsidering. In this essay Lupton looks to account for how Kelly's work has achieved "a high profile status in the art world through its theoretical commitments"[37] and considers how these commitments have led not only to the critical success of Kelly's practice but also to it being perceived "by sections of the feminist art community as part of the problem".[38] Lupton's suggestion, that the theoretical self-sufficiency of Kelly's practice is perhaps part of its problem, may offer those producing practices in education a useful word of caution about the relationship between students and the educational situation within which they are produced: "My broad hypothesis is that the discursive apparatus which exists around 'Mary Kelly' is, within its own terms of reference, a

[37] John Roberts, 'Introduction' in J. Roberts, *op. cit.*, p24.

[38] C. Lupton, *ibid.*, p239.

remarkably smooth running mechanism which is very difficult to question or disrupt, without adopting critical positions which this apparatus has already managed to deflect or contain".[39]

[39] *Ibid.*

[40] *Ibid.*

Lupton accounts for the specific nature of Kelly's practice by looking at how it was formed out of specific historical circumstances and "at the conjunction of certain paradigmatic moments in the history of second wave white Western feminism and its encounter with certain varieties of post-structuralist and critical theory":[40] those same circumstances described by Pollock as the conditions of feminist intervention in art education.

While the achievements – artistic, political and discursive – of Kelly's practice are well documented, less is understood about how, and to what effect, such work has been used in art education. Lupton's analysis makes significant and politically important headway in this project and allows a way for thinking about such feminist practices, not just as the historically and politically necessary articulations of educated middle-class women in British art and design, but as what Carmen Luke calls 'feminist regimes of truth' in higher education. Drawing on the work of people like bell hooks, Lubaina Himid and Chandra Mohanty, Luke is concerned with what happens when practices such as Mary Kelly's are used metonymically in education, to stand in for feminist practice *tout court*. How, they ask us, do we represent feminism through our teaching? What subject positions are offered to our students as feminist points of identification? What practices get produced in and through our teaching, and how can we account for them? What theoretical and discursive apparatuses do we construct as mechanisms for the facilitation of practice in and through our teaching? How can we deploy the work of women artists like Mary Kelly, but do it historically, in a way that does not deflect or contain critical positions which may be adopted by our students in relation to it?

The success of the discursive intervention in visual culture, launched in Britain by artists like Mary Kelly and Yve Lomax and historians such as Lisa Tickner and Griselda Pollock, has had many and far reaching impacts on the art community here. The strategies deployed by these artists/writers and their attention to Lacanian psychoanalysis and post-structuralist ideas about representation, language and textuality soon became the 'official' practices of second wave feminism in Britain. The work of these artists and writers facilitated an exciting and intellectually challenging interrogation of the relationship between subjectivity, ideology, representation, sexuality and pleasure - a project that was as politically necessary as it was ambitious. Yet the project had more sinister outcomes than these. Faced with a compelling and theoretically reinforced idea of feminism in visual culture, an idea that privileged practices that were engaged in the deployment of certain material or theoretical practices, feminist artists who were working as painters to articulate and produce different experiences of femininity, found themselves critically and institutionally isolated. Black women, women from post-colonial countries, lesbian and working class women who did not identify with that experience of femininity articulated by the educated women of the feminist vanguard in British art and art education, found ourselves at the margins of, rather than embroiled in, the discussion of feminism in art and art education, albeit in critically different ways.

However, as in other 'difficult' situations, the encounter between Britain's white-educated and middle class feminists and artists and student artists from different historical locations has proven to be a worthwhile and productive one. It has been an encounter that has facilitated the production of new work, forged in relation to this moment of feminism, but also in relation to theories of culture, language and representation organised in (and by) different intellectual and political traditions: from colonial and post-colonial theory, oral history and cultural studies to art practices like painting and performance that continued to resonate in many communities. It was apparently a situation that conceived the production of a work like Lubaina Himid's *Fashionable Marriage* (1986),[41] a work that invited feminist producers and consumers of visual culture to think about feminist art practices as historically and discursively produced, and to think about the production of them in ways not necessarily prescribed by the practitioners themselves.[42]

But perhaps Himid's invitation is more difficult to take up than it may seem, for the majority of practising artists in Britain, feminist or otherwise, have been through formal art education, and in education they will have encountered teachers, many of whom were directly involved in the feminist interventions in British visual culture discussed here. As teachers, we should never underestimate what Judith Williamson has called the "flattering sense of power and superiority" that comes with being a teacher. For feminist teachers (in often anti-feminist institutions) this can be an even more compelling position as we look back over the struggles and obstacles we have surmounted on the way to these positions.[43] The power of being a teacher of art students is an enabling and intoxicating one, and, if deployed in certain ways, can make it difficult for students to think about working in a way that is appropriate for them, instead of trying to meet the (albeit often implicit) expectations of the teacher. It takes a courageous and theoretically sophisticated artist to construct a response to the feminist practices discussed here. Producing a work like Himid's will be outside the reach of many students, who (in the context discussed above) often struggle to produce work they think they should make rather than work they want to do. This can be in the form of practical studio work, spoken responses in seminars, presentations or essays. Williamson suggests that we need to be wary about dogma in teaching. For those of us caught up in a political project such as feminism this is not always easy. "Dogmatically taught theory", she suggests, "always comes out in affected or uncomfortable practical work - often done under a sense of ought, rather than think, feel or want. And teachers should never underestimate the 'oughtness' which surrounds them as a teacher even before they open their mouths".[44]

As teachers working in a field as carefully and rigorously shored up as that of feminism, such as it has operated in the fields of art and art education, we could do worse than attend to lessons learned from the experience of our colleagues in related fields like Women's Studies, where it has been suggested that a way of avoiding the 'oughtness' Williamson speaks of, might be for us "to be extremely sensitive to any gaps between (our) theory and (our) pedagogical practice".[45]

Chandra Mohanty is one among many teaching feminists concerned with bridging the theory/practice divide in and through pedagogy. Mohanty proposes a form of theory in practice that can take feminist, post-structuralist and post-colonial positions and

[41] Lubaina Himid's installation *A Fashionable Marriage* is discussed by G. Pollock in M. Barrett and A. Phillips, *op. cit.*

[42] Both Victor Burgin and Mary Kelly are examples of such practitioners. For an interesting approach and related discussion of Victor Burgin see Jessica Evans, 'Victor Burgin's Polysemic Dreamcoat' in J. Roberts (ed), *op. cit.* See also Mary Kelly, *Imaging Desire*, The MIT Press, Cambridge, Mass. 1997 and G. Pollock, 'Screening the Seventies' in *Vision and Difference*, *op. cit.*

[43] See Himani Bannerji, Linda Carty, Kari Dehli, Susan Heald, and Kate McKenna, *Unsettling Relations: The University as a Site of Feminist Struggles*, Women's Press, Toronto 1991.

[44] J. Williamson, *op. cit.*, p86.

[45] Jane Kenway and Helen Modra, 'Feminist Pedagogy and Emancipatory Possibilities' in Carmen Luke and Jennifer Gore (eds), *Feminisms and Critical Pedagogy*, Routledge, London and New York 1992, p160.

chapter 4

[46] Here I am referring to Williamson's essay 'How Does Girl Number Twenty Understand Ideology?' p87 where she talks specifically about the relationship between teaching and theory in media education: "If you are teaching radical things, this position of power seems to become, nowadays, suspiciously ideologically sound. But I sometimes suspect that theoreticians' sense of rightness comes precisely because they teach, and are so much in a situation where whatever they say is going to be 'right', since they are the teacher with the power: it's right because they say so".

[47] Following the Brazilian critical pedagogue Paolo Freire, Mohanty, like bell hooks, has engaged with radical educational projects which theorise or propose all education "as the practice of freedom".

[48] C. Mohanty, op. cit., pp154-155.

[49] G. Pollock, 'Feminism and Modernism' in R. Parker and G. Pollock, op. cit., p88.

[50] Abdul R. Janmohamed, 'Some Implications of Paolo Freire's Border Pedagogy' in H. Giroux and P. Mc Laren, op. cit., p245.

[51] bell hooks, Ain't I a Woman. Black Women and Feminism, South End Press, Boston 1994, p5.

[52] G. Pollock in J. Bird et al, op. cit., pp50-67.

use them, not to construct for ourselves positions of "ideological soundness"[46] from which to teach, but as elements of a pedagogical practice structured with political and theoretical rigour. Mohanty suggests that the practice of such a pedagogy can be theorised as the practice of decolonisation.[47] Like Williamson, she insists that this sort of teaching practice requires that we take seriously the logic of different theories (and cultures) as they are located within asymmetrical power relations: situations where as teachers (feminist or not) we do have a power and authority in the discursive and pedagogical field, a power that is not enjoyed by our students. For Mohanty, this sort of feminist teaching

> involves understanding that culture, especially academic culture, is a terrain of struggle (rather than an amalgam of discrete consumable entities). And finally, within the classroom it requires that teachers and students develop a critical analysis of how experience itself is named, constructed, and legitimated in the academy. Without this critical analysis of culture and of experience in the classroom or art school studio, there is no way to develop and nurture oppositional practices. After all, critical education concerns the production of subjectivities in relation to discourses of knowledge and power.[48]

If feminism in art and art education is related (as we know it is) to existing social, institutional and discursive powers, we cannot expect it to operate as an ahistorical and apolitical framework; we cannot expect all women who are students, of all cultures, holding all sorts of political convictions and from every class background, to work in a consensual way towards some singular project. Rather we might well learn from people like Himid, Mohanty and Williamson and look at what is being implicitly, as well as explicitly, demanded by our teaching. If we (as many feminists do) believe that "the project of the Women's Movement is the transformation of all practices and institutions which perpetuate the subordination of women"[49] and if we encourage students to develop critical practices that consider the conditions of their production as gendered subjects in language, discourse and history, then are we not also implicitly persuading "them to study the power relations that define their current and future identities"?[50] As bell hooks has commented, that while feminist and women's studies programmes in higher education may not always have been "eager to nurture any interest in feminist thinking and scholarship on the part of black female students if that interest included critical challenge"; they remained, however, "the one space where pedagogical practices were interrogated, where it was assumed that the knowledge offered students would empower them to be better scholars, to live more fully in the world beyond academe. The feminist classroom was the one place where students could raise critical questions about pedagogical process".[51]

In this context, artwork like Lubaina Himid's, work that is both produced by and productive of the conflicts in the feminist art community in Britain, can be read not as the nemesis of this feminist intervention, but as a testament to its success. Work like Himid's helps us map the places from which real, materially and historically located women have operated in Britain, not isolated in a community of women, or cloistered in art schools, but as active cultural producers "in the social synthesis of which cultural producton"[52] is just one part.

revolting 90s in estonian art

Katrin Kivimaa

[1] Hasso Krull, 'Feminism and the Estonian Community', *Est.Fem*, exhibition catalogue, Tallinn 1995, p9.

In the catalogue of *Est.Fem*, probably the first exhibition attempting to set the terms for the articulation of a feminist practice in Estonian art, the literary critic and poet Hasso Krull stated that "feminism is a scandal for the Estonian intellectual; it makes little difference whether this intellectual is male or female".[1] Today, when looking back at the artistic events of the past four years or so, there emerges a problem of definition: how is Estonian feminist art to be defined outside its parochial framing as a 'scandalous' attitude - a view expressed in the general-interest media and the art press alike? In other words, what is, or can be, a feminist practice in Estonian art, irrespective of what has already been categorised, and consequently attacked, as such during the first efforts to introduce a feminist problematic to the field of visual arts?

In Estonia, the contested reception of feminist art (whatever this term may encompass) has been shaped by the overall hostility towards feminism itself which, in the first place, has been understood as a 'hatred of men' and as 'the spoiling of our nice women with these foreign ideas'. Even though certain questions posed by feminism have found their way to the field of cultural production, the position of feminism *per se* remains contested. So far, feminism as a politics addressing sexual difference in practices of representation has been granted only marginal visibility. For the dominant voices of art criticism in Estonia, the word 'feminist' is interchangeable with 'second-rate'.

The marginalisation of gender discourse in the visual arts is not accidental. The reasons for the misrepresentations of feminism in general, including feminism in the arts, are complex and diverse, and their concrete analysis lies well beyond the scope of this study, which remains a tentative exploration of the issues involved. Part of the problem has to do with the structure of the art system itself. On one hand, most artists have been trained to consider the concept of gender irrelevant to so-called artistic creativity; on the other hand, (some) critics are in a position to actively oppose an understanding of art as a gendered practice. It is precisely the lack of sustained theoretical analysis, which allows the perpetuation of blatant prejudice in the treatment of that part of Estonian art which takes feminist politics on board. The way the art system is shaped has everything to do with Estonian history and the current conditions of social existence. The controversial status of feminism in art practice can best be approached through more general arguments put forward in the course of the debate on the necessity, or otherwise, of feminism in Eastern Europe.

Although marginal, the feminist problematic in art has received a certain amount of attention which deserves to be examined separately from the interest generated by its purported 'scandalous' image. The question to be asked now is to what extent, and in what way, feminism has influenced the perception of art in contemporary Estonia. I would claim that feminism's greatest impact on the Estonian art world (and on Estonian society in general) lies in the introduction of specific topics, diverse

perspectives and ways of seeing, as these emerged in the context of ensuing debates. Feminism's attendance to conflicts in the field of vision as a gendered space has been a major breakthrough despite the fact that this articulation has been non-programmatic to this day. Such shifts in our understanding of how gender is implicated in artistic practice could not have been immediate. Structural inequalities in specific societies are rarely visible at first sight; that is why it is still so difficult to answer the questions, 'what does it mean to be a feminist artist and make feminist art in Estonia today?' and, 'is there feminist art in Estonia at all?'

is there feminist art in estonia?

The emergence of a feminist problematic in Estonian art is necessarily linked to the profound social changes the Soviet Union and the post-socialist regions underwent in the late eighties and early nineties. In fact, the visual arts were among the first areas in Estonian culture where a feminist standpoint became manifest openly and persistently, if not consistently. How women's roles had, up to that moment, been conceived within Estonian culture and art had a decisive effect on the forms of intervention pursued during the first attempts to introduce a feminist agenda that would attend to the specific historical conditions. For instance, women were not altogether excluded from being artists or from being critics and curators. Many of them have occupied, and still do occupy, important positions in various art institutions. This fact, however, was used against feminism in the early nineties: since Estonian women had already been powerful to some extent, the argument was that feminism, as a politics foreign to the needs of Estonian culture, had nothing to offer. Yet talking about Estonian women in terms of power was a false generalisation, as differences among Estonian women were not taken into account. That Estonian society was, and still is, a gendered society was conveniently ignored. What gender difference entailed and how feminine and masculine subjects were shaped became legitimate questions only within the frame of feminism.

At the same time, the presence of a large number of women in the art world was perceived as potentially harmful: it threatened to lead to the 'feminisation' of art. This was pointed out by both male and female artists as well as critics, without them realising how this perception relied on traditional assumptions about the nature of women's art and the identity of women artists. So-called feminine arts such as the applied arts, graphic arts or water-colour painting were found to be more 'appropriate' for women. The participation of large numbers of women artists in the art world was, and still is, based on their engagement with these particular practices. Both the choice of medium and subject-matter by artists and interpretative models developed by critics were largely dependent on traditional notions of masculinity and femininity and their supposed 'expression' in art.[2] And this despite the fact that certain women artists sought to locate their practice within the modernist frame of a presumably gender-neutral, universal artistic idiom. Significantly, while the emphasis on traditional female roles formed part of an official iconography, it also developed as a reaction to 'images of equality' (such as working women) which also belonged to the official visual language based upon the ossification of certain ideals in the Soviet regime.

[2] Regarding subject matter, it should be stressed that this did not necessarily entail so-called 'feminine' themes (e.g. mother and child, female activities, etc.). Many graphic artists, for instance, chose to explore fantasy and represent a supposedly shared female unconscious. Nevertheless, representations of a mythical or enigmatic female psyche ultimately seemed to affirm, rather than subvert, the prevalent patriarchal notion of femininity and the presumably essential attributes of female subjectivity.

chapter 5

An artistic practice effecting a critique of gender relations had no place in Soviet society, where the feminist movement was rejected as a bourgeois phenomenon. In the Estonian art world, the development of a so-called 'pure' art served as an oppositional alternative to state ideology and its commitment to a particular type and understanding of politics. It was convenient to dismiss the emergence of feminist thought in Estonia as a mere transcription of Western ideas. At this point, then, the task of the feminist critic is to undertake an analysis of critical artistic practices which focus on issues of gender and sexual difference; to explore the conditions of these practices' emergence at this particular moment in Estonian history; to pinpoint their characteristics; and, finally, to claim them as an organic part of Estonian culture in a way that prevents their marginalisation as something alien and imported from the West - which is how they have been presented up to now.

There is perhaps no point in questioning the crucial influence of Western feminism in making and writing about art from a feminist perspective in Estonia today. The first feminist exhibitions arose either from debates about feminism and the possibility and/or necessity of feminist art in Estonia, or from collaborative projects with Nordic artists. Feminist thought, as a relatively coherent set of ideas occupying a specific position in the academy, was brought into Estonia (as well as in the whole post-Soviet world)[3] from the West. However, there were local responses – despite the considerable difficulties of translating a Western way of thinking into a different context and/or resisting the overwhelmingly hostile media discourse.

[3] The history of the emergence and presence of a feminist/gender approach differs in each field and from country to country. Thus it is difficult to generalise about the ex-Soviet area as a whole but many ideological, social and cultural patterns seem to be similar.

It is evident that the efforts to introduce feminist thought into Estonian culture have only been partly successful. This is the case with, for example, art and art criticism. Although feminism has claimed a space, many women artists dealing either directly or indirectly with issues of gender still do not wish their practice to be connected with the traditions of feminism. The fact that feminism has been caricatured as a polemic stance, an aggressive politics and a scandalous attitude of no further consequence to the development of art 'proper' has been crucial in this respect. Moreover, at this particular historical juncture, when the idea of art as individual expression is being reinstated in Estonia (and perhaps elsewhere), many artists wish to avoid any kind of labelling; yet the reaction to the label 'postmodernist' or even 'postfeminist' is different from the reaction the label 'feminist artist' normally sparks. Feminism's partial acceptance also has to do with the distrust of certain political movements (for instance any leftist or radical movement, including feminism) currently characterising all post-socialist regions. There is an insistence on the separation of art from the social and political spheres, a separation which admittedly implies a rather limited understanding of what the term 'politics' can encompass. The myth of the artist as an autonomous creator operating beyond social and cultural constraints appeals to many Estonian artists today. According to this view, art has to engage with the universal and not the particular. Feminism appears dangerously ideological and, therefore, 'limiting'.

Since nowadays it makes sense to talk of feminisms rather than feminism, it is difficult to determine what kind of feminism we refer to when examining the situation in

Estonia. The difficulties in applying Western theory to local practice are obvious in the case of visual art practice at its intersection with feminism. If we choose to see feminist art as a practice developed within the confines of a movement, one based on a politics shared among women (when the latter are regarded as a social group), then there is hardly any feminist art in Estonia. This does not mean that certain experiences are not shared by large numbers of women, but, nevertheless, these have not led so far to a sense of belonging to a social and/or political group. Again, how politics is defined is crucial at this stage. As already mentioned, the idea of 'art as politics' is currently profoundly problematic for the Estonian people, especially when it involves 'in-your-face' attitudes. At this precise moment in the history of Estonian culture, personal experience finds expression in a form of individualism opposed to any collective identity.

Yet the increasing number of group and one-woman shows which engage with feminism or critically deal with gender issues points to the existence of what is usually referred to as feminist art in Estonia. This scene is very much defined by specific art events, including exhibitions explicitly conceptualised as feminist. Individual initiatives have not, however, resulted in the formation of a network of artists and critics negotiating the conjunction of feminism and artistic practice in Estonia. Most of the women artists who deal with gender issues are very loosely connected; contacts among feminist artists often develop through participation in theme-based exhibitions introducing a feminist perspective. This is why curatorial policies can currently be so important for the development of a critical feminist practice in Estonia.

Only a handful of Estonian women artists, such as Tiina Tammetalu or Mare Tralla, have chosen to identify themselves as feminist artists in a consistent way. Yet there are many others who have participated in feminist exhibitions and who incorporate questions of gender and sexual difference in their practice. Their repudiation of the label 'feminist' has more to do with the reasons given above, and especially with the overall reaction to the image of feminism in Estonian society, for the issues they deal with could only have emerged in the context of a feminist enquiry. Thus, a possible basis for the definition of a feminist and/or gender-conscious art in Estonia could be subject-matter, which corresponds to the idea that feminist art should be, in the first place, for and about women. Nevertheless, whether we are entitled to call feminist every kind of art made by women on women's issues is moot.

Besides being an affirmative practice in terms of women's creative potential, feminist art remains, for some, committed to the deconstruction of patriarchal ideologies, structures, images, and so on. As put by the Western feminist theorist Griselda Pollock, feminism in art "signifies a set of positions, not an essence; a critical practice not a doxa; a dynamic and self-critical response and intervention, not a platform".[4] As will become clear in the following discussion of specific artworks, this self-critical and multi-faceted approach is quite new to Estonian feminists. Although such a practice can be said to exist to a limited extent, it is difficult to define Estonian feminist art as a primarily disaffirming practice, since such a definition would exclude too many artists working with issues of gender and contributing to the debates. In some cases, however, it is possible to distinguish between a self-consciously political

[4] Griselda Pollock, 'The Politics of Theory' in G. Pollock (ed) *Generations and Geographies in the Visual Arts: Feminist Readings*, Routledge, London and New York 1996, p5.

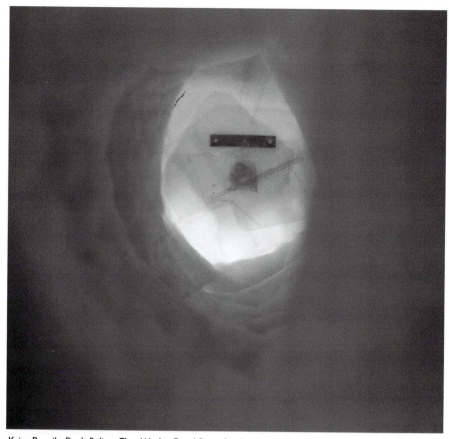

Kaire Rannik, *Don't Believe That We Are Equal Since Our Inside Is Different,* installation, detail, *Est Fem*, Vaal gallery, Tallinn 1995

feminist practice and art which takes account of gender difference. In short, critical art by women who do not call themselves feminists can also be seen as a response to the debates instigated by feminism.

The following overview includes both artists who claim to be feminists and those who do not position themselves very clearly in this respect, or who want to be situated outside the dichotomy feminism/anti-feminism. The presentation will be a largely chronological mapping of the development of Estonian feminist and gender-conscious women's art as landmarked by group exhibitions - four to this date. The first two, *Kood-eks* (1994) and *Est.Fem* (1995), effected the first feminist challenge to the conventions of the Estonian art world. They were followed by a period of personal statements in which questions about gender were rendered more visible and became gradually integrated into artistic practice. This was when questions about gender and difference began to inform works not commissioned for specific shows. The importance of group exhibitions was foregrounded again in 1998, when *(Meta)Dialogue* and *Private Views* reopened the discussion around the meanings and purpose of feminist art in Estonia.

feminism and subject-matter

To Estonian feminist artists, Western feminism offered (and still does) both a theoretical background and a tradition of interventions in artistic practice. By the end of the eighties both seemed to be characterised by the essentialism versus anti-essentialism debate - whatever form this debate took in different contexts. Although these two axes of feminism, namely so-called essentialist or celebratory and theory-based or deconstructive practices, are present in Estonian feminist and women's art, the first approach, postulating a shared female identity based on the presumed biological, cultural, or social unity among women, was the one mostly taken up by Estonian artists. Specific artworks illuminate how these concepts have been transposed and reinterpreted within an Estonian context. However, the step from claiming a shared female consciousness to defining women as a social or political force (in a broad sense of the word) was not taken. The idea of female power has so far signified in terms of personal fulfilment and only rarely in terms of a collective identity and struggle.

The first feminist exhibition in Estonia was the Swedish-Estonian collaboration *Kood-eks (Code-Ex)*, held in Tallinn in the autumn of 1994. Estonian art was represented by Karin Luts (1904-1993), an established woman artist from the period before World War II, and by two contemporary women artists, Epp-Maria Kokamägi and Anu Põder. Since then, a gap has opened between 'active' and 'passive' approaches within the discourse of feminist Estonian art. Curator Reet Varblane argued that, while the Swedish artists propagated a standpoint of 'active' engagement with social issues, the Estonian artists' works remained primarily concerned with aesthetics, while still allowing for feminist readings.[5] The Swedish artists offered to the Estonian public for the first time a genuine feminist critique in the field of visual art, while Kokamägi dealt with self-representation in terms of a mythological female imagery. Põder also based her project on a particular notion of femininity, trying to uncover the hidden strength of women, generally considered physically weaker than men.[6] (Anu Põder's more recent body-sculptures, made out of articles of clothing, can be read as a critical enquiry into the socialised female body which is turned into the sign of femininity *par excellence* - in this case through the use of garments. Parts of the fabric were arranged so as to reveal sewing patterns which referred back to an 'ever-female' occupation - sewing.)

Retrospectively, it seems that the exhibition *Kood-eks*, though important at that moment, held mostly a symbolic significance: it provided a first point of reference for the further development and the opening up of the debate. It was then that the term 'feminism' entered the Estonian art world and art press.

The project *SHOP* (December 1994 to January 1995) developed by Kai Kaljo, Ann Lumiste and Tiina Tammetalu deserves to be mentioned. In Tallinn City Gallery the artists recreated the environment of a typical slum apartment inhabited by their alter egos in the form of rag dolls, invoking memories of their troubled childhoods. Autobiographical narrative, conjuring up childhood memories and present reality, features regularly in the art of many Estonian women artists. In this context, a documentary approach appears to be frequently inflected by idealising tendencies.[7]

[5] Reet Varblane, 'Introduction' in *Est.Fem op. cit.* p7.

[6] *Ibid.*

[7] On autobiography in contemporary Estonian art see Reet Varblane 'Autobiograafia - üleminekuaja laste-haigus või sotsiaalse kunsti võimalus?' ('Autobiography: An Infantile Disease of the Transition Period or a Possibility for the Development of Social Art?') in *Changes in Art and Understanding It: Materials of Autumn Conferences of TUA and Estonian AICA, 1994-1995*, Proceedings of Tallinn Art University No.4, Tallinn 1996, pp39-44.

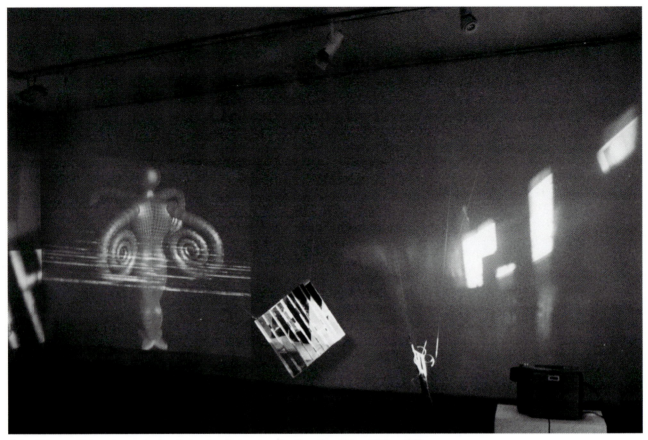

Raivo Kelomees *Animus*, interactive installation, installation view, *Est. Fem*, City Gallery, Tallinn 1995

[8] According to Griselda Pollock, "to define oneself as an artist without the qualifier 'woman' is to repress the important and desirable fact of being a woman. To be labelled a woman artist is to be placed in a separate sphere where only gender matters, where gender is assumed biologically to determine the kind of art that is made". Griselda Pollock, 'Feminism and Modernism', in Roszika Parker and Griselda Pollock (eds), *Framing Feminism: Art and the Women's Movement 1970-85*, Pandora, London 1987, p87.

[9] Esther Zhesmer, 'The First Feminist Art Exhibitions in the USSR', *Heresies/idiomA: Bilingual Russian/ English Edition*, vol.7, no.2, Issue 26, 1992, p65.

As signifiers of what it means to live as a woman, the remains of everyday life were exhibited by Tiina Tammetalu in her show, *Cultural Sushi* (1995). She documented her life as structured upon the opposition of being a woman and a woman/artist. This historically embedded opposition, also experienced by Western women artists,[8] is one of the central dilemmas faced by contemporary women artists in Estonia. Describing the situation during the nineties in Russia, Esther Zhesmer points out that women artists have 'either to be considered second-rate men (a standard compliment being that one is a woman artist [but] possessing the heart/wisdom/logic of a man) or to drop out of the context altogether'.[9] Research has not so far attempted to demonstrate that Estonian women artists have had to face a similarly hard choice. Nevertheless, the partial reception of their art, based on the conventional dichotomy between 'masculine' and 'feminine' art forms, implies precisely that. A woman artist may still be labelled masculine or, at least, be characterised as non-feminine if she chooses to 'express' herself in a way 'inappropriate' for a woman. In her exhibition, Tiina Tammetalu turned her paintings towards the wall.

The connections between the project *SHOP* and the video *Loser* (1997) by Kai Kaljo can be easily grasped. *Loser* offers perhaps the most poignant commentary on the

status of being a woman and a woman artist in post-socialist society. A short and witty autobiographical video piece, *Loser* consists of half a dozen phrases infused with self-irony and accompanied by background laughter, as in a TV sitcom. The artist tells the viewers her age, weight, and marital status - the data on the basis of which women are usually assessed. She then informs her audience of her profession (Estonian artist) and the ridiculously low salary she is paid in the Estonian Academy of Arts where she works. This piece was part of *Interstanding 2*, the fifth annual exhibition organised by the Estonian Soros Center for Contemporary Art. Yet Kaljo also attempted an intervention in media spaces outside the art world. *Loser* was shown on several TV channels between commercials.

Est.Fem, the group show that in a way summarised the issues and put into perspective the tendencies of feminist art in Estonia, took place in August 1995 in several galleries around Tallinn. Curators Eha Komissarov, Reet Varblane (both these art critics have contributed to introducing feminist ideas into Estonian culture) and Mare Tralla (who was to become an emblematic figure of the Estonian feminist art scene) undertook the task of setting the terms for a focused feminist critique in the context of a relatively conservative society which appeared reluctant to revise its deeply embedded patriarchal values. *Est.Fem* was very much prompted by the desire to challenge the negative predisposition towards feminism in Estonian society - which had so far known feminism neither as a grass-roots movement nor as a radical theory leading to groundbreaking academic research. The aim of the exhibition was to offer the general and specialist public an overview of the directions taken by feminist artists in Estonia; the emphasis was on education rather than a radical critique. This perspective can perhaps explain why challenging and ironic works like Tralla's *So We Gave Birth to Estonian Feminism* or Kaire Rannik's installation *Don't Believe That We Are Equal Since Our Inside Is Different* lost something of their poignancy in the context of more conventional approaches.

Yet some young artists ventured to criticise the existing patterns and stereotypes of femininity. Piia Ruber presented the female 'words of wisdom' addressed to a young girl, comprising instructions on how to become a 'real' woman; Piret Räni documented the process of becoming an 'ideal' woman. Could 'real' and 'ideal' mean one and the same thing in this case? Both projects were especially relevant at the moment when a new cult of the real/ideal woman (either home-made Estonian mothers or imported Barbie dolls of standard measurements) was gaining ground in Estonian society. Overall, the organisers of *Est.Fem* tried not to alienate the audience with shock tactics and chose not to stress the subversive impulse of many of the works, but even this effort was not fully appreciated. The necessity of a feminist agenda in Estonian art was still disputed, especially by male critics.

Things have recently become more complicated, given the tendency to refer to artistic practice concerned with gender in terms of postfeminism. Introduced from the West, postfeminism's descriptive value is also contextual. Postfeminism implies that feminism has already claimed a space within a specific cultural frame and has been superseded by something else. What exactly could postfeminism designate in Estonia where feminism has just emerged as a critical position from which social relations can be addressed? Taking up this term expresses, then, the desire to

contain the critical and subversive edge of feminist art already present in *Est.Fem* and which was to gain momentum in subsequent projects. But, for some, postfeminism implied a more open attitude towards issues of gender. If feminism just posed questions about women's identities and social roles, postfeminism seemed to shift the terms of enquiry so as to encompass marginalised sexualities in general while also appearing less straightforwardly political.

The effort to also engage male artists in feminist projects demonstrated that gender issues in the visual arts were not seen as the exclusive concern of women artists. Male subjectivity provided the focus in the works of Toomas Volkmann, who was dealing with gay issues and the transgression of traditional gender images. Pieces by Raivo Kelomees, based on Jungian animus/anima theory, and by Peeter Maria Laurits, dealing with the stereotypes of sexual behaviour, suggested the possibility of an expanded debate around the definition of masculinity in a changing culture. It should perhaps be pointed out that such efforts have not had many followers so far.

With the benefit of hindsight, it can be said that even though existing presuppositions about ideals of femininity were criticised, the very notion of female experience as a unified field and the grounds of a shared 'female' identity remained unquestioned. On the contrary, even now many women artists take for granted their experience as 'women' without acknowledging the possibility of their experiences being constructed within, or at least mediated by, institutions and discourses. In a situation where any kind of critique in terms of gender was in general condemned and the issue of female subjectivity was almost non-existent, women artists sought to (re)discover and (re)evaluate female experience as an alternative history with female protagonists. In the course of this, the traps of essentialising and affirming the prescribed gender roles and divisions were often difficult to avoid.

Est.Fem demonstrated how problematic it was to provide an analysis of gender (not to mention that of sexuality) as a socio-historical construction and not as something 'natural'. The reasons are quite obvious: Estonian women, like other women in post-Soviet regimes, do not share with Western women the past forty years of feminist intellectual history which followed Simone de Beauvoir's 1949 statement "One is not born, but rather becomes a woman".[10] Introducing feminism to the Estonian art scene meant introducing feminist theory as well. One of the most pressing tasks facing Estonian women continues to be the development of a theoretical project attending to their own needs at this specific historical conjunction. Nevertheless, *Est.Fem* was successful in at least demonstrating the potential and possible routes of such a development.

female sexuality and power

Julia Kristeva argued in 'Women's Time' (1979) that, while the requirements of egalitarian feminism (that is political, economical and educational equality) had been more or less fulfilled in Eastern European socialist countries, a reconsideration of sexuality was limited by both Marxian ethics and state power.[11] Or, to be more precise, claims on sexuality and sexual difference were almost impossible to make in

[10] Jo Anna Isaak, 'Reflections of Resistance: Women Artists on Both Sides of the Mir', *op. cit.* p10.

[11] Julia Kristeva, 'Women's Time' in Toril Moi (ed), *The Kristeva Reader*, Blackwell, Oxford 1996, p196. It has to be added, though, that here Kristeva makes a generalisation based on what was visible from outside the region. This claim overlooks the reality of pseudo-equality and women's over-burdening. At the same time it makes an important distinction between the situation of 'emancipated' Eastern European women (as indicated by the high percentage of working and educated women in socialist societies) and that of Western women who had to fight for equal rights in civil society.

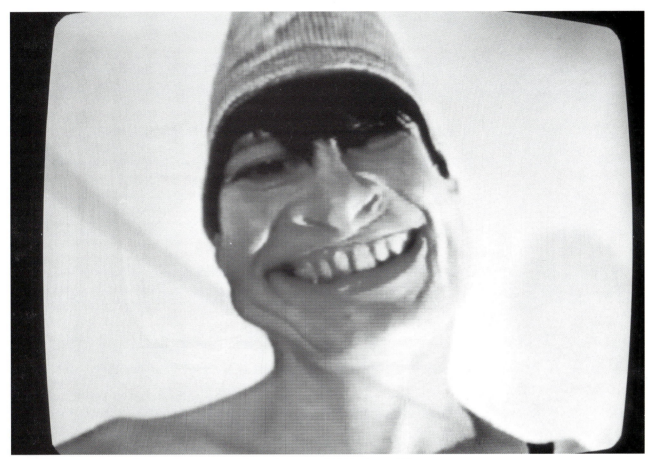

Mare Tralla A Toy, video-installation, still, Biotoopia, 3rd Annual Exhibition of SCCA, Estonia, Tallinn 1995

the Soviet regime (where, for instance, homosexuality was constitutionally designated as criminal activity). In principle, men and women were regarded as equal participants in society. This meant that both men and women were supposed to be 'sexless' workers. On the other hand, what was seen as the premise of female difference - women's ability to reproduce - was mainly considered in terms of (female) labour and women's contribution to the transition to a new communist society. Female sexuality, understood in terms other than these, simply fell outside the scheme of things. Paradoxically, traditional gender roles were perpetuated and reinforced both in public life and in the private sphere. In the first case, the state had a vested interest in controlling even the most private aspect of human life, that of sexuality. In the second, the perpetuation of traditional divisions of labour, based on gender, came as a reaction to the changes imposed by the state and the instability plaguing the public domain.

No wonder, then, that after 1989 many women artists took an interest in sexuality and its multiple forms, seeking in fact to understand 'sexuality as a locus of subjectivity'.[12] Some turned to the female body's specificity and rhythms, or even to the female body as a source of power. In this instance, feminism was taken up as a

[12] Isaak, op. cit. p. 27

93

license to articulate a visual language capable of expressing female experience and aspects of the feminine which, prior to that moment, were dismissed as unworthy of representation. In a post-Soviet regime such as Estonia, this was a radical departure from the conventions surrounding 'female' imagery.

Among the works trying to voice female experiences are the video installation *Untitled: A Hole* (1995) by Mare Tralla and the graphic pieces depicting red-coloured goddesses by Eve Kask. Both address the taboo of menstruation in its relation to fertility and as a source of female power so feared by men. Eve Kask's exhibition *291/2* (April 1998) made a case for an explicitly essentialist approach that stands out in the Estonian art scene. In her work, the female body and its rhythms are directly connected with the mystical power of earth-goddesses. Kask has been among the first Estonian women artists to rely on mythological female figures in order to point at a specifically female power located in the body. Interestingly, although her works tackle existing taboos of representation, they have always been received more positively than those by other artists dealing with similar issues. Perhaps it is Kask's particular visual idiom and aesthetic concerns which make her work more acceptable to the dominant voices of art criticism while other works, using subversive form as well as subversive content, may be received more negatively.

bodies

One of the first radical steps undertaken by women artists was the representation of the male nude. The male nude, seen from a woman's point of view, was introduced into Estonian contemporary art by two young women artists, Maria-Kristiina Ulas and Ly Lestberg, during the second half of the eighties. Ulas's works, especially, were characterised by their strong eroticism and were for this reason radical in the context in which they first appeared. Lestberg's approach to the male body began from a formal, 'sculptural' position, but in 1997 her subject-matter was intensified by a distinct homosexual element between the male bodies in her photographs. However, images of women loving women are virtually absent in Estonian art, with the exception of the sensual female nudes of Lilian Mosolainen.

Video and body artist Ene-Liis Semper has concentrated on the androgynous body on the one hand, and performing a culturally defined femininity on the other. Her performances are characterised by a purposeful transparency in which she manages to maintain a critical distance from complete identification with the roles she assumes. Androgynous bodies, transgressing gender stereotypes and anonymous bodyscapes are realised in some of her works. In others, femininity is enacted as a series of simulations by those subjects who are excluded from it. The project *Mutant à la carte* (1996) seems to be inspired by Cindy Sherman's *Untitled Film Stills*, but in Semper's photographs ideal femininity remains in a sense incomplete. All her adopted personae appear to have one leg cut off, suggesting mutilation. This does not merely negate the possibility of a state of perfection in conventional terms; it also intensifies the feeling of internalised controversy accompanying the social process of becoming an 'ideal' woman.

In Tiia Johannson's videos *I Clicked My Heart* (1997) and *Female Fish* (1997), the sick and vulnerable body of the artist acquires a certain symbolic function. In the first instance the artist uses excerpts from her personal video collection, echocardiogram photos of her heart, footage from a video piece by her husband and fragmented images from her immediate environment in order to put together a visual narrative of her illness. *Female Fish* can be read in terms of the pathology of the female body, the construction of woman as *a priori* ill, as biologically different, or simply as other. Johannson's approach differs significantly from that of other women artists dealing with the body. She refrains from using images of the female form, instead referencing 'abstract' photos of her heart. Her chosen metaphors (such as dead and alive fish) and background narration demonstrate how difficult it has become to re-contextualise the body in an attempt to construct new codes of visibility.

Along with Semper and Johannson's work, the project *Dream* (1996), by Piret Räni, takes a look at the daydreams and fantasies of young women and underscores the reality of the body as culturally coded. The photos for which young women participating in *Dream* had to pose illustrated how certain emotions are inscribed on our bodies in specific ways. The patterns of bodily expressions, the repetition of dreams and fantasies and the similarities in living what is commonly designated as 'personal' experience seem only to suggest the latter as ideologically defined. Moreover, since 'some essences are more essential than others', the belief that shared experience can provide an adequate basis for the articulation of (female) subjectivity can operate as the legitimation of an exclusion on the grounds of different experiences - as the construction of yet another form of otherness.[13]

stereotypes and social criticism

The dismantling of stereotypes developed concurrently with attempts to provide alternative images of the female body can be seen to be part of a wider project undertaken by feminist artists, one best described as social criticism. Feminist critique initially focused on a harsh reality characterised by cultural injustice - that is, injustice in representation, communication and interpretation,[14] as already presented in *Est.Fem*. Feminist artists developed a self-conscious attitude towards their critical projects, one frequently involving not only self-parody but also a certain amount of self-reflexivity. This became necessary as the stereotype of the angry feminist emerged in Estonian society together with the first efforts to articulate the parameters of a feminist way of thinking and seeing.

Autobiography and the critique of existing stereotypes of women, including that of the outrageous feminist, are combined in Mare Tralla's 'all-embracing' project, which involves fashioning an image of herself as the feminist artist (called Disgusting Girl) not only in and through her art, but also in the media. Tralla's strategy is based on the stretching of stereotypes to their limits, or what Rosi Braidotti has called politics of parody.[15] So far she has (perhaps not without effort) managed to be one step beyond those who have sought to identify in her personality the most telling illustration of the 'mad feminist artist'. She has also worked with other kinds of stereotypes, those originating in the history of Estonia, paying particular attention to

[13] Diana Fuss, 'Essentialism in the Classroom' in *Essentially Speaking*, Routledge, London and New York 1989, pp113-119.

[14] This distinction is made by Nancy Fraser, who sees a difference between cultural or symbolic and socio-economic injustice, arguing, however, that this distinction is purely analytical and that in practice the two are intertwined. Nancy Fraser, *Justice Interruptus: Critical Reflection on the "Post-Socialist" Condition*, Routledge, London and New York 1996, pp13-15.

[15] Rosi Braidotti, 'Cyberfeminism with Difference' in Sandra Kemp and Judith Squires (eds) *Feminisms*, Oxford Readers, Oxford University Press 1997, pp520–529.

constructions of femininity in the Soviet regime, which she frequently juxtaposes with those of the West, as well as with those currently in the making within Estonian society. Tralla traces contradictions, dead-ends and compatibilities among these three different social realities (national Estonian culture, the Soviet regime and the West) regarding women's lives. By manipulating and working on stereotypes, she attempts an exploration of Estonian women's response to feminism largely formed as a reaction to the pseudo-equality of the Soviet era.

Irony and sexual titillation are combined in Tralla's video installation *A Toy* (1995). Tralla attempts to subvert the passivity of the female body as spectacle in striptease, when the latter is considered as a form of performance with predetermined effects: a performance that seeks to stir the desire of the heterosexual male viewer. Even though a male figure (on one TV screen) gazes at the women (on a facing TV screen), he cannot have full pleasure in projecting his 'fantasy onto the female figure', because the sequence of changing images escapes his control. Neither can he choose the 'erotic objects' he would like to enjoy. The power to project an active gaze onto a passive body is denied him. Moreover, these normally 'disempowered' female bodies address him as being trapped within and manipulated by the promise of a prescribed form of visual pleasure - a promise that remains unfulfilled.[16] Thus *A Toy* becomes a witty, ironical tool for the critique of striptease as one of the most widely accepted expressions of gender relations within patriarchal societies.

Her installation *Second-Hand Love Stories* (1996) and performance *Kiss* (1996) deal explicitly with the issues surrounding female creativity. The first work involved making up 'banal' (i.e. conventionally narrated) 'love-stories', and attributing these to celebrated feminist theorists and artists, as if bringing them closer to 'ordinary' women tuned to the discourse of women's magazines. A key to the interpretation of the whole installation can be the story of Simone de Beauvoir, whose 'loving Sartre too much' occupied the gap between her philosophy and her private life (which is not to say that male philosophers do not demonstrate the same tendency. The contrary is more likely, but less publicised or condemned).

In *Kiss*, Tralla projected on a mirror/screen the faces of Estonian male critics expressing their opinions on artist Mare Tralla, as if inspired by Virginia Woolf's famous quote: "Women have served all these centuries as looking-glasses possessing the magic and delicious power of reflecting the figure of man at twice its natural size".[17] Now it is men's turn to perform the function of the looking-glass. The artist is only being fair: those who praise her are rewarded with a kiss and those who don't are hit with lipstick. Nevertheless, Tralla manages to only partly distance herself from this discursively constructed 'self'. To some extent, her artistic persona is constituted in the speech of these male critics, and perhaps her playing along only perpetuates the power of the male critic to master language and thus to define her position as artist in relation to what is uttered.[18]

One of the most typical examples of art operating as social critique is the work of Liina Siib. In her one-woman show entitled *The Presumption of Innocence* (1997), she exhibited colour photos of female prisoners and young girls studying at modelling school. In both cases the traditional understanding of femininity as based upon a

[16] My reading is based on Laura Mulvey's distinction between a male/ active spectator and a female/passive object implicated in her theorisation of the male gaze as it has been presented in Laura Mulvey, 'Visual Pleasure and Narrative Cinema,' in *Visual and Other Pleasures,* Macmillan Press, London 1989, pp14-26.

[17] Quoted in Isaak *op. cit.* p37.

[18] *Kiss* invites a Lacanian reading as well: references to the mirror stage and the process of the constitution of self through others and in the symbolic order, that is in language, are explicit in the work. On the importance of the mirror stage as a primary site of identification (or rather as *méconnaissance* or 'misconstruction' in the development of the child) see Jacques Lacan, 'The Mirror Stage as Formative of the Function of the I as Revealed in Psychoanalytic Experience' in *Ecrits: A Selection*, Routledge, London and New York 1992, pp1-7. Lacan's account of the relationship between language and the unconscious, and subjectivity as constructed in acquisition of language, is presented, for instance, in his essay 'The Agency of the Letter in the Unconscious or Reason since Freud', *ibid.* pp146-178.

'natural' female feature, i.e. innocence, is taken as the object of analysis: how can a female prisoner wearing a wedding veil (thus doubly coded as innocent) fulfil the ideal of purity embodied by the innocent/virgin bride? Do female prisoners fall outside the prescribed limits of femininity? Does learning how to perform the feminine guarantee certain power for women, and especially for women prisoners, since this way they would also be considered inherently 'pure'?[19]

The group F.F.F.F. (Kaire Rannik, Kristi Paap, Berit Teeäär, Ketli Tiitsar and Maria Valdma) is the most prominent women artists' group in Estonia. Their issue-based project *Message to the Future* included in *Interstanding 2* (1997) was one of the few works trying to transgress the borders of the art world and intervene in people's daily lives.[20] The project, consisting of containers dispersed across urban space and the final display of collected materials, presented at the same time a random but interesting sociological investigation into the questions of 'participation' and social problems. The results shed light on one of the most painful realities of Estonian society, namely the issue of national minorities. People of Russian origin were keener to participate, their messages communicating anxiety about their future status and present socio-economic situation in the Estonian Republic. Surprisingly, this project hardly received any attention in the art world - or perhaps this was the only response that was possible. After all, shunning feminist politics reflects a wider tendency against an understanding of art as a social practice, so any socially based statement runs the risk of being incomprehensible and therefore silenced.

the 'new wave' of feminist exhibitions

In 1998 there was a 'new wave' of feminist exhibitions in Estonia. In April the group show *(Meta)Dialogue* took place in Tallinn. Having already been exhibited in quite marginal exhibition spaces, *(Meta)Dialogue* was instrumental in introducing to the public a younger generation of women artists, plus the young male artist KIWA, many of whom were still students at the Estonian Academy of Arts. For these artists who are not yet fully established in the art world, a 'room of their own' seems to be an issue. They locate themselves in areas outside the mainstream art scene (both in terms of space and media) which they consider as closer to their understanding of an alternative practice. Besides the favourite media of many women artists (i.e. video and photography), the display surprised its public by incorporating a variety of techniques associated with the applied arts and crafts, such as stitching (Helena Palm) and jewellery (Piia Ruber). The exhibits also included toys (Helen Lehismets) and various kinds of objects and souvenirs (Mari Laanemets, Killu Sukmit).

Young women artists concentrating on a re-evaluation of applied arts and crafts certainly take a risk since, to this day, institutional discourses in Estonia have not given up on the modernist dictum designating these areas as distinctly separate from so-called high art. It seems, however, that women artists themselves regard these areas as a space in which they can operate as women and artists without the feeling of inferiority in respect to 'high' art. At the same time, there is a manifest desire on the part of many women artists to critically address the designation of the applied arts as 'low' and 'feminine' while, through their work, the possibility has arisen of

[19] While Siib's photos of female prisoners and young models deal mainly with how social injustice is also gendered, her photos of Estonian homeless people and of abandoned empty houses address the issue of social injustice in more general terms. Her installation *Hospitality* (1997), constructed from photos and found objects, continues the same line of exoticised poverty or the perceived reality of everyday life that was already present in the work by the group SHOP. Consequently, Siib's interest is focused on individuals, activities and objects which signify the relationship between dominant and marginalised subjects in Estonian 'early' capitalist society.

[20] Here I was interested in the fact that this kind of project was made by women artists dealing with gender issues in art; in general a certain type of social art, concentrating on current social problems, seems to be the priority of women artists, especially those having some affinity to a feminist approach.

claiming different spaces in the Estonian art world, challenging the latter's tendency to an often suffocating homogenisation.

The turn to crafts and the use of alternative materials, as well as the preoccupation with the so-called feminine/private sphere recently witnessed, exposed the processes of hierarchisation which were already occurring within the realm of feminist art in Estonia: although the focus on gender has overall remained peripheral to the concerns of mainstream art, there are definitely a number of feminist artists who have established themselves in the art world. At the same time, certain subject-matter and media used in the context of feminist art are more acceptable than others, which makes it interesting, then, to observe the tendency of younger artists to explore the possibilities of media that have formerly been denigrated as second-rate, in an attempt to transgress the division between 'high' and 'low' art. In general, however, Estonian feminist art seems to have paid less attention to craft, and particularly textiles, with the exception of very few examples.[21]

The group show *Private Views: Space Re/cognised in Contemporary Art from Estonia and Britain* generated a debate which illustrates the present state of affairs regarding the conjunction of feminism and contemporary art. In Estonia, without acknowledging the possibility that the dismantling of (gendered) space can consist of something more than a polemical attitude towards men or getting attention in the media, male critics failed to reflect on why Estonian artists are concerned with issues that form part of a wider feminist agenda and the way in which feminism informs contemporary Estonian art. Predictably, certain critics were all too eager to identify most of the works on show as postfeminist, without at the same time clarifying the possible meanings of the term in contemporary Estonian art. If nothing else, this points to a rather limited understanding of the scope of feminist artistic practices. At the same time, the juxtaposition of Estonian works with those from Britain, where perhaps postfeminism denotes a legitimate shift in the debate around gender issues, has posed a new series of questions about Estonian art and the politics of its reception in an international context. The existence of different subject positions and the recognition of these differences among women does not mean, however, giving up the possibility of a feminist practice. On the contrary, the critical power of feminist enquiry is based precisely on self-reflexivity: on feminism's ability to reinterpret and redefine its own practices and theories, especially as current processes facilitate interaction among women from diverse cultural backgrounds.

So, how is feminist artistic practice positioned in relation to the multiple faces of feminism on the one hand, and the Estonian art world on the other? The slogan of second wave feminism 'the personal is political', rephrased by the art critic Lucy Lippard as 'If my art isn't my politics, then what is?', does not really apply to the precarious position of feminist art in Estonia, where feminism's marginality is in many respects different from the marginalisation of feminist practice in the West, in the aftermath of direct political action. Specific historical conditions have prevented the emergence of a women's movement in the arts in Estonia. Not many women artists' groups have formed and the contested position of gender studies in the academy, to say the least, diminishes the chances of an expanded dialogue on issues of gender. Notwithstanding these factors, the feminist critique has already made an important

[21] Regarding the use of textiles in Estonian feminist art, two pieces exhibited in *Est.Fem* deserve to be mentioned: Ele Praks's photos of schoolchildren from the beginning of the century printed on textile and Kaire Rannik's replicas of female and male body interiors made with soft cottonwool. Kadri Kangilaski's collages on 'real' love or sexual behaviour use paper-dolls and fairy-like figurines, while the content of her work draws heavily on Soviet experience. Young artists Helena Palm, Ele Praks, Merle Suurkask and Kadi Soosalu have attempted to claim textile art as a means to express specifically women's 'experiences'. However their exhibition, *Caring* (1996), went almost unnoticed by the media.

intervention, at least to the extent that it has foregrounded the politicisation of artistic practice from a different perspective. The phrase 'aesthetics and politics' still has a negative ring for many artists and critics in Estonia, given its particular meanings within Soviet culture. In fact, this partly explains the reluctance to acknowledge the exclusions upon which the modernist principle of aesthetic detachment is based. Yet these exclusions, debated within a philosophy of difference, have lately provided a radical point of departure for both female and male artists who wish to investigate the currency of fixed boundaries.

Estonian women artists have turned to the exploration of areas which had previously received no attention within Estonian cultural practices, simply because the dominant modes of thinking about art did not provide a programme of critical intervention. Among these issues, female subjectivity and creativity, and the process of understanding art as first and foremost a social practice, have been of paramount importance. The fact that struggles and conflicts are not currently entrenched within a political movement similar to those that shook the Western art world in the seventies and early eighties does not diminish their impact. After all, every step leads to another.

chapter 6

women, nationalism and citizenship in post-communist europe

Joanne P. Sharp

In *Three Guineas,* Virginia Woolf stated famously: "As a woman I have no country. As a woman I want no country. As a woman my country is the whole world". A number of feminist writers have drawn inspiration from Woolf's claims. A feminist rejection of the masculinist political culture of the state and the divisive borders between competitive nation-states has led instead to an image of a 'global sisterhood' of women united in a common struggle against universal oppression.[1]

[1] Robin Morgan, *Sisterhood Is Global: The International Women's Movement Anthology*, Anchor Press/Doubleday, New York 1984.

However, Adrienne Rich has challenged this feminist politics, arguing that it understands neither history nor geography. Rich argues that:

> As a woman I have a country; as a woman I cannot divest myself of that country merely by condemning its government or by saying three times 'As a woman my country is the whole world.' Tribal loyalties aside, and even if nation-states are now just pretexts used by multinational conglomerates to serve their interests, I need to understand how a place on the map is also a place in history within which as a woman, a Jew, a lesbian, a feminist I am created and trying to create.[2]

[2] Adrienne Rich, *Blood, Bread and Poetry: Selected Prose 1979-1985*, Norton, New York 1986, p212.

Rich's critical reflection on Woolf's global sisterhood shows how problematic such universalist claims can be. Rich insists that womanhood is constructed specifically in different locations, as a result of many geographies playing out local and global relationships of colonialism, trade, exploration and struggle. Rich's opportunities, experiences, expectations and actions are both constrained and made possible by her multiple positionings within different power 'containers': the West, the North, the Developed World, the First World, the Global Hegemony, North America – and perhaps most significantly, the nation-state (the USA) of which she is a citizen.

Rich beautifully articulates a problem that faces feminist theorising: how to engage with the various exploitations and oppressions of women around the globe without producing an insipid image of global sisterhood which ignores all of the differences, inconsistencies and histories which make up the notion of womanhood in different places. Past theories of patriarchy as a universal exploitation faced by all women, and thus defining the experience of womanhood and the necessary outlines of feminist politics, are now exposed as deeply flawed. As Chandra Mohanty argues, seeing feminism as such a universal struggle not only erases the agency of women in particular historical struggles, but also seems to require that "the categories of race and class have to become invisible for gender to become visible".[3] For Third World feminists like Mohanty, the global sisterhood image silences the histories of colonialism, imperialism and racism from which Western feminists still benefit. Second World - now more appropriately termed 'post-communist' - feminists have similarly critiqued Western feminism for its liberal, middle class assumptions.

[3] Chandra T. Mohanty, 'Feminist Encounters: Locating the Politics of Experience' in Linda McDowell and Joanne P. Sharp (eds), *Space, Gender, Knowledge: Feminist Readings*, Arnold, London 1997, p83.

The problem remains: if feminists want to try to make some sense of the nature of gender relations in Europe, as the subcontinent reacts to globalised processes, investments, media and changes in regional governance and geopolitics, how are the similarities and differences between the experiences of women in different places to be accounted for? Furthermore, what is a legitimate space of gender? Is Europe itself a coherent space, or do the experiences of Eastern and Western Europe during the Cold War, the historical and cultural differences between North and South Europe, or linguistic diversity across Europe, make this too heterogeneous a space to represent as one? Is the nation state the more 'natural' level for the articulation of identity, or is it necessary to delve to smaller scales, to go to the level of everyday life enacted in place and community? In this essay I want to investigate these different spaces of gendered identity, to argue that gender is indeed articulated differently in different spaces, to try to account for the processes at work at different scales. However, I will conclude by scrambling this explanation in order to recognise another facet of spatiality: its fluidity and ability to resist 'capture' by static concepts like scale.

The nation is perhaps the most significant territorially based identity in contemporary society. Despite continued predictions of its demise - from Marxist and liberal theorists alike, who saw (respectively) class identity and the power of the market as much more powerful forces - the power of national identity persists and perhaps is even boosted or revived in the context of postmodern, or globalised, society.[4] Certainly, for many it remains a primary loyalty and defining facet of their personality, whether expressed in political reactionism against migration and ethnic difference, or in a more benign form in support of national sporting achievement. I will consider the revival of nationalism in post-communist countries of Eastern and Central Europe as a way into understanding the entanglements of gender and space. Having discussed the gendering of national identity, I will explore the other spaces of gendering that coexist with and contradict nationalism.

[4] Arjun Appadurai, 'Disjuncture and Difference in the Global Cultural Economy', *Theory, Culture & Society*, Issue 7, 1990, pp295-310.

gender, nation and citizenship

Despite its universalising rhetoric, nationalism as a form of identity formation is inherently gendered. Although women appear in national imagery - as symbols of nation (Britannia, Marianne and Mother Russia) or symbolic bearers of it as mothers - the agency of the nation is embodied within its male citizens. In his influential account of the rise and spread of nationalism, Benedict Anderson[5] depicts the power of nationalism as lying in the horizontal fraternity of national citizens. This fraternity emerges from the fact that any man could be the Unknown Soldier who has laid down his life for his country, providing the ultimate sacrifice. In the national imaginary, women are mothers of the nation or vulnerable citizens to be protected. Anne McClintock has observed that in this role, women "are typically construed as the symbolic bearers of the nation but are denied any direct relation to national agency".[6]

[5] Benedict Anderson, *Imagined Communities: Reflections on the Origin and Spread of Nationalism*, Verso, London 1983.

[6] Anne McClintock, 'Family Feuds: Gender, Nationalism and the Family', *Feminist Review* 44, 1993, p62.

The gendered rhetoric of national identity is reinforced through the national landscape and through practices of national identification - what Billig has termed

chapter 6

[7] Michael Billig, *Banal Nationalism*, Sage, London 1995.

[8] Judith Butler, *Gender Trouble: Feminism and the Subversion of Identity*, Routledge, London and New York 1990.

[9] Chantal Mouffe quoted in Nira Yuval-Davis, *Gender and Nation*, Sage, London 1997, p73.

[10] Barbara Einhorn, *Cinderella Goes to Market: Citizenship, Gender and Women's Movements in East Central Europe*, Verso, London 1993, p3.

[11] Slavenka Drakulic, *How We Survived Communism and Even Laughed*, Verso, London 1988, p911.

[12] bell hooks, *Yearning: Race, Gender and Cultural Politics*, South End Press, Boston 1991.

[13] Larissa Lissyutkina, 'Soviet Women at the Crossroads of Perestroika' in Nanette Funk and Magda Mueller (eds), *Gender Politics and Post-Communism: Reflections from Eastern Europe and the Former Soviet Union*, Routledge, London and New York 1993, p276.

'banal nationalism'.[7] The nation does not have an essence or singular character, but instead is created as an identity through the repetition of these everyday activities, just as gender identity, in Butler's formulation,[8] is seen as the result of repeated performance rather than the expression of a deep sense of person. These performances of identity will become entangled: gender and national identities cannot be distilled out one from another.

The effects of this gendering of national identity go beyond image and metaphor. Feminist theorists have pointed to differences in access to citizenship between men and women. As politics "is about the constitution of the political community, not something that takes place within it",[9] then this gendering of national identity and citizenship effects the morphology of the political community that emerges. The national community is created through the political process rather than being a coherent and known entity which precedes it. Thus the repetitions of identity will influence the make-up of community and the politics enacted through this body.

A number of feminist writers have recently noted the effects of the entanglements of national and gendered identities in the political communities of post-communist Europe. Eastern and Central European countries are currently deemed to be in transition from communism to post-communism. The notion of 'transition' suggests an inevitable - and unidirectional - movement from one state to another, in this case from totalitarian, state centred politics, to a society characterised by freedom, equality and the re-emergence of civil society. However, the change has been more complex than this would suggest. One of the effects has been a reconfiguration of spatiality. Under communism, the public/private dichotomy described and critiqued by feminists in the West did not emerge. Instead, the opposition was between the state and the family, a division "between public (mendacious, ideological) and private (dignified, truthful) discourses".[10] The private sphere of the family provided a space of resistance which was antithetical to the public space of the totalitarian state. Václav Havel and George Konrád cynically called domestic space 'anti-politics', symbolising direct opposition to the ideology of the state. Slavenka Drakulic[11] is more prosaic in her claim that "an apartment was a metaphysical space, the only place where we felt a little bit more secure. It was a dark cave into which to withdraw from the omnipresent eyes of the state". Like bell hooks,[12] some Eastern European feminists celebrate the 'homeplace as a site of resistance' to the state rather than simply seeing the home as a location of patriarchal authority and repression. Given that many remember the home under communism as a resistant space, the meaning of different social spaces was quite different to that perceived by Western feminists:

> The house, and especially the kitchen, in the 1960s, 1970s, and 1980s was the only free sphere. In Russia, to aspire to the kitchen does not have the same connotations as in the West. The Russian kitchen was a front of massive resistance to the totalitarian regime and is perceived with sentimental nostalgia today...[13]

However, the homeplace image should not be overly romanticised. Because the family occupied the social space posed in opposition to the state, women have been

102

able to effect few changes to familial or gender roles which would be accepted as progressive by mainstream society. That the family symbolised free space, in contrast to the state, tended to deflect attention away from patriarchal relations operating within the family. The binary pair family/state meant that women who criticised the family were interpreted as being on the side of the state. In effect this has discouraged women from pressing for state intervention in the 'private sphere' or family matters, whereas 'private' issues such as domestic violence are key concerns for Western feminists.[14]

Public and private spaces have also been inscribed through questions of economics. Whereas in the West, the feminist movement (dominated by middle class women) struggled for the right of women to enter the public sphere and so find employment or enter into politics, leaving the domestic sphere did not represent the same liberation for those women living under communism. Here, full employment did not represent a fulfillment of the right to work; there was no decision to be made. Instead, there was a compulsion to work, not only for ideological reasons but also, just as for working class women in the West, from economic necessity. Women had work, but it was concentrated in blue collar sectors of the economy rather than less alienating and better paid labour.[15] Significantly, there was no reduction of women's domestic labour in this conception of emancipation; they had to shoulder this 'double burden'. Thus, movement outside the home was seen by women with a profound sense of ambivalence, so that, for example, "[m]any Polish women cannot decide if their employment under communism marked liberation or oppression".[16]

Developments since 1989, during the 'post-communist' era, have witnessed the public-private division being inscribed into social space. Some commentators have read this as a masculinisation of culture.[17] The reintroduction of civil society has not heralded the period of freedom and equality that had been promised:

> The long awaited emergence of civil society has mainly been restricted to male actors and led to the empowerment of men and the institutionalisation of masculinism, whereas to women, 'freedom' has been associated with the freedom to enact a traditional feminine identity more fully, and femininity has been associated with the private sphere which consistently has been identified with the traditional domain of women.[18]

Masculinity structures the public domain in such a way that the concept of 'freedom' for female citizens comes with the detachment of femininity from the public sphere and its reinscribing within the traditional 'private' sphere.[19] The possibilities offered to women are narrowed. This is reinforced by the relative weakness of feminist politics in post-communism. The notion of female emancipation is tightly associated with old communist regimes[20] and, as a result, less attractive to nationalist movements.[21] Feminist issues are either considered leftist[22] and as such become discredited by association with the old regimes, or perceived to represent unconditional acceptance of Western values.[23] Also, despite many apparently favourable conditions for the emergence of a feminist consciousness across the former communist states, there has not been a widespread expression of this

[14] B. Einhorn, op. cit., p6.

[15] Irene Dölling, 'Between Hope and Hopelessness: Women in the GDR after the 'Turning Point'', Feminist Review 39, 1991, p9.

[16] Ewa Hauser, Barbara Heynes and Jane Mansbridge in N. Funk and M. Mueller (eds), op. cit., p261.

[17] Roza Tsagarousianou, ''God, Patria and Home': 'Reproductive Politics' and Nationalist (re)Definitions of Women in East/Central Europe', Social Identities 1, 1995, pp283-295.

[18] Ibid., p288.

[19] Ibid., p289.

[20] Hanna Jankowska, 'Abortion, Church and Politics in Poland', Feminist Review 39, 1991, p174.

[21] There has in fact been a more general devaluation of the language of emancipation because of its association with the rhetoric of communist regimes. See Maxine Molyneux, 'Interview with Anastasya Posadskaya, (25 September 1990)', Feminist Review 39, 1991, p135.

[22] N. Funk and M. Mueller, op. cit.

[23] Katalin Fábián, 'The Political Aspects of Women's Changing Status in Central and Eastern Europe', Proceedings of the 1993 Maxwell Colloquium, Maxwell School of Citizenship and Public Affairs, Syracuse University 1993, p74.

chapter 6

[24] Yudit Kiss, 'The Second 'No': Women in Hungary', *Feminist Review* 39, 1991, p51.

[25] Mikhail Gorbachev, *Perestroika: New Thinking for Our Country and the World*, Fontana, London 1987, p117.

[26] *Ibid.*

[27] Nanette Funk, 'Feminism East and West' in N. Funk and M. Mueller, *op. cit.*, p194.

[28] Peggy Watson, 'Eastern Europe's Silent Revolution: Gender', *Sociology* 27, 3, 1993, p472.

[29] The objectification of female bodies in post-communism can also be seen to be articulated in the rise of pornography.

[30] R. Tsagarousianou, *op. cit.*, p291.

identity or politics. Kiss has suggested that this is because, under communism, emancipation was granted from the state - equality (or at least the rhetoric of equality) was imposed from above - rather than women engaging in social change to achieve their own emancipation.[24]

Furthermore, women's movement into the home has become an expectation rather than a choice (just as previously their move out of the home was an expectation rather than a choice). Women are now told that they should return to domesticity for the good of the nation: it is women's natural duty to return to the domestic sphere. Women are often blamed for social problems. In his book *Perestroika*, Mikhail Gorbachev[25] claimed that "women no longer have time to perform their everyday daily duties at home...many of our problems...are partially caused by the weakening of family ties and slack attitude to family responsibilities". Gorbachev, evidently addressing the male citizenry, asked, "what *we* should do to make it possible for women to return to their purely womanly mission" (emphasis mine).[26] This attitude legitimates women's return to the domestic sphere while helping to alleviate high unemployment as a result of the closure of state-controlled industry by nationalist governments. Perhaps unsurprisingly, previously state-sponsored provision of child care and maternity leave are the first services to go in the transition to a capitalist economy. Certain aspects of 'transition' clearly have very uneven effects with women shouldering a particularly heavy burden.

This division of social space into the public and private has further effects. Perhaps most significantly, it helps to reinforce the idea of women embracing national identity in their roles as literal bearers of the nation. Nanette Funk[27] suggests that competition between East and West during the Cold War provided an incentive for East Germany to liberalise abortion laws. In a sense, such liberalisation symbolised a modern nation-state unfettered by the demands of bourgeois or religious moralities. Under post-communism, perhaps as a reaction to state control, previous policies concerning morality, traditional family values or religion are being overturned. These highly emotive issues provided contours of family space and lines of resistance during communist regimes, and are currently proving to be important elements of post-communist national identification.[28] Communism is perceived to have eroded traditional values and now these values are being recuperated, often in rather uncritical form. Especially in states where religion provided a major component of cultures of resistance to communism, religious morality has represented a weighty voice in debates over national culture: in many cases the results have included the illegalising of abortion.

Even in states where abortion has not been illegalised, increased bureaucratisation or requirements for counselling have meant that abortions are more difficult to obtain. Many commentators have suggested that the link between banning abortions or making them harder to obtain represents a state disciplining of women's bodies. Although formally recognised as citizens, women find their citizenship rights undermined by a specific definition of 'woman' which is tied to the idea that femininity is inherently linked to motherhood. This potentially limits the right of women to exercise control over their bodies[29] and reproductive capacity; women are treated as state property, the primacy of the nation over women is writ large.[30]

In addition, policies based upon the expectation of women adopting the role of wife and mother, rather than worker, make alternatives to monogamous heterosexuality difficult. With access to paid employment becoming increasingly problematic, it is harder for women to support themselves in lesbian relationships. The representation of women as wives and mothers raises important questions about the relationship between masculinism and citizenship.

In some states, ethnic tensions have made women's reproductive capabilities an issue of national interest, even national survival. In Croatia, for example, the nationalist party outlawed abortion in 1992. Slavenka Drakulic suggests that feminists should not be too surprised at this outcome:

> One cannot expect that such a nationalist party, worried that the Croatian nation is soon going to disappear because Croatian women aren't giving birth to more than 1.8 children, is going to promote anything progressive for women.[31]

In Serbia, covert ethnic policies operate through limitations to child care and social security provision for women with more than three children - a family structure characteristic of Albanians.[32] Here, nationalist policy is aimed more consciously and overtly towards women's bodies. In the war in Bosnia-Herzegovina, Bosnian Serb soldiers' rapes of Bosnian minority women - in many cases action ordered of them - solidifies all too clearly the links between individual female bodies and the nation in both nationalist rhetoric and *Realpolitik*.[33]

This privileging of the national interest over women's needs (and those of other 'minorities') demonstrates a politics of community over difference. Nationalists are keen to destroy the effects of communism and re-establish national culture as the central point of society. This often includes the rearticulation of a rather conservative and uncritical romanticised vision of 'the past'. In addition to often quite xenophobic claims to regenerating an ethnic purity, one goal involves the regaining of a "traditionally prescribed gender identity [which] is an important aspect of nostalgia for 'normality'" which people anticipate current change will provide.[34]

In times of threat to the nation - the all-too familiar cry for protection of the 'national interest' - women's issues are often marginalised. Women are accused of being divisive in a time of need, privileging one internal division over the community as a whole:

> Women who have called for a more genuine equality between the sexes 'in the movement, in the home' have been told that now is not the time, the nation is too fragile, the enemy is too near. Women must be patient, they must wait until the national goal is achieved; then relations between women and men can be addressed.[35]

These feelings are enforced in attempts to unite the community in the face of hardship. Bulgarian feminist Maria Todorova tells of claims which state that since the Bulgarian economy is so fragile, society cannot 'afford' to become divided along sex

[31] Slavenka Drakulic, 'Women and the New Democracy in the Former Yugoslavia' in N. Funk and M. Mueller, *op. cit.*, p125.

[32] Andjelka Milic, 'Women and Nationalism in the former Yugoslavia', in N. Funk and M. Mueller, *op. cit.*, p113.

[33] The huge amount of coverage of this aspect of the conflict similarly reinforces this link, showing that women's bodies do, indeed, lie at the heart of the nation.

[34] P. Watson, *op. cit.*, p473.

[35] Cynthia Enloe, *Bananas, Beaches and Bases: Making Feminist Sense of International Relations*, University of California Press, Berkeley CA 1989, p62.

[36] Partha Chatterjee, *The Nation and Its Fragments*, Princeton University Press, Princeton NJ 1993, p133.

[37] Sally Marsden, 'Who are 'The People'? Gender, Citizenship and the Making of the American Nation', *Environment and Planning D: Society and Space* 8, 1990, pp449-458.

[38] Cathie Lloyd, 'Rendez-vous Manqués: Feminisms and Anti-Racisms in France', *Modern and Contemporary France*, 6, 1998, pp61-73.

or gender lines. This argument, of course, implies that it is feminism rather than sexism which has split the community. What this represents is a movement of gender issues from the public sphere of contested politics into a private sphere of cultural matters in the manner that Partha Chatterjee[36] has described as operating during India's struggle for national independence. During the nationalist revolt, the 'women's question' disappeared as a political issue, he observes, because this inner domain of sovereignty was removed from the public sphere of political contest with the colonial state. It was argued that the 'women's question' would return to the public sphere of politics once independence had been attained. Sally Marsden[37] and Cathie Lloyd[38] similarly show how even the radicalism of the American and French Revolutions have failed to change the status of women much, as they depended heavily upon notions of political fraternity and the long-established division between the public and private spheres (assuming that women were located in the private, not in the arena of political agency).

feminist spaces

One effect of feminist critiques of nationalism and state politics has been a valorisation of the local as a better, or more 'natural', site for the production of feminist knowledges and identities. The local is regarded by many as the location of difference, other scales as homogenising and disciplining to sameness: the local offers an alternative, or a site of resistance, to the universalising aspirations of nationalist rhetoric. However, just as with the nation, region, or any other scale, the local is politically ambivalent: there is nothing *inherently* liberatory or progressive about the local; local knowledge cannot be considered a truer form of knowledge than the knowledge of other scales unless one resorts to a naive empiricism. In fact domination, distortion, inequities and exclusion work just as well at the local level as at any other. "In defending the idea of 'local truth'", Ulf Strohmayer and Matthew Hannah have written, "some writers assume that language used in highly specific discourses or by inhabitants of particular places escapes relativism because the conversants share so much in the way of vocabulary, background, rules of discourse, place-specific history, etc.". There is a belief that somehow face-to-face conversation avoids problems of mediation. However, Strohmayer and Hannah continue to suggest that "the problem of representation hounds communication at every scale, from a two-person discussion on up. Thus every consensus, even at a local scale, conceals the problem *only* through an exercise of power".[39] Calls for community too often end up privileging sameness over difference and stressing the importance of 'authentic' over what is considered to be inauthentic.

[39] Ulf Strohmayer and Matthew Hannah, 'Domesticating Post-modernism', *Antipode* 24, 1992, p51.

Clearly then, no scale is innocent. Scale is a social construction of space: nations, regions and localities have no ontological existence but are 'imagined geographies' constantly recreated through practices of politics, culture, economics and so on. Before dismissing scale as nothing more than a discursive construct, though, it is necessary to remember that despite their discursive or ideological creation, certain spaces do have material effects. Despite the rhetoric of globalisation, travelling theory, nomadology and so on, not all people do have such global mobility. The reality of patrolled borders and institutionalised rites of passage across space ensure

that space is clearly demarcated for some. Nevertheless, it is important not to leave our discussion of the spaces of gender with such neatly defined territorial units. To do so would be to buy into the rhetoric of the nation as a natural expression of the common identity of a people residing in a particular territory, or to the notion that the residents of a place possess a distinct identity which means that their ownership of it should be exclusive.

The different spaces I have examined above are not hermetically sealed. To understand changes to national culture, it has been necessary to explore notions of public and private, a spatiality linked to the most intimate, and also most mundane, practices of everyday life. Similarly, it can be argued that to understand the nation it is also necessary to look to larger scales. Inter-national relations are less about protecting an identity which already exists than about creating identities. Through the repeated insistence that those outside of the national boundary, those who occupy other spaces, are different or other, national identity can be reproduced as a coherent and universal form. Nation-state boundaries have been constructed through this process rather than predating it. This kind of imagined geography can aid in the repression of alternative identities (such as ethnic minorities or minority nationalisms) or political challenges (such as gender politics). In a sense, these projects of rendering the private political and challenging the definition of (nation) state political agency are not dissimilar, as Simon Dalby suggests:

> Just as some feminists challenge the ideology of the family in suggesting that private spaces are 'safe' because of the presence of a male protector, whereas public spaces are dangerous to women [...] it is a simple extension of these arguments to argue that states do not really protect all their (domestic) citizens while providing protection from the perils of the anarchy beyond the bounds of the state.[40]

Hence it is necessary to formulate a way of understanding the permeability of different spaces, the fluidity of spatial processes, without losing sight of the very real barriers and inscriptions that exist within space. It is necessary to understand the specificities of local expressions of identity without dislocating them from larger processes. Massey calls this an "extroverted sense of place".[41] She claims that an extroverted sense of place can be imagined to form around networks of relations and connections rather than being enacted by boundaries and through exclusions. This requires us to think of gender as something formulated through localised networks that are nevertheless inherently linked into global processes.

Massey suggests that places are not static but should instead be understood as processes. This means that places should not be seen to be demarcated by rigid boundaries. Much place-based politics is organised around demonstrating and protecting the borders of places, defending them from infringements to their authentic tradition, landscape and identity. Place - or territorially-based identity - is usually organised around constructing a sense of Otherness, or difference, against which the place can be defined. For example, definitions of who belongs in a country revolve around establishing heritage or genealogy, drawing a border to keep out those who do not belong.[42]

[40] Simon Dalby, 'Gender and Geopolitics: Reading Security Discourse in the New World Order', *Environment and Planning D: Society and Space*, 12, 1994, p531.

[41] Doreen Massey, 'A Global Sense of Place', *Marxism Today*, June 1991, pp24-29.

[42] This process does not only occur at the state level as this example shows, but also at the local level, as is most evident now in some of the more exclusive American and British suburbs which are protected from the apparently dangerous remainder of society with video cameras and in some cases road blocks.

chapter 6

Massey suggests that this is not necessarily how place should be understood. It can be shown that in actuality the clear difference between inside and outside, self and other, does not exist in real life - reality does not possess the hard lines of a map. Massey is encouraging us to acknowledge the extra-local similarities and linkages that make up a place, in addition to the differences. For example, she describes a walk to her local shopping centre in Kilburn thus:

> It is a pretty ordinary place, north west of the centre of London. Under the railway bridge the newspaper stand sells papers from every county of what my neighbours, many of whom come from there, still often call the Irish Free State. The post-boxes down the High Road, and many an empty space on a wall, are adorned with the letters IRA [...] On another ad, for the end of the month, is written 'All Hindus are cordially invited'. In another newsagents I chat with the man who keeps it, a Muslim unutterably depressed by events in the Gulf, silently chafing at having to sell the *Sun*. Overhead there is always at least one aeroplane [...] Below, the reason the traffic is snarled up [...] is in part because this is one of the main entrances to and escape-routes from London....[43]

[43] D. Massey, *op. cit.*, p28.

This construction of place is one in which a sense of belonging is clear and yet this does not exclude others: it is an identification that seeks to include rather than to exclude.

conclusion

Nationalism asserts an inherent linkage between a people and a place, arguing that the nation is a natural territorial expression of a people with an inalienable right to that space. Feminists have argued against such politics, insisting that they are divisive and lead to dominance within the national community. They expose nationalist claims to the inevitability of sovereignty to be a particular cultural production, not only tied in to an imagined community of nation, but also of a fraternity of national citizens. Feminist reactions have been twofold: on the one hand there has been a turn towards a global sisterhood transcending national borders, and on the other, a turn to smaller scales, towards local identities, communities and knowledges. Both of these alternative scales are equally constructed and open to critique and scrutiny. Indeed, feminists need to regard space with some ambivalence, recognising that in any territorial expression there are coexistent forces of deterritorialisation and movement, revealing the territory as a fiction. Any boundaries closed in absolute terms, be they public-private, national-international or East-West, tend to lead to an authoritarian form of politics.

[44] Gillian Rose, 'The Struggle for Political Democracy: Emancipation, Gender and Geography', *Environment and Planning D: Society and Space* 8, 1990, p406.

However, letting go of all spatial expression problematises feminist politics. Any attempt to gain freedom "requires political struggle, collective action, and this must mean temporary halts in the refusal to be categorised", but the "sites of these halts are in no sense final".[44] Perhaps a strategic spatial essentialism is needed to ensure that certain politics can be enacted because, to allow nationalism to continue

"*without* a feminist understanding of its inner workings and its consequences [...] might simply revise patriarchy so that it can thrive in new forms fit for a post-Cold War world".[45]

[45] Cynthia Enloe, *The Morning After: Sexual Politics at the End of the Cold War*, University of California Press, Berkeley CA 1993, p251.

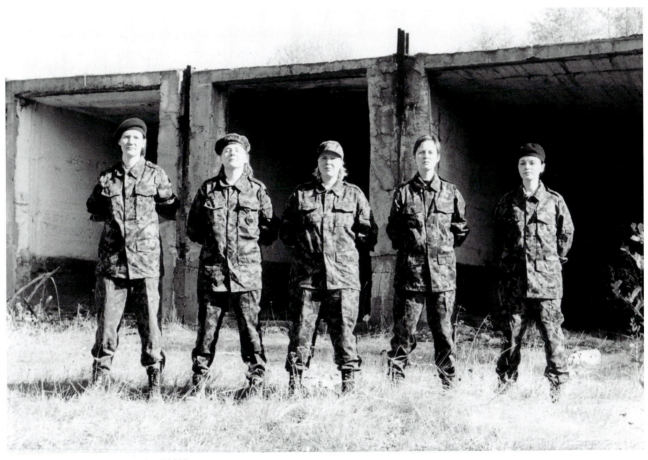

F.F.F.F. *F-files*, photo-installation, detail 1998

infallible universal happiness
media technology and creativity

Tiziana Terranova

I am interested in the way the issue of media art, and especially feminist media art, rearticulates the question of technology as a constitutive part of the media as such. Media art engages its medium (photography, video and computers) as an inextricable, implosive field of matter and culture. It brings back home the truth that the technological nature of the medium cannot be dissociated from what you make with it, what you make with it cannot be dissociated from what you are, and what you are cannot be dissociated from your historically and materially constituted self. Media art explores the collapse of the self, the body, culture and technology into a sensuous whole.

The unity of the things which allegedly make up the media and the limits between their political economy, their technological components, their capacity to generate meaning and their relationship with the embodied self are all imploded in the immediacy of the sensuous, but are not reducible to sensuality in any simple sense. Confronted with such immediacy, I am tempted to do what people like me (people who use a particular kind of language, the language of theory) usually do: pick it apart. I promise I will try to avoid that as much as I can. Instead, it is my intention that this essay should be read as a way of making connections; I would like it to work like a mutated, experimental cybernetic device whose nominal purpose is to keep open the lines of communication between two differently, and at the same time equally, dense worlds - academic criticism and artistic practice.

My references to embodied selves and cultural subjectivities, to material technologies and political economies are not meant to close down the debate by means of the usual academic dissection. I am thinking of them as possible lines of flight in the Deleuzian sense, lines which are already there in the artwork you experience and which connect it productively to other places. My most immediate connection with media artwork, as I mentioned above, is triggered by a common interest in technologies in general and media technologies in particular. I am interested in ways of looking/touching/using technology which acknowledge both the materiality of the latter and its being a locus for the implosion of culture, aesthetics, economics and politics (among other things). Media technologies fascinate me because they are the material constituents of media culture. At a very basic level, they ground the spectacle of the media in the nitty-gritty of technical protocols, valves, transistors, lenses and, more recently, microchips. I think of media technologies as the culmination of a kind of visible invisibility of matter: they are omnipresent, often fetishised, but are always somehow subordinated to something else - the 'content' which comes to them from the outside.

Recently I have also become more and more interested in approaches to media culture that do not forget its technological constituents and do not dissolve the latter

into culture and discourse. At the same time I do not want to separate media technologies from the whole apparatus of production and consumption of meanings which does take place in and through them. In this sense my disciplinary home (media and cultural studies) has offered mixed help. In spite of the plethora of recent theorising about new media and the widespread use of 'technology' as a catchword, media theory rarely starts from technology. There are several obvious reasons why it should be reluctant to do so, first and foremost the dangerous effects of 'technological determinism'. This, in fact, has been proved to get hold of anybody who starts from technology as such. In its more common manifestations it induces the most remarkable strands of delirium about progress, change and infallible universal happiness or its opposite and complement - the terrible consequences of dehumanisation and the end of nature.

When more cautious disciplines such as sociology and cultural studies tackle technology, then, they are always taking with them an excessive surplus of antibodies - in the forms of the omnipresent cultural, social and economic forces which 'shape' technology in the first place. The cultural studies and the political economy of the media would rather engage with meaning or social and economic structures than with technology as such. The assumption is that if we approach technology carefully with our most sophisticated understandings of society and culture, then we will exorcise the former's dangerous appeal.[1]

Since technology does seem to have a powerful, seductive effect on many of those who approach it, this is a useful strategy. This is particularly true when we consider how influential very streamlined versions of technological determinism are in the political and cultural arena. There is a bias in Western culture (and a very exportable bias indeed) towards the fix-all qualities of technology. In the case of the media, the most hyper-visible and excruciatingly meaning-ridden technology of our time, the temptation is even stronger. Didn't it all start with McLuhan's prophecy that media technologies were going to produce a diverse and yet peaceful global village? And how many times have we heard that new media such as the Internet are 'inherently' democratic because of their technological bias to many-to-many communication?[2] And what about the capacity of digitalisation to break down those old barriers between production and consumption?

However, even as I politically understand the urge of cultural and social theory to demystify technological determinism, I would suggest that maybe there are things we do give up when we translate the materiality of technology into the different levels of materiality of culture, society and language. This is something I think artists working with media technologies are in a position to know. They know that there is a physicality to the technology which cannot be separated from the things you can do with it; the kind of limits you can push it towards and what you can make it produce. And such limits are not just about its technical configurations in any narrow sense.

The technology which makes media formats possible is a corporeal reality with a complex relationship to the situated knowledges produced by the embodied subjects which use it, stretch it, bend it and reshape it when possible. It is malleable

[1] Examples of the latter include interesting and useful textbooks such as Jon Dovey (ed), *Fractal Dreams: New Media in Social Context*, Lawrence and Wishart, London 1997 and James Brook and Iain A. Boal (eds), *Resisting the Virtual Life: The Culture and Politics of Information*, City Lights Books, San Francisco 1995.

[2] See Nicholas Negroponte, *Being Digital*, Alfred A. Knopf, New York 1995 and Howard Rheingold, *The Virtual Community: Homesteading on the Electronic Frontier*, Harper Perennials 1994.

chapter 7

[3] Donna Haraway, 'Situated Knowledges: The Science Question in Feminism and the Privilege of Partial Perspective' in her *Simians, Cyborgs, and Women: The Reinvention of Nature*, Free Association Books, London 1991.

[4] Bruno Latour and Steve Woolgar, *Laboratory Life: The Social Construction of Scientific Fact*, Sage, London 1979.

[5] See especially Gilles Deleuze and Felix Guattari, *A Thousand Plateaus: Capitalism and Schizophrenia*, University of Minnesota Press, Minneapolis 1983.

but not infinitely malleable. It is matter and it does matter. Most of all, technology is not just about its technical traits, but about the way these traits are circuited into larger cultural, political and economic processes. It is, then, not a question of how technologies are shaped by something else; it is more about how they are connected in specific ways, but as full entities, to that 'something else'.

It is obviously no easy task to come up with theoretical models which take technology into account without dissolving it in its technical traits or its cultural and social determinations. There are, however, some positions and traditions within the interdisciplinary field of cultural studies which provide useful ways of at least unlocking the question. I have been particularly influenced by Donna Haraway's understanding of nature (and technology) as 'coyote' (the trickster figure of Native American folk tales);[3] by Bruno Latour and Steve Woolgar's suggestion that technologies are, among other things, material-semiotic actors;[4] and, more recently, by Gilles Deleuze and Felix Guattari's insistence that there is a machinic connection operating between different levels of materiality.[5]

In different (and often incompatible) ways, these theorists are pointing to strategies for dealing with matter without subsuming it under discourse. It is not, then, just a question of understanding how technologies are represented or how technologies represent something. To look at technology exclusively as technics (a mute cluster of mechanical devices) robs technologies of their specificity and turns them into empty mediators between different languages. I would, therefore, suggest that there are ways of looking at the media as, among other things, technologies. Such ways could be useful for embodied political practices such as feminist media art. Feminist artists already understand well that making art is not just about embodied subjectivities and disembodied economic and political relationships. It is never just a question of discourses and technologies: it is about the sensuous and its complex relationship with all of the above.

media, art, technology

The media are peculiar kinds of technologies. Their technological components, in fact, are hardly the first thing people notice about them (unless they break down). Because of their privileged and open relationship to the world of meaning production, media technologies are often more invisible than others. They can also be seen as 'media' in the same way as painting and sculpture - that is, material channels of 'expression', which have to be understood on their own terms. They are immensely popular and omni-pervasive and they cannot and will not dis-acknowledge in any way their ties to popular culture and capitalism. They are maddening spaces of difference and homogeneity.

What can artists do with the media? Since the relatively recent rapprochement between media and art, a certain 'common sense' infected with critical impulse requires that artists should do with the media what the media industry won't: they should reclaim the media as a sensuous experience and return it to a less homogenised and power-structured space. I think there is a truth to this statement

which goes beyond a simplistic notion of art as an exclusively 'oppositional' practice. What media artists have done is to recover the materiality of the medium, go back to its most fundamental aesthetic possibilities and push its boundaries towards places where the industry won't go. In so doing, they open (rather than foreclose) questions that more sociological and cultural approaches to the media usually avoid.

However, there is also another side to the story about media art as a radical version of media culture. If we understand media technology as something more than a representational device, then we understand media art as something more than alternative representation. When artists appropriate media technologies they are plugged into a whole set of social, political and technical relationships which go beyond issues of meaning in any straightforward sense (meaning as content). They are also plugged into the political economy of the medium in a relationship of continuity and discontinuity with the larger context where media technologies are deployed. In my chosen field, digital technology, this relationship is still in the making, more so than with established media technologies such as photography, film and video.

Let us consider photography. There is a material/discursive/practical continuity between photography as the repository of memory in its domestic uses, photography in the news and advertising, and feminist photographic artwork. This continuity crosses the uses of the medium at the levels of meaning, production, economic relationship to the art/media market and the technical machine as a reconfigurable and resistant material entity. Similarly, there are important continuities between television, camcorder culture and video art. Some of this continuity is discursive in as much as this artwork engages with the clusters of meaning produced by the medium at large. For example, it would be pointless to deny the centrality of feminist struggles over representation in the last thirty years or so. However, at some other level the connections between media artwork and mainstream media go beyond the struggle about the shift in meaning. If meaning is about stories and narratives, it is also about the reconfiguration of the media as technology in a non-deterministic way.

I call it non-deterministic because media technologies are not made up exclusively of representational strategies interfaced with technical apparatuses. Technologies are not closed technical systems. Media technologies are enormously complex machines and they are always connected with something else. But technologies are not just machines; they are multiple machines with material characteristics which must be taken into account. You cannot make technology do things it does not want to do (other than by turning it into something else). Technologies are also forever dragging you somewhere else. When art moves into a technological space (whether invited or not) it is always starting a process of multiple connections, of mutually affecting exchanges and flows. A task facing theorists and artists alike could best be described as the attempt to map critically this web of interactions.

chapter 7

enter the digital

How is this process of 'mutual affection' unfolding within digital art? Again it is important to stress the issue of continuity. Some of the questions which digital art opened up for feminism, for example, can be explained in terms of problems which feminist art practice has been dealing with for a long time. In its most visible form, the relationship between digital technology and feminist art is a reworking of the question of embodiment. Theorists such as Claudia Springer, Rosanne Alluquere Stone and Anne Balsamo have shown a keen understanding of the challenges presented by the 'disembodied' qualities of the digital as a medium.[6] With the sophistication characteristic of current feminist scholarship, they have analysed the 'splitting of the body from the subject' taking place, for example, in chatlines, MUDs and Virtual Reality games. Feminist installation work such as that performed by VNS Matrix on the LambdaMOO site, or feminist artists' work with Virtual Reality, have asked poignant questions about what happens to gender in the digital space ruled by the disembodied logic of the 0 and 1. These are by now well-trodden territories which have produced revealing insights into the 'work' of gender in the age of virtuality. These lines have been opened elsewhere and they will not be my concern here.

What I would like to do here is to keep my attention focused on the line my text-as-cybernetic-device has been busily working at. I would like to insist, then, particularly in the field of the digital, on the continuities of technology. I am not referring just to historical continuities as a safeguard against the overemphasis on change in digital culture. Things are never just the same or completely new. I am, rather, emphasising my point about the relationship between art facing digital technologies as the interface (a space of exchange) between two open technical-social systems. In particular I am interested in what happens with digital art when it positions itself more squarely within the burgeoning economy of the World Wide Web.

Since I am opening this tack from the perspective of digital culture, I will not spend much time explaining or describing feminist artwork on the Web. Instead, I want to look at some of the specific problems the Internet poses to artists in general and feminists in particular. Those artists who engage with digital art, and especially net art, are creating connections between two different fields of forces, governed by different and yet contiguous rules. The question of digital art on the Internet is, obviously, not just about 'doing' art and 'putting it up' on the Net. Practices do not get translated across technologies so easily and if they do, they are generally not very successful: few would argue that the artwork contained in the Louvre could look better on Bill Gates' computer screen than in the museum (unless it is a really big computer screen, maybe). I think that digitality has already made up a space for art and it has done so by a series of interesting slippages between art, creativity, production, knowledge, information, nature and capital. These slippages are largely ideological (that is constituted in and by the vested interests of some sections of the high-tech industry), but they are also real: they capture real aspects of the political economy of the Net and its relation to art.

The way the Net is understood as a kind of organic machine for the production and

[6] See Claudia Springer, *Electronic Eros, Bodies and Desire in the Postindustrial Age*, University of Texas Press, Austin 1996; Rosanne Alluquere Stone, 'Will the Real Body Please Stand Up?: Boundary Stories About Virtual Cultures', in Michael Benedikt (ed), *Cyberspace First Steps*, The MIT Press, Cambridge, Mass. 1991, pp81-118; and finally Anne Balsamo, *Technologies of the Gendered Body: Reading Cyborg Women*, Duke University Press, Durham 1996.

circulation of difference is an issue in its own right. Especially since the World Wide Web has become the unifying protocol of Internet culture (and a much more visually oriented one than MUDs or Usenet), there has also been a lot of talk about the essential function of art in the new Net-economy. Briefly, I think that art is asked to plug into the Distributed Difference Engine (the Internet) as the principle generative of change and a synecdoche for the creative spirit which allegedly makes up the essence of the Net as a whole.

the wired line

This perspective on the Internet will be familiar to anybody who has been following its politics in the last five years. They would know immediately that I am referring to the work of the much reviled *Wired* writers. To demolish the *Wired* perspective has become a bit of an easy shot in Internet circles (with hardly any effect on the unrepentant magazine). However, I would like here to stop for a second the reasonable irritation induced by *Wired* and take it seriously on its own terms.

According to the group of writers associated with the magazine, the Internet is a fertile 'culture' (in the biological sense); a self-organising organism able to produce change at accelerated rates.[7] According to this perspective, becoming part of the Net means becoming part of a productive biological economy. It is biological because it takes inspiration from (or, better, magically reproduces) the logic of Nature as such: the latter's 'passion' for variation, its trying everything out at once, and its way of producing difference without degenerating into useless disorder. In these writings nature provides a model for an economy of abundance, difference and innovation. Following another line of argument in the same context, the generative principle of the Internet as a Distributed Difference Engine is not 'information': it is creativity. Creativity absorbs art and production in ways which make the question of the difference between the three obsolete. In order to be really part of Net culture, you have to be creative.

[7] See especially Kevin Kelly, *Out of Control*, Addison Wesley Inc, USA 1994.

The silicon life of the Internet is made up of the products of the collective intelligence: a huge neural network spanning the globe, the Net is fertile ground for the proliferation of difference and change. The only other world-wide system which parallels the Net in taking its inspiration from Nature is free-market capitalism.[8] Therefore we have the infamous *Wired* corollary: deregulate, let go of control and things will sort themselves out thanks to the infallible logic of the free market. The silicon life forms which inhabit the Internet do not care much for old distinctions either. The omnipresent 'information' encompasses business ideas, software, TV gossip and art. Writing software, managing web sites, posting to mailing lists and making art are all ways to contribute to the Net as the magic difference engine. Creativity in digitality always happens at the interface between the individual and a continuous becoming of the info/biosphere. It is a mutual bargain: on the one hand the Net provides the best interface between the creative individual and a collective intelligence which transcends while empowering the individual as such; on the other hand the creative efforts of its users transmogrify the Net into the ultimate machine for the production of infinite variation.

[8] They are not the only ones to see a strong connection between the Internet and the logic of global capitalism (although with no need to invoke Nature). As an example see the book by Manuel Castells, *The Rise of the Network Society*, Blackwell, Oxford 1996.

In a way, then, the information overload represented by the millions of Web pages (most of which are universally acknowledged as 'mediocre') does not constitute an indictment of the medium. On the contrary, it confirms its links to the profuse, excessive and yet functional vitalist logic of Nature. These continuous slippages between art, creativity, productivity, nature, organism, capital and technology are fundamental to any understanding of the ambitions of digitalisation.

Such statements are obviously contradictory and controversial and there have been several deconstructive readings of the Internet as a self-regulating biotechnical machine (including my own).[9] I am still convinced of the necessity to critique these discursive formations on the basis of what they hide: the ugly belly of naked capitalism, its ruthless embrace of the crudest Darwinism, its complicity with the disavowal of the structural inequalities created by such a system and its defiance of feminism in its understanding of nature as that whose logic must be stolen. All of the above was necessary and needed to be said (although there is a faith behind the naked capitalism of the digital entrepreneur which cannot be convinced by rational argument or rhetorical sophistication).

These days, however, I also think that the ideological critique should constitute only a moment of a careful confrontation with the issues opened by digitalisation as the material medium described above. If art is to be plugged into digitality (and vice versa), then it needs to develop a better understanding not only of the latter's visible ideological limitations, but also of its partial 'truths'. Digitality is a machine composed of technology, economy and culture. The description of the Internet as this huge organic machine capable of mobilising an organic, bacteria-like proliferation of life-creative expression is not just about false consciousness and vested ideological interests (although of course it is about that as well). Plugging into the digital machine, confronting digitalisation, is also confronting this reconfiguration of creative expression in a tight interface with the processes set in motion by high-tech capitalism. For better or worse.

The *Wired* understanding of the Internet as the space of implosion of nature, art and capital, for example, throws a different light on the current fondness of the digital industry for artists. Talking about the recent sponsorship deal between SUN Microsystems and the Institute of Contemporary Arts in London, Armin Medosch reports how "[t]he blurring of boundaries between art and science, art and technology, culture and commerce was praised. It was said that digital technology would change everything...until we will all live a life that's all digital", as a SUN Marketing representative said with real emotion.[10]

If we stick to a reading of *The California Ideology* (Richard Barbrook's name for the *Wired* position) as ideological propaganda, then all we really have to be concerned about is commodification and the incorporation of artists as the content providers of the digital industry. These issues should be familiar to anybody who has ever attended any of the rowdy occasions when digital artists come together. How should we read the eagerness of the industry in embracing this collapse between art and commerce? Do we have to acknowledge that artists need to make a living, and that the digital industry produces new sets of transferable skills beyond teaching? Do we

[9] Chief among them Richard Barbrook and Andy Cameron, *The California Ideology* (http://www. hrc.wmin.ac.uk/); see also my 'Digital Darwin: Nature, Evolution and Control in the Rhetoric of Electronic Communication' in *New Formations 'Technoscience'* 29, Autumn 1996, pp69-83.

[10] Armin Medosch, 'Art and Business: Report from cyber.salon', in *Telepolis - Magazine of NetCulture* (http://www. heise.de/tp/), 1998.

have to protest the radical incorporation of art through digitalisation? What happens to the oppositional nature of artwork when the latter is completely subsumed by a corporate culture obsessed with change and novelty?

These are pertinent questions, but at the same time they are not the whole story. Making digital art demands more than defending the rights of reproduction of the artwork published on the Net or trying to maintain a creative independence in the midst of pressures by the industry. Engaging with digital art at this stage means to engage with the medium itself in the sense defined above: as an engine for the proliferation of difference, parallel and yet strongly connected to the logic of the free market (the naked mutant free market of Arthur Kroker's virtual capitalism).[11] Digitalisation invests art practice with a new set of concerns about the relationship between creativity, change, incorporation and high-tech capitalism.

[11] See Arthur Kroker and Michael Weinstein, *Data Crash: The Theory of the Virtual Class*, St Martin's Press, New York 1995.

This poses at least two crucial questions for artists: the first is the question underlying all the debates about commodification and incorporation. If plugging into the digital machine means plugging straight into the heart of the most advanced expression of contemporary capitalism, how is this relation to be conceived in terms other than those provided by the industry? How should artists deal with the inextricable presence of capital in digital technology if the former is such an integral part of the medium? It would then be a matter of looking at incorporation as something which should be incorporated in its turn, faced up to and creatively reworked in ways which go beyond the narrowest interests of the industry. I am not saying that artists should adapt and celebrate the industry's need for art. I am saying that by facing up critically to the new relationship between high-tech capital, digital technology and art they could come up with productive ways of undoing the deadlock of incorporation. And they could do this by making it part of the aesthetic challenge posed by digital technology, by turning it into art. However, the problem of incorporation is obviously not the exclusive concern of artists. It is a valid question for Netculture as a whole but also one which artists have been put in an ideal position to confront. It is about what to do with a system which puts to work and circulates, at ever increasing speed, everything you do and enjoy doing.

The second question is more pertinent to the work of women artists. What does it mean to become involved with a medium which puts such an emphasis on 'difference'? If women have been 'different' all their historical life, this difference has always been conceived as other from the male norm. Being the locus of difference has been a heavy historical burden, but it has also allowed women in their historical situation to explore difference in rich, nuanced and productive ways. Digital culture, however, does not seem to be concerned with difference as gender. In a way, the Net as an organism is more like a bacterial colony: sexual reproduction is exchanged for replication and mutation. Difference is multiple rather than binary.

I am not arguing that gender as a whole does not exist on the Net or is not important. On the contrary, it is extremely important. There is a very powerful argument for the binary logic of the Internet as the culmination of the dialectic between self and other, male and female. One of the most flagrant examples is the porn industry, at the vanguard of technological innovation on the Net (a better image

for gender structures being the engine of change I could not find myself). The Distributed Difference Engine loves certain kinds of differences more than others, especially when they come in the economically viable shape of porn. However deep gender structures go to the heart of the Net, there is also a truth to the statement that digital difference is not necessarily binary. Then the question becomes: how do we reconcile the structural importance of gendered difference in real life with the multiple differences of the Distributed Difference Engine? Women artists have had two options until now: they have chosen to play the usual game and stay there to remind the virtual of the corporeal (as particularly evident in feminist theoretical analyses of the Net); or they have gone the cyberfeminist way and celebrated the relative freedom of difference in the multiple rather than the binary.

In the first case, women have had to become those who remind the boys that the body matters, even in the bacterial economy of the Net. Although one could think of worse things to be burdened with, this strategy has some real limits. It takes up only a tiny section of the challenges put to art by digitality and ends up tracing the same argument again and again. The tediousness of the task might be an explanation as good as any for the cyberfeminists' choice. Headed by the British Sadie Plant, the latter have preferred to regard the Net as a machine for the inducement of mutation and explore how this mutation affects our relationship with gender.[12] It is a serious political problem for feminists interested in digitalisation and there are no easy solutions - only those that come from a long-term commitment to understanding the relationship between gender and digitality. I would suggest, however, that the question of the role of 'difference' within digitality and the relationship between feminist art practice and the political economy of the Net will provide some of the challenges peculiar to this medium. The two questions are inextricably linked by the issue of difference, at the border between binary difference and proliferating, bacterial mutation. The engagement with 'difference' and the ways in which the latter is articulated and deployed within the regime of the digital is the double challenge open to feminist digital art.

conclusion

It is becoming impossible not to acknowledge the increasing relevance of the question of creativity for the economy of the Net. I have tried as much as possible to safeguard my objects of discussion (art and the Internet) from the totalising ambitions of theory. This does not mean that I do not have a strong investment in the digital and that I do not feel like saying a few totalising things about it. The creative pull of Net culture, and its continuous seduction into the economy of change and creation, exercise a powerful influence on my life and presumably other people's lives as well. Sometimes I feel I need the 'slacker' in me to put up some resistance to the lure of 'interactivity'. There are things about that pull, however, which do not demand just a few hours of passive resistance. They demand an engagement with the multiple connections engendered by the difference engine and some of these connections drive deep into the heart of artistic practice. I have tried, therefore, to point out how digitality is mobilising art in a particular way and to indicate the challenge this poses for artists in general and women artists in particular. My hope is

[12] See Josephine Bosma, 'Interview with Alla Mitrofanova & Olga Suslova' in Nettime (http://www.desk.nl/~nettime/), 1997.

that the connections I have drawn here might be taken up, redrawn, and connected in their turn to something else. Part of the Engine, but not quite.

Private Views web site, screenshot 2000

appendix

contributors - artists and writers

Susan Brind is an artist and curator currently teaching at Glasgow School of Art. Using predominantly video and photography, her work examines the complex and ambivalent relationships structuring the mind/body dichotomy.

Angela Dimitrakaki studied art history and archaeology. She is Research Co-ordinator at the Centre for Art International Research (cair), LJMU. Her research and publications focus on gender, cultural difference and the histories of feminism. She joined the board of directors of the Foundation for Art & Creative Technology (FACT) in 1999.

Naomi Dines is a London-based artist and lecturer. She currently teaches at Central Saint Martins College of Art & Design. Her work employs object, installation and image to investigate aspects of identity, self, body and conceptions of the 'other', particularly in relation to gender and desirability.

F.F.F.F. – are a group of five female artists: Berit Teeäär, Kaire Rannik, Ketli Tiitsar, Kristi Paap and Maria Valdma. They graduated from the Estonian Academy of Arts and have been working and exhibiting together since 1994. They use a wide range of media, from small objects to photography, video and installation. Their work is concerned with exploring social memory and stereotypes.

Marit Følstad is an artist and holds an MFA from The Art Institute of Chicago, USA. Her practice employs lens-based media, sound and performance to address the conditions which arise when the space of the body is used as direct working material for exploring the boundaries of conscious and unconscious memory.

Anu Juurak began her career as a graphic artist. Since 1996 her main sphere of interest has been video installation and interactive space. She has twice (1996, 1997) been awarded the Soros prize at the annual exhibition of the Estonian Soros Center for her video installations.

Eve Kiiler is an artist and Head of the Photography Department at the Estonian Academy of Arts. Kiiler is also the co-curator (with Peeter Linnap) of the international photography event *Saaremaa biennale*, which is an independently organised art event in Estonia.

Katrin Kivimaa is a Ph.D. candidate in the History of Art at the University of Leeds. She was the art editor for the Estonian cultural weekly *Sirp* and her writing on contemporary art appears in many Estonian newspapers and journals. Her research concentrates on feminism and women's art in contemporary Estonia.

KIWA is an artist whose practice includes a wide range of media: sculpture, painting, video, installation, graffiti, performance and body art. His art draws on pop-lifestyles, youth and club culture and the nineties counter-cultures.

Mari Koort practised as a solicitor before studying sculpture at the Estonian

Academy of Arts. She mostly works in the fields of sculpture and photography.

Pauline van Mourik Broekman is an artist and co-editor of *Mute,* a magazine on culture and technology. She has written for various publications, including *Andere Sinema; the Nettime anthology ReadMe!; Somewhere* - a catalogue of networks by Nina Pope and Karen J. Guthrie; and more recently, *Locus Solus* - an anthology and critical discussion of projects commissioned by Locus Plus.

Aoife Mac Namara is Lecturer in Visual Culture and Media in the School of Art, Design and Performing Arts at Middlesex University, London. As an historian and artist her interests focus on the relationship between visual culture, imperialism and gender in post-sixteenth century Ireland and the UK.

Barbi Pilvre holds an MA in Social Sciences from Tallinn University of Educational Sciences (TUES) and works as a journalist for the weekly *Eesti Ekspress*. She is a founding member of the Centre for Women and Gender Studies at TUES. Her research interests are gender and the image in Estonian media.

Ene-Liis Semper is a video and performance artist and currently a theatre designer at the Eesti Draamateater. Semper has experimented with video and performance since the beginning of the nineties. Her work often uses narrative structures which subvert notions of 'natural' sexuality.

Joanne P. Sharp is Lecturer in Geography at the University of Glasgow. Her interests are in feminist geography, particularly the relationships between gender and nationalism, and in the role of the media in (re)producing national and international geographies.

Liina Siib graduated from the Department of Graphics at the Estonian Academy of Arts in 1989. Siib is interested in experimental print techniques and photo-based digital print, which she often incorporates into installations. Her work tests institutions and social structures and their relationship to individuals.

S.Girls is an internet project, which was initiated by a group of Estonian women. It is a collection of women's stories at http://www.artun.ee/~trimadu/S_girls/.

Pam Skelton is an artist and Senior Lecturer in Fine Art at Central Saint Martins College of Art & Design. Her work in painting and video installation has principally explored history as a space of ruptures and dislocations which occur between site, memory and event.

Tiziana Terranova teaches in the Department of Cultural Studies at the University of East London. Her interests include the function of science and technology within cultural formations associated with the Internet. Her published research, in Italian and English, focuses on gender, science and internet culture and has appeared in various publications, including *New Formations*. She is currently working on a book about the cultural politics of the Internet.

Annika Tonts graduated from the Estonian Academy of Arts and currently lives and

works in Finland. Her recent work combines kinetic objects and installations. Tonts was one of the first Estonian artists to use the Internet as a space for art: http://ameba.lpt.fi/~tonts/

Mare Tralla (Disgusting Girl) lives and works in London and Tallinn. She is currently Head of the E-Media Centre at the Estonian Academy of Arts. Her art practice incorporates photography, video, installation, performance and digital media. In 1995 she was co-curator of Estonia's first feminist art project *Est.Fem*. http://www.artun.ee/~trimadu/

Sonja Zelic graduated from Central Saint Martins College of Art & Design in 1997. Her practice encompasses a variety of media including film, video, sound and site specific installation. Her work often employs a minimal figurative language in which images of animals and insects are used to explore the boundaries of the 'unspeakable'; images in which we nevertheless recognise something human.